CONTEMPORARY

celtic crochet

24 cabled designs
for sweaters, scarves,
hats and more

BONNIE BARKER

Fons&Porter

CINCINNATI, OHIO

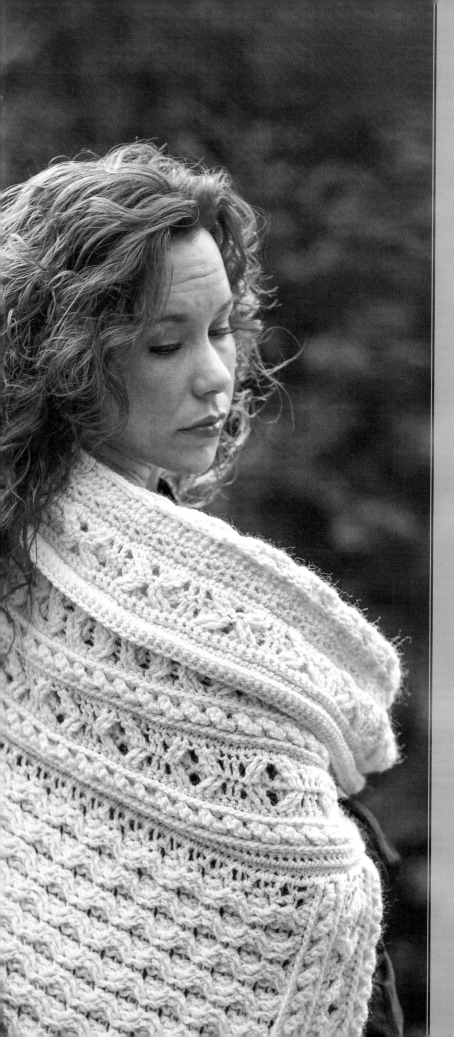

TABLE OF CONTENTS

Introduction **3**
Getting Started **4**
List of Abbreviations **5**
Crochet Stitch Guide **6**

PROJECTS **42**

Liffy in a Jiffy **44**
Burren Braids Hat & Scarf **46**
Pennywhistler's Purse & Pack **48**
Jig Infinity Scarf & Headband **52**
Blarney Blanket **54**
Tipperary Sweater & Vest **56**
Hialeah Honey Baby Blanket **62**
Cables Meet Lace Cape **64**
Celtic Carryall **68**
Gaithersburg Stole **72**
Inisheer Sweater Wrap **76**
Sailboats Baby Blanket **80**
Knockardakin Wrap **84**
Gavotte Gigs **88**
Aran Diamonds Cardigan and Vest **92**
Busking Beauty Sweater Wrap **98**
Doolin Delight Sweater Wrap **102**
Baby Feet Baby Blanket **108**
Kells Cabled Sweater **112**
Celtic Cross Afghan & Pillow **116**

Resources **122**
Meet Bonnie Barker **124**
Acknowledgements **125**
Index 127

Introduction

Welcome to the contemporary world of Celtic crochet! There's one message I want you to hear before you run away screaming in fear from any perceived difficulty in any of these projects: *These stitches are not hard!* Every stitch on every page of every pattern in this book is based on basic, fundamental crochet stitches you probably already know, *and* you don't have to run out and purchase any other fancy equipment (save that money for beautiful yarn). If you know how to crochet a chain, single crochet, double crochet, slip stitch and treble crochet already, you've got all the tools you need in your tool box and can complete any project in this book. That said, the projects do progress to offer intermediate and seasoned crocheters a pleasant and inspiring challenge.

If you are a beginner or new to these stitches, that's great! Please become familiar with the basic stitches mentioned above. Once you know these basic stitches, I would encourage you to start on the patterns toward the front of the book, which focus on only one or two stitches at a time, until your stitches are reasonably even in size. A scarf is always a great way to start. Should you ever get stuck, you can always go to the stitch guide for step-by-step instructions for each stitch. You can also watch instructional videos on my website at www.BonnieBayCrochet.com. There are many ways to learn these wonderful stitches.

I've been infatuated with the beauty of Aran knit stitches for years, but I have a confession to make: I don't enjoy knitting! Yes, I've tried it and can do it, but I prefer crochet. I just love the smooth and relaxing motion of the hook in my hand, not to mention that the process is so much faster, at least for me. Hence, this book on contemporary Celtic crochet is my answer to this dilemma. Yes, I *do* want it all!

Knitters, please know that I will always admire what you do (I have to, especially since my budding crochet designer daughter has recently gone over to the dark side of the Force and learned to knit), yet I will seek every opportunity to imitate it with crochet stitches if and when humanly possible. Yes, you may call me stubborn, but contented I remain.

—Bonnie Barker

DEDICATION
To *the* master designer, Jesus the Christ.

"For you, O Lord, have made me glad by your work; at the works of Your hands I sing for joy." Psalm 92:4

GETTING STARTED

A FEW WORDS ABOUT YARN WEIGHTS AND SUBSTITUTIONS

Each pattern in this book lists the specific yarn used as well as the classification of the yarn weight, which is directly related to the yarn's thickness. If you choose another type of yarn, I would encourage you to stay within that numbered weight in order for your project to remain consistent. However, even within each weight category, you will find a subtle variation in yarn thickness. In other words, not all DK weight yarns are exactly the same, nor are all worsted weight yarns the same, either. Depending on the content of the yarn (wool, acrylic, cotton, blends, etc.), it will behave differently. Your best bet is to make a small swatch before beginning your project and evaluate whether that particular yarn would be a good substitute.

SKILL LEVEL SYMBOLS

Don't be afraid of these symbols. They are your friends! As mentioned earlier in the book, once you have become familiar with the most basic crochet stitches (chain, single crochet, double crochet, treble crochet and slip stitch), you should be able to attempt most of the projects up through the intermediate level. If you are an intermediate crocheter, don't be afraid of the experienced symbols. Consider these an opportunity to grow and add a new skill or two to your crochet repertoire.

WHY IS MY SCARF GETTING FAT OR SKINNY?

If you've crocheted for long, you've probably experienced your work growing or shrinking in places when you don't want it to. Once you're past the beginning stage of your crochet career, you will understand how to fix this problem: place only one stitch in each stitch. If you skip the first stitch of the row, then put the last stitch in the turning chain. If you do this consistently, your crochet piece won't grow or shrink. If only dieting were as easy!

THE GREAT TURNING CHAIN DEBATE

If you follow the Craft Yarn Council of America's excellent recommendations (skipping the first stitch in double crochet rows and making a double crochet in the turning chain), you will maintain an even stitch count and straight sides. However, you will also have a slightly larger hole where the chain 3 is located. Since many of my designs are anything but straight double or treble crochet, I've taken some liberties to rid most of my designs of these dreaded holes. This is why I choose to use a chain 2 for double crochet turning chains, and chain 3 for treble crochets. These are not misprints! I also begin crocheting in the first stitch of the row and only crochet into the turning chain when specifically directed to do so by the pattern. Consider it use of my artistic license. I apologize if this small adjustment rocks the boat too much for any seasoned crocheters. If you complete a pattern or two, you'll understand. I may even win you over to my side of the Great Turning Chain Debate!

BEGINNER

EASY

INTERMEDIATE

EXPERIENCED

LIST OF ABBREVIATIONS

approximately	approx	half double crochet	hdc
back loop(s)	blp(s)	increase(s)	inc
back post	bp	loop(s)	lp(s)
back post Braided Cable	bpBC	low back ridge	LBR
back post Celtic Weave	bpCW	low front ridge	LFR
back post double crochet	bpdc	main color	MC
back post treble crochet	bptr	popcorn	pc
beginning	beg	previous	prev
Braided Cable	BC	remaining	rem
Celtic Weave	CW	repeat(s)	rep(s)
chain	ch	right side	RS
chain space	ch sp	round(s)	rnd(s)
cluster	CL	single crochet	sc
continue	cont	skip	sk
contrasting color	CC	slip stitch	sl st
decrease(s)	dec(s)	space(s)	sp(s)
double crochet	dc	stitch(es)	st(s)
double crochet popcorn	dcpc	together	tog
front loop(s)	flp(s)	treble crochet	tr
front post Braided Cable	fpBC	Woven stitch	Woven st
front post Celtic Weave	fpCW	wrong side	WS
front post double crochet	fpdc	yarn over	yo
front post treble crochet	fptr		

Crochet Stitch Guide

ARROW (MULTIPLE OF 4 + 2)

Row 1: (Be sure to ch 2 at the end of the prev row before beg this row.) Dc in the next st.

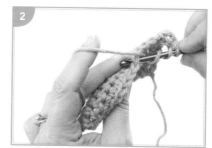

Sk the next 3 sc.

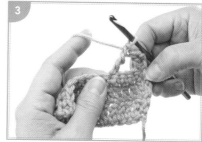

Tr in the next st.

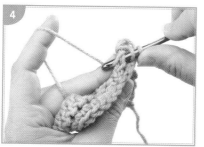

Working behind the tr just worked, dc in each of the 3 sts just skipped.

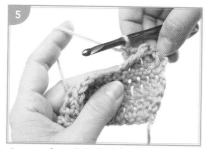

3 completed dc behind tr.

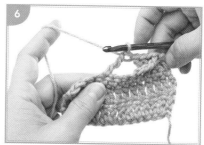

Sk the next 3 sc, tr in the next st.

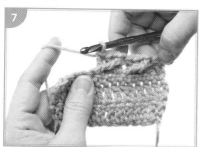

Working behind the tr just worked, dc in each of the 3 sts just skipped.

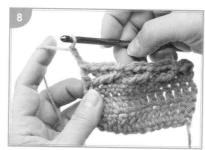

Cont the pattern to the end of the row, ch 2.

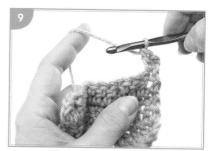

Row 2: Turn, dc in the 1st dc of the row.

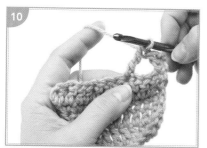

Sk the next 3 sc, tr in the next st.

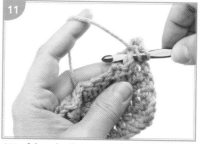

Working in front of the tr just completed, dc in each of the 3 skipped dc.

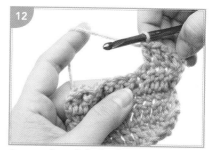

3 completed dc in front of the tr.

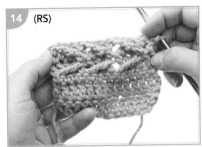

The WS of the Arrow st.

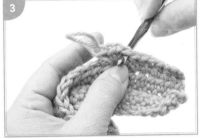

The RS of the Arrow st.

BABY FEET TOE POPCORN

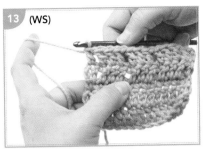

Work 4 sc in the same st.

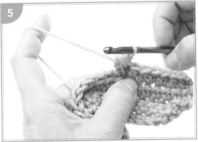

Pull up the lp.

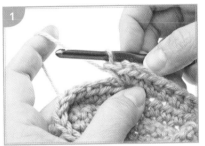

Insert the hook into the 1st st (of the 4 sc) from the WS of the st.

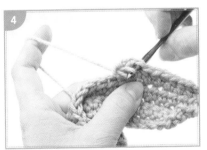

Place the working lp around the hook.

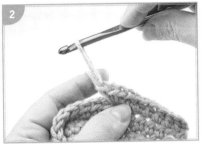

Pull the lp through, from front to back.

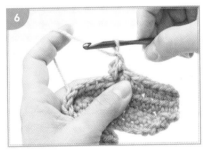

Ch 1.

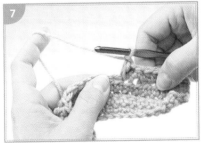

Pc should protrude outward, away from the back, so that the texture is on the RS.

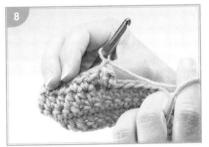

Pc texture "pops" on the RS.

7

BACK POST DOUBLE CROCHET (BPDC)

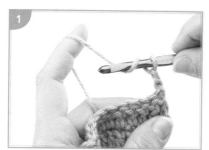

Yo.

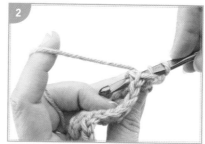

Insert the hook from the WS of the st toward the RS and then to the WS again.

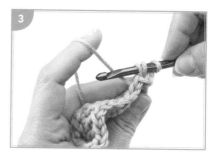

Pull up a lp.

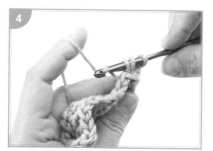

Yo the back of the hook.

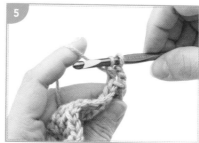

Pull through 2 lps on the hook.

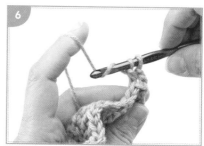

Yo and pull through both lps on the hook.

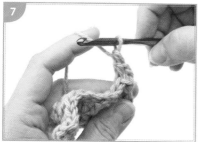

One bpdc is complete.

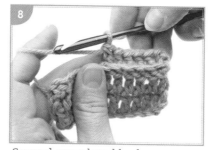

Several completed bpdc.

TIP

Visit BonnieBayCrochet.com for video examples of the stitches in the Crochet Stitch Guide.

BACK POST TREBLE CROCHET (BPTR)

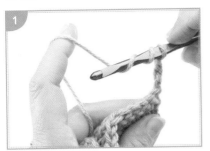

Yo twice.

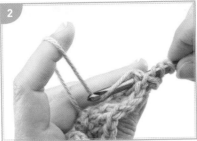

Insert the hook from the WS of the st toward the RS and then to the WS again.

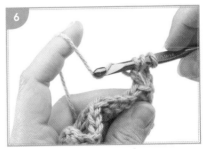

Pull up a lp.

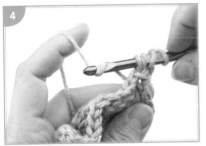

Yo the back of the hook.

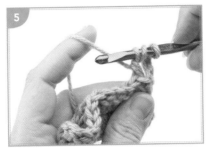

Pull through 2 lps.

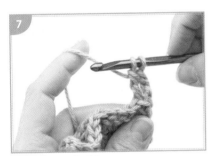

Yo the back of the hook.

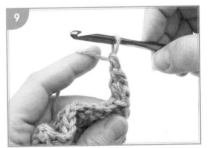

Pull through 2 lps.

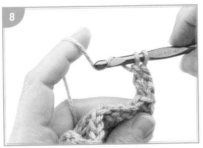

Yo the back of the hook.

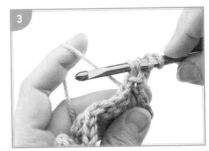

Pull through 2 lps, bptr completed.

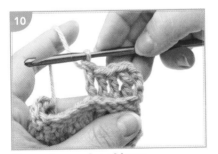

Several completed bptr.

BASKET WEAVE (MULTIPLE OF 6 + 1)

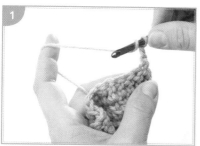

Row 1: (The sts of these rows will be made by working around the body or "post" of the sts of the prev row instead of working in the top lps.) Ch 2.

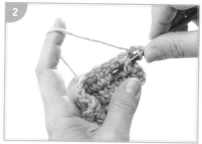

Sk the 1st st of the row, insert the hook around the next st from the front.

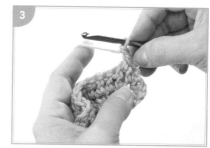

Complete the fpdc.

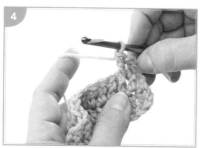

Fpdc around the next st.

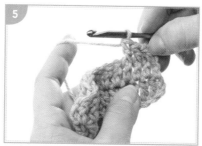

Fpdc around the next st (3 fpdc).

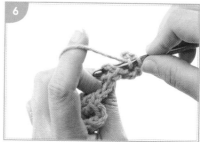

Insert the hook from the back and around the st.

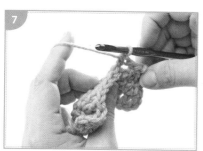

Complete the bpdc.

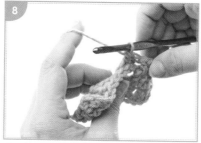

Bpdc around the next st.

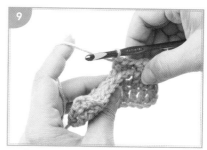

Bpdc around the next st (3 bpdc). Cont to alternate between 3 fpdc and 3 bpdc across the row. At the end of the row, hdc in the turning ch. Turn, ch 2 at the beg of each row. Complete 2 more rows (Rows 2 & 3), being careful to work fpdc over fpdc, and bpdc over bpdc. Turn.

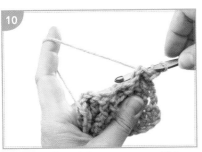

Row 4: Ch 2. (The pattern will be more established in this row as the fpdc and bpdc will be worked the opposite of the prev row.) Insert the hook from the back of the next dc.

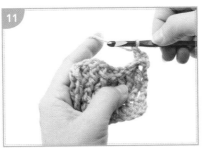

Complete the bpdc.

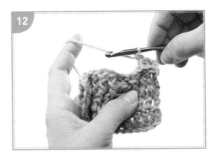

Bpdc around the next st.

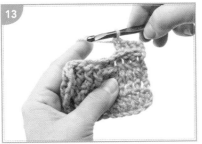

Bpdc around the next st (3 bpdc).

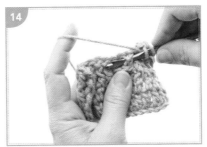

Insert the hook from the front of the next dc.

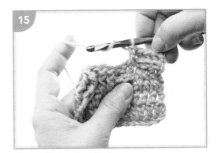

Complete the fpdc.

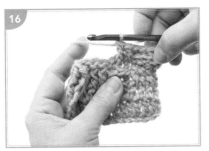

Fpdc around the next st.

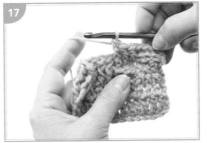

Fpdc around the next st (3 fpdc). Cont to alternate between 3 bpdc and 3 fpdc across the row. At the end of the row, hdc in the turning ch. Turn, ch 2 at the beg of each row. Complete 2 more rows (Rows 5 & 6), being careful to work fpdc over fpdc, and bpdc over bpdc.

At the end of Row 6, rep Rows 1–6 to maintain the pattern.

BIG TOE POPCORN

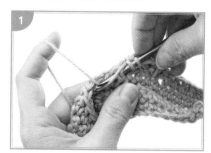

Work one fpdc around the st post.

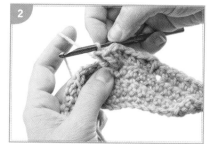

Work 3 more fpdc around the same post.

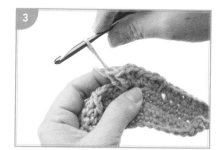

Pull up a lp.

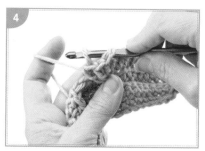

Insert the hook into the 1st of the 4 fpdc and put a lp on the hook.

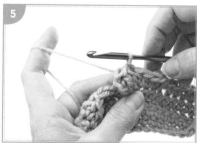

Pull through all the lps on the hook.

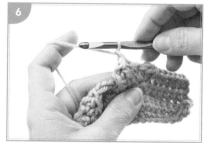

Ch 1. Big toe completed.

BRAIDED CABLE (BC) (MULTIPLE OF 6 + 2)

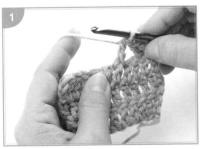

Yo twice, sk 2 sts, work fptr around the next st post.

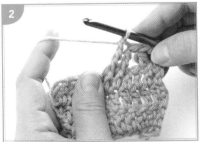

Fptr around the next st post.

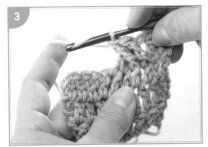

Work fptr around each of the 2 sts skipped.

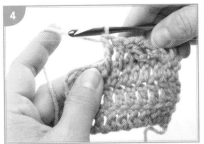

Work fptr in each of the next 2 sts. One braid completed from the RS.

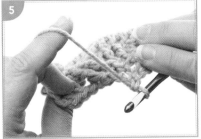

Working from the WS, sk 2 sts of the braid, bptr around each of the next 2 sts.

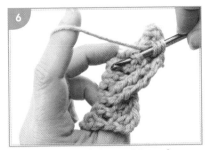

Bptr in each of the 2 skipped sts.

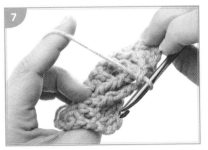

Bptr complete.

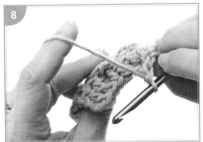

Completed braids shown from the WS.

BEGINNING CHAIN (BEG CH)

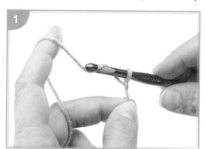

After forming a slip knot, yo the back of the hook.

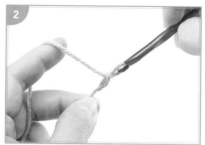

Pull through the lp.

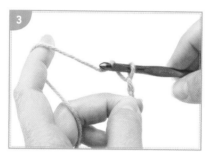

Yo again.

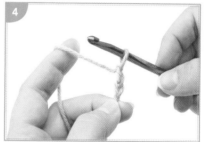

Pull through the lp. Cont to form a ch to the needed length.

BUTTONHOLES

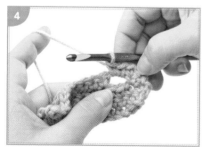

Ch 2, then sk the next 2 sts of the row.

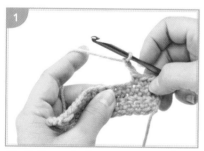

Sc in the next st. You should have formed a hole 2 sts wide in your work.

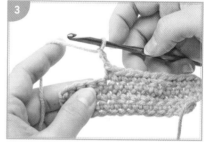

Row 1: Sc the desired distance from the buttonhole just made to the beg of the next buttonhole. Ch 2, sk 2 sts, sc in the next st.

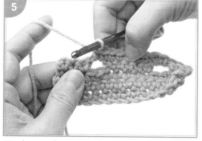

Row 2: Sc until you reach the ch-2 sp. *Work 2 sc in the ch-2 sp.

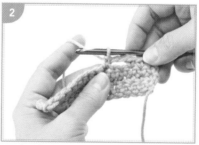

Sc in each st to the next ch-2 sp. Work 2 sc in the next ch-2 sp.

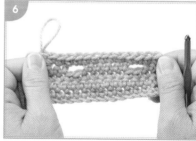

Completed example of buttonholes.

CABLE (MULTIPLE OF 3 + 2)

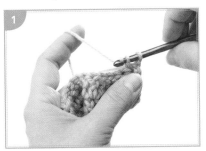

Row 1: Sc in the 1st st of the row.

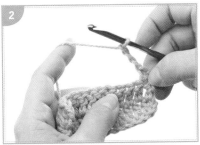

Ch 3.

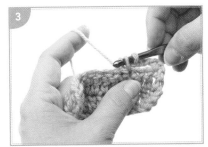

Sk the next 2 unworked sc of the prev row, *sc in the next sc.

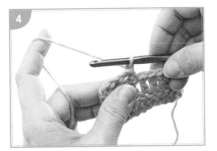

Turn.

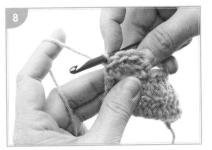

Work sc in each ch of the ch-3 just made.

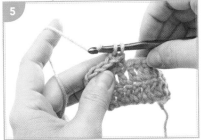

3 sc completed in ch-3.

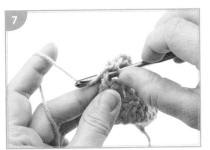

Sl st in the next sc.

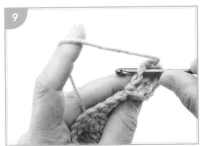

One cable made.

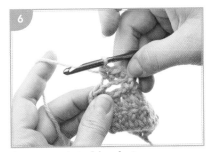

Turn. Working behind the cable, sc in each of the 2 skipped sc.

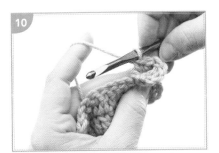

2 sc behind cable completed.

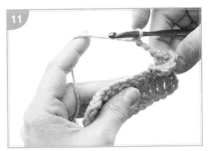

Ch 3.

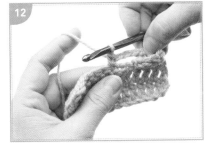

Sk the sc that was made after the ch-3, rep from * across the row. End by working a sc in the last sc of the row.

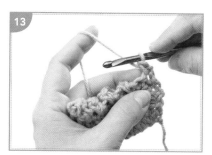

Row 2: Sc in the 1st sc.

(Note: In this row, you will work a sc in the 1st and last st, and 3 sc evenly spaced behind each cable [on the WS]. The 3 sc behind each cable are worked into the sc that were worked into the 2 skipped sc. Work a sc in one of these skipped sc and 2 sc into the other. Do not work into the sc of the cables. Push the cables toward the RS of your project as you work.)

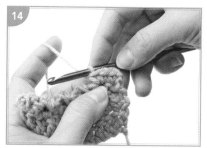

2 sc in the next sc (see the note in Step 13).

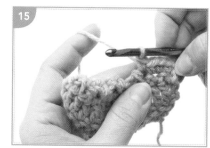

1 sc in the next sc. (There should be 3 sc behind the 1st cable, not including the 1st st of the row.)

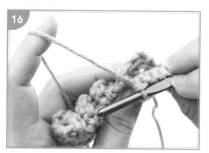

Another view of working a sc behind the cables.

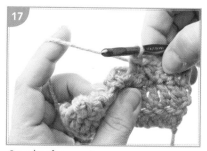

2 sc in the next sc.

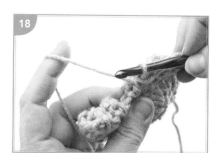

1 sc in the next sc. Cont across the row.

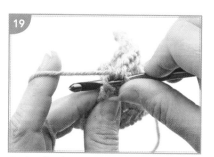

Sc in the last st of the row.

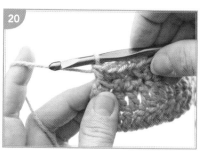

Back view of the Cable st.

CELTIC CROSS

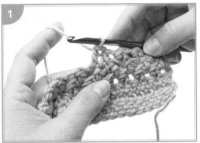

Row 1: Sk the next Woven st, working in the 2 sets of lps of the Woven st, dc in each set of top lps of the next Woven st.

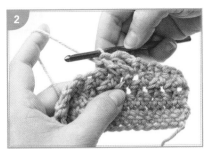

Working in the Woven st just skipped, dc in each set of top lps of the next Woven st.

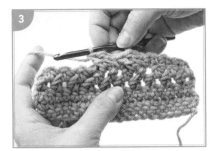

View of working over 2 more Woven sts.

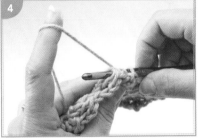

Row 2 (for the cross portion): Bpdc over the 1st dc of the cross.

(Note: The rest of the rows where the cross occurs will use either fpdc or bpdc.)

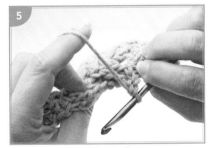

Bpdc over the next dc.

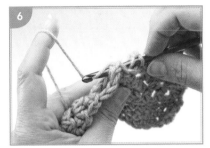

Sk 2 sts, bpdc around the next dc.

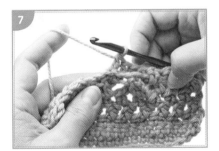

Bpdc around the next dc.

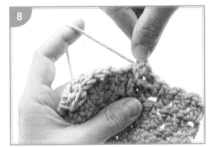

Working behind the 2 dc just made, bpdc in the 2 skipped dc.

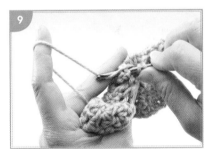

For the last 2 sts of the cross, bpdc in the last 2 sts.

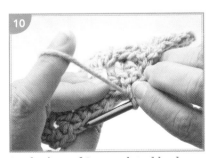

Back view of 2 completed bpdc.

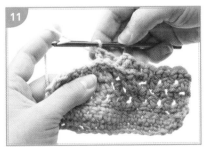

View from the WS after completing 2 rows.

CELTIC WEAVE (CW) (MULTIPLE OF 4)

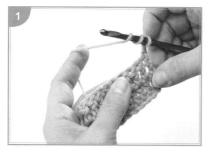

Row 1: With RS facing, ch 2, sk the 1st 3 sts.

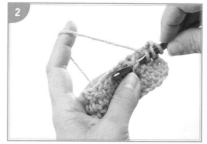

Fptr around the next st.

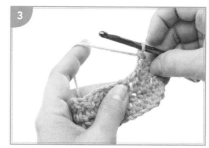

Fptr completed.

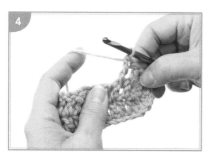

Fptr around the next st.

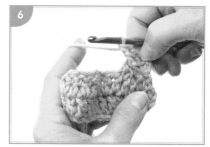

Working in front of the last 2 sts, fptr around the 2nd skipped st.

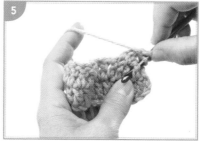

Fptr completed.

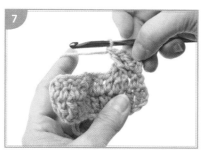

Fptr around the 3rd st skipped.

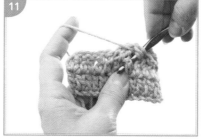

Sk 2 sts.

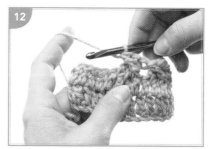

Fptr around the next st.

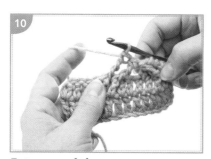

Fptr around the next st.

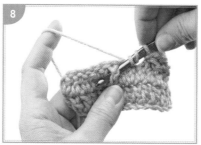

Working in front of the last 2 sts, fptr around the 1st skipped st.

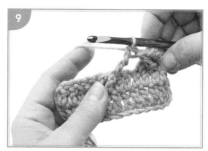

Fptr completed.

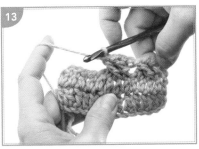

Fptr around the next st. Cont across the row. Dc in the turning ch, turn.

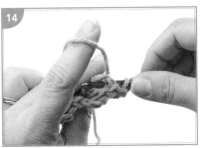

Row 2: Ch 2. With WS facing, bptr in the 2nd st of the row.

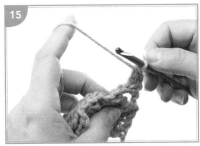

Bptr completed.

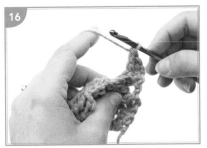

Bptr around the next st.

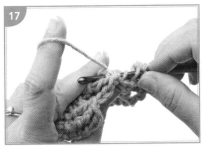

Sk 2 sts.

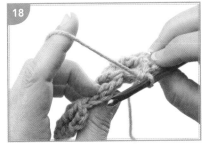

Bptr around the next st.

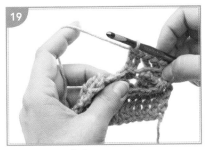

Bptr around the next st.

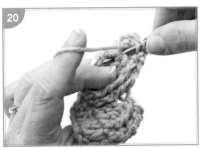

Working in front of the last 2 sts (as seen from the WS), bptr around the 2 skipped sts.

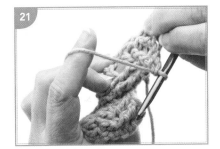

Bptr completed.

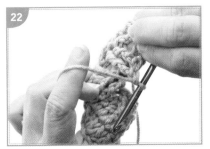

Bptr around the next st.

TIP

Since it's much easier to feel these stitches than it is to see them, you may find it helpful to use the thumb and fingers of the hand holding the yarn to help guide your hook to the two stitches in Step 20.

CROCHET IN THE ROUND

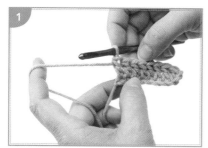

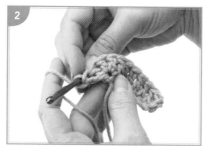

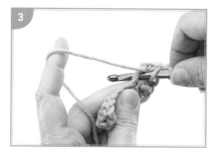

Start with a row of ch sts. Dc in the 3rd ch from the hook and in each ch across.

Make 3 more dc in the last ch of the row (for a total of 4 dc in the end st).

Working on the opposite side of the ch, and being careful to work in the rem lps, dc in the next st.

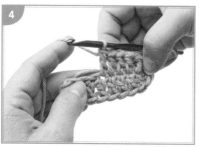

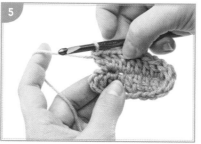

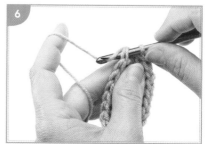

Dc across the row to the last ch. Hide the loose strand by crocheting around it alongside the ch.

Work 3 dc in the last ch of the row.

Connect to the 1st dc of the row using a sl st. (Do not work in the ch-2.)

Clip the loose strand from the ch if it has been hidden with crochet, as mentioned in Step 4. Otherwise, hide the tail with a yarn needle before trimming.

DIAMOND

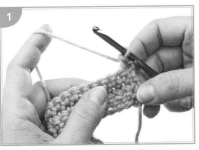

Rows 1–3: Ch 1, sc in each st across, turn. **Row 4:** Sc in the 1st st.

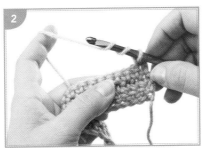

Yo the back of the hook twice.

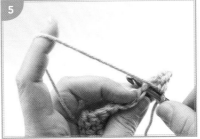

Sk 3 sc on Row 1, fptr around the next sc (still on Row 1).

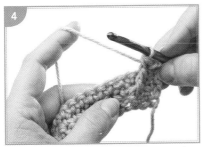

Completed fptr, beg of diamond.

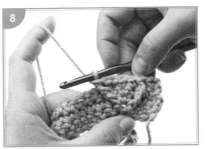

Working back on Row 4, sk 1 sc, sc in the next sc.

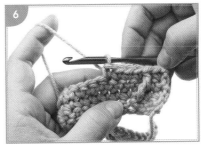

Sc in the next 3 sc also.

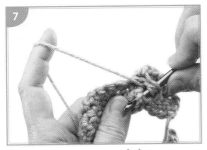

Fptr on Row 1 around the sc next to the last fptr worked.

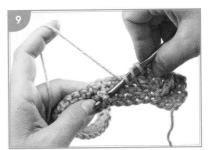

Completed fptr.

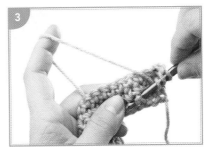

Sk 4 sc (on Row 1), work fptr around the next sc.

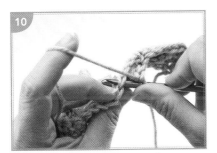

Working back on Row 4, sk 2 sc.

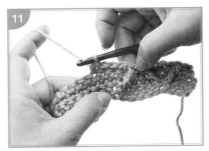

Sc in the next 4 sc.

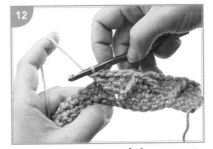

Fptr on Row 1 around the sc next to the last fptr worked.

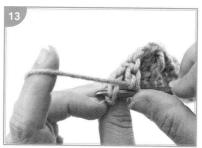

Cont the pattern across the row, ending with a sc in the last st of the row.

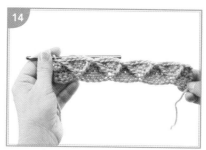

Completion of the 1st 4 rows of the Diamond pattern.

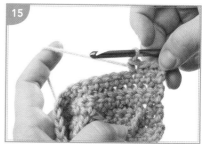

Rows 5–7: Ch 1, sc in each st across, turn. **Row 8:** Sc in the 1st 3 sc.

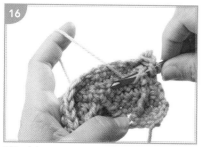

Working on Row 4 (this is also the sc row just above the row with the fptr), fptr around the sc just above the fptr on Row 4.

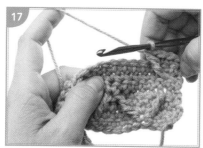

Completed fptr.

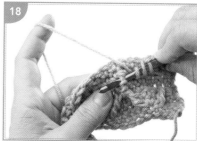

Fptr around the sc next to the last fptr (on Row 4).

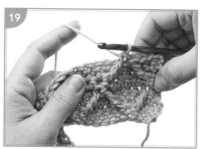

2nd fptr completed, forming 1st diamond.

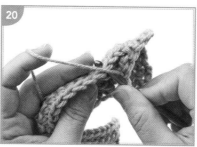

Working on Row 8, sk 2 sc.

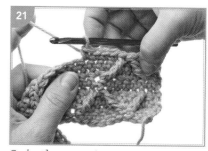

Sc in the next 4 sc.

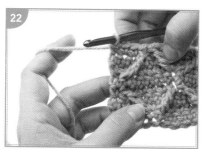

Working on Row 5, fptr around the sc just above the next fptr, sk 4 sc (on Row 5), fptr around the sc just above the next fptr (on Row 5). Sc in the next 3 sc (on Row 8).

Rep Rows 1–8 to cont the Diamond pattern.

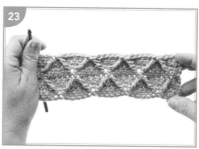

Completed sample of the Diamond pattern.

DOUBLE CROCHET (DC)

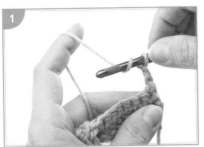

After completing a turning ch of 2 ch, yo.

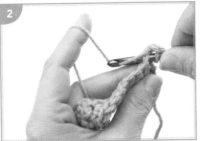

Insert the hook into the 1st st of the row (by going under both lps on top).

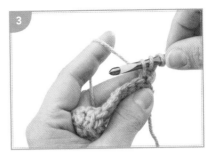

Pull up a lp.

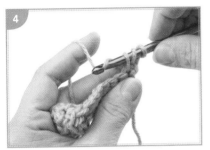

Yo the back of the hook.

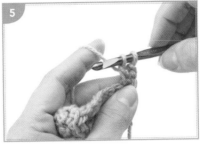

Pull through 2 lps.

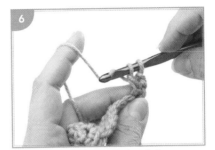

Yo and pull through both lps on the hook.

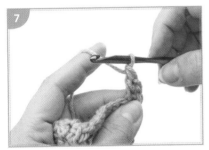

Dc complete.

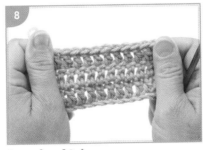

Sample of 3 dc rows.

FRONT POST DOUBLE CROCHET (FPDC)

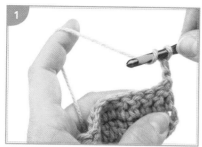

Starting from a turning ch of 2 ch, yo the back of the hook.

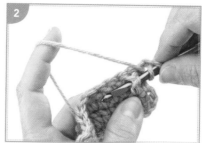

Starting in the 2nd dc from the edge, insert the hook around the body of the st until the hook comes out the other side.

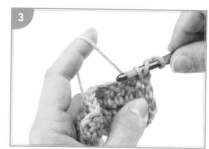

Yo and pull up a lp, yo the back of the hook.

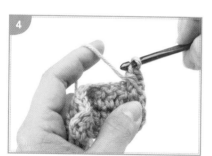

Pull through 2 lps.

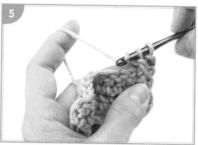

Yo and pull through 2 lps.

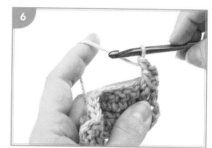

1st fpdc completed.

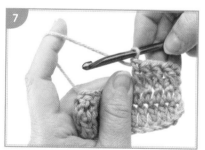

Several fpdc in a row.

FRONT POST TREBLE CROCHET (FPTR)

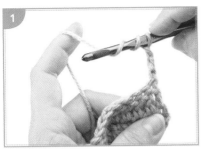

Yo the back of the hook twice.

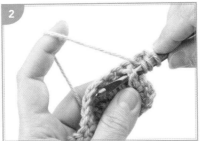

Starting in the 2nd tr from the edge, insert the hook around the body of the st until the hook comes out the other side.

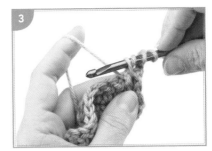

Yo and pull up a lp.

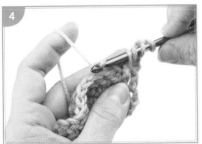

Yo and pull through 2 lps.

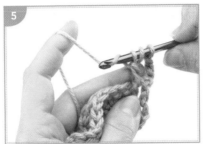

Yo and pull through 2 lps.

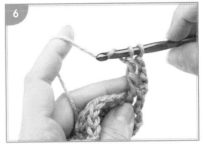

Yo and pull though 2 lps.

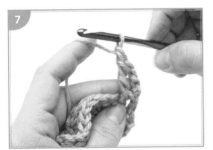

Completed fptr.

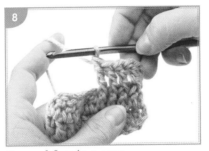

Several fptr in a row.

HONEYCOMB

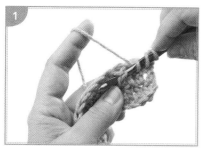

Starting at the beg of the row, sk the 1st 3 sts, yo the back of the hook twice and begin fptr in the next st (4th st from the edge).

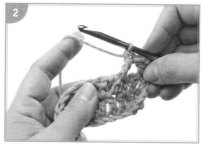

1st fptr completed.

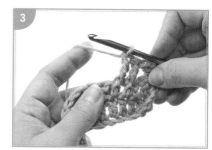

Work a fptr in the next st.

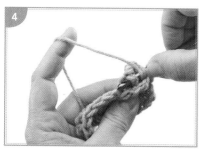

Working behind the 2 fptr just completed, fptr in the 2nd skipped st.

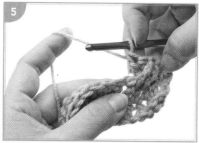

Fptr in the next st (also a skipped st).

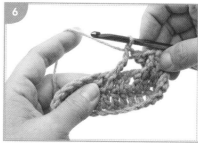

Sk 2 sts, fptr in the next st.

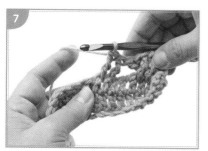

Fptr in the next st also.

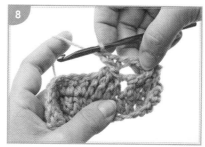

Working in front of the last 2 sts, fptr in the 1st of the skipped sts.

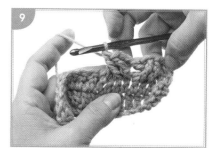

Fptr in the next st. Bottom half of the Honeycomb completed.

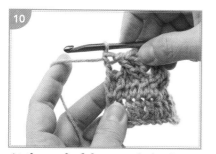

At the end of the row, dc in the ch-2 space. Ch 2, turn.

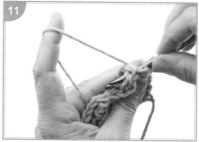

Beg in the 2nd st of the row, begin bpdc.

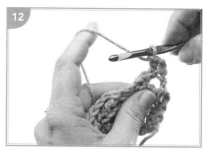

Completed bpdc.

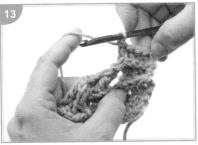

13

Work bpdc in each st across the row, and a dc in the turning ch. Ch 2, turn.

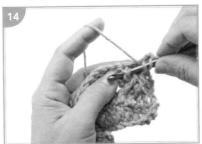

14

Sk the 1st 3 st, fptr in the next st.

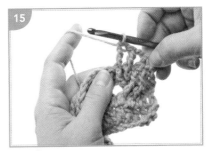

15

Fptr in next st.

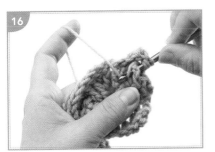

16

Working in front of the last 2 sts, fptr in the 2nd st from the edge.

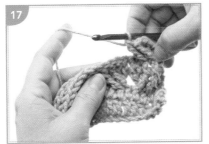

17

Fptr in the next st.

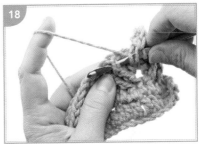

18

Sk the next 2 sts.

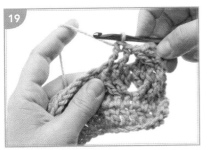

19

Fptr in the next 2 sts.

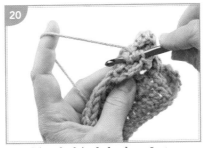

20

Working behind the last 2 sts.

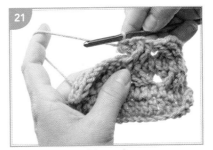

21

Fptr in the 2 skipped sts.

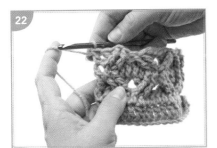

22

Dc in the turning ch.

23

A completed sample of the Honeycomb pattern.

KNOTTED FRINGE

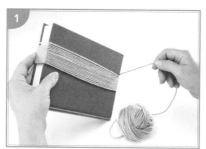

Gather yarn, scissors and a sturdy book or piece of cardboard. Loosely wrap the yarn around the book or cardboard, being careful not to pull too tightly.

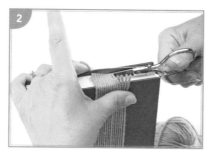

While holding the yarn in place, carefully cut the strands.

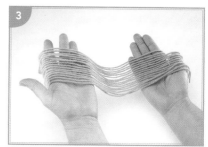

Now the evenly cut strands are ready to be used for fringe.

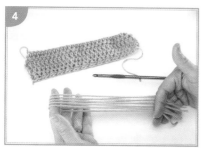

Carefully align the strands for your tassel. Fold them in half so that the ends are even at one end.

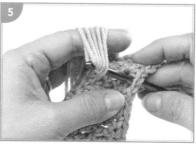

Insert the hook into the place where the tassel will be connected. Place all of the strands on the hook.

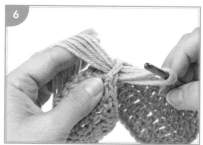

Pull through a st along the bottom.

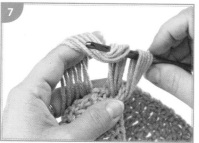

Place all strands over the back of the hook.

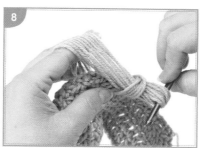

Pull all the strands through.

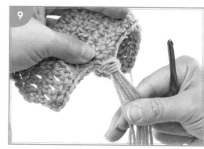

Pull gently until the tassel is secured.

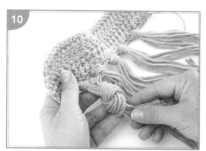

Knot the fringe by taking all of the end tassel strands and half of the next tassel's strands and wrapping to form a simple knot 1" (2.5cm) to 1¼" (3.2cm) below the tassel connection. Gently pull to tighten, adjusting the position as you go.

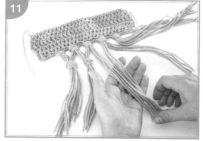

Using the rem strands from the last tassel, add half of the strands from the next tassel. Form a knot, pulling gently to tighten and adjusting the position to line up with the prev knot.

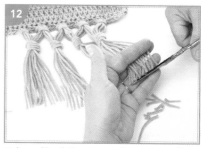

Trim all of the strands across the bottom to make the tassels even.

KNURL (REVERSE SC)

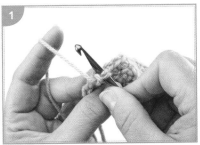

Row 1: (This row will be worked left to right.) Working only in the front lp of the prev sc row, sk the first sc and insert the hook into the next sc (to the right of the hook).

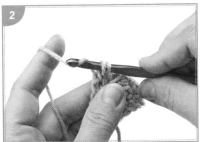

Hook the yarn and pull through to the left of the lp on the hook. Yo the back of the hook.

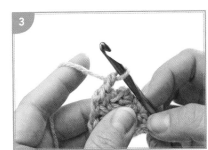

Pull through both lps on the hook (1 knurl completed).

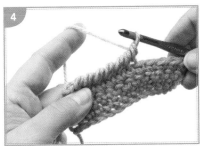

Rep in each sc across the row to the last sc.

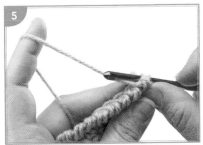

Sl st in the last sc.

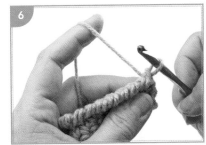

One row of knurls and sl st completed.

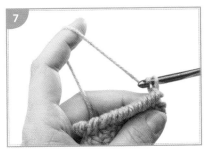

Ch 1.

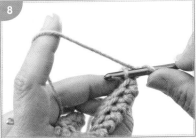

Row 2: Working from right to left and in the rem lp, sc in 1st sc.

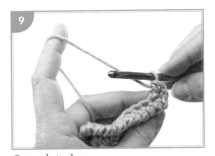

Completed sc.

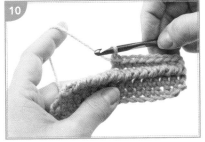

Sc in each of the rem lps across the row.

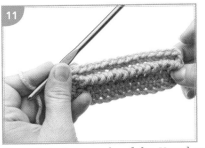

Completed example of the Knurl st.

LOW BACK RIDGE (LBR)

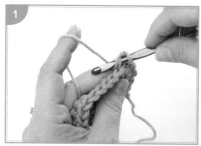

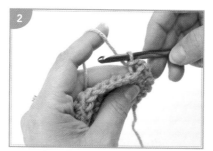

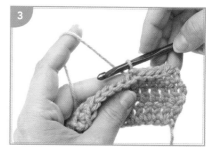

Row 1: Working in the blps only, and with the WS facing, sk the 1st st of the row and sl st in the next sc.

Completed sl st.

Sl st (in blps only) in each sc across the row.

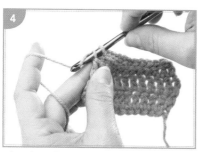

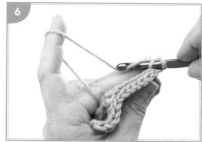

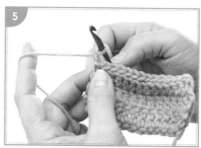

Sl st in 1 lp of turning ch, turn.

Ch 1.

Row 2: Working in the rem lp of the sc, sk the turning ch, sc in the 1st sc of the row.

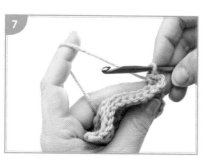

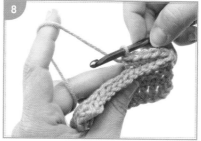

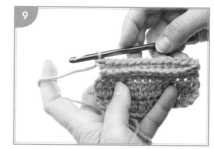

Completed sc.

Sc across the row, working the last sc in the last sc.

Completed LBR.

LOW FRONT RIDGE (LFR)

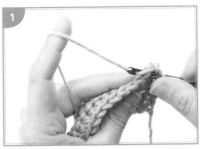

Row 1: Working in flps only, and with RS facing, sk 1st st and insert the hook into the next st.

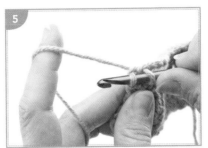

Pull up a lp.

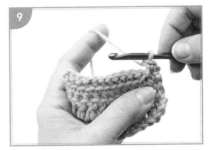

Pull through the lp on the hook, completing the sl st.

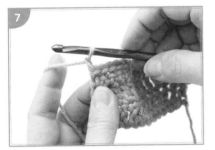

Sl st in each sc across the row.

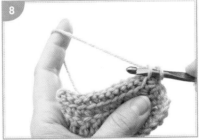

Sl st in the turning ch.

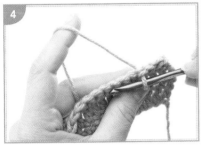

Completed Row 1 of LFR.

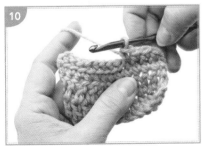

Ch 1.

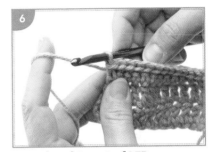

Row 2: Working in the rem lps of the last sc row, sc in the 1st sc.

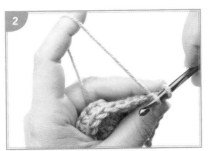

Completed sc.

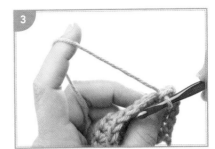

Sc in each sc across. End by working a sc in the last sc of the row.

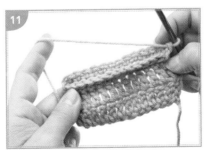

Completed LFR.

31

POPCORN (PC) (MULTIPLE OF 4 + 1)

Be sure to use a larger hook for these rows.

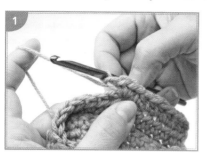

Work 4 sc in the same st.

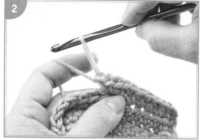

Pull up a lp.

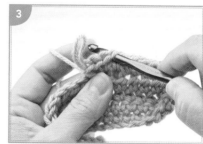

Insert the hook into the 1st of the 4 sc.

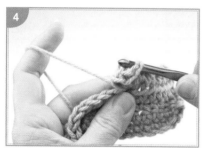

Yo (from the 4th sc).

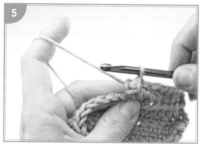

Pull through to form a pc.

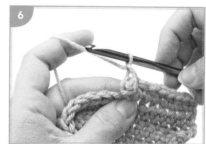

Ch 1. Pc st complete.

RIBBING USING FRONT POST & BACK POST

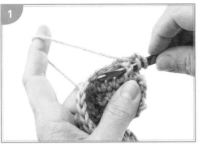
Work a fpdc in the 2nd st of the row.

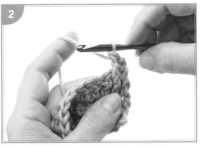
Completed fpdc.

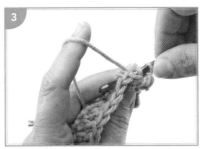
Work a bpdc in the next st.

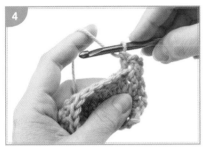
Completed bpdc.

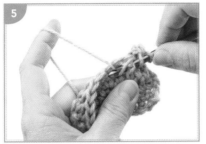
Work a fpdc in the next st.

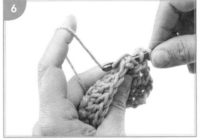
Work a bpdc in the next st. Cont alternating fpdc and bpdc across the row. At the end of the row, turn.

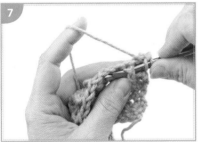
Ch 2 at the beg of the row, then work a fpdc over the fpdc of the prev row.

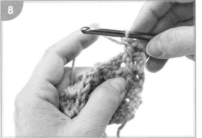
Completed fpdc worked over the fpdc of the prev row.

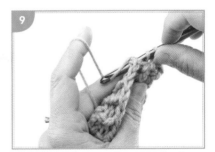
Work a bpdc over the next bpdc.

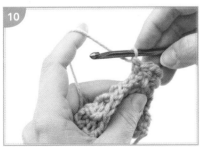
Completed bpdc worked over the bpdc of the prev row.

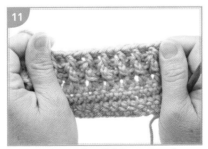
Front view of a ribbing sample.

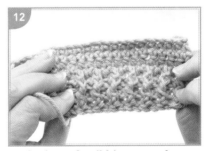
Back view of a ribbing sample.

SHADOW BOX (MULTIPLE OF 10 + 1)

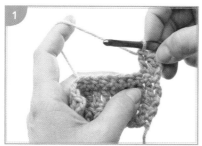

Row 1: With RS facing, ch 2, then dc in the 1st 2 sts of the row.

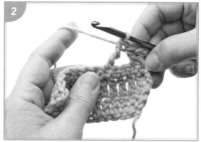

Sk 2 sts, tr in the next st.

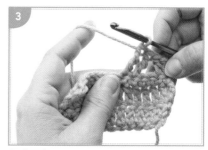

Tr in the next st.

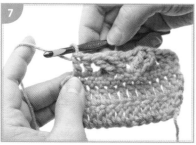

Working behind the tr just worked, tr in each of the 2 skipped sc.

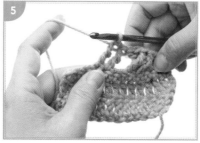

Sk 2 sts, tr in the next 2 sts.

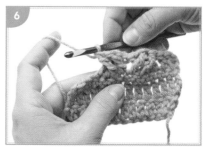

Working in front of the tr just worked, tr in the 2 skipped sts.

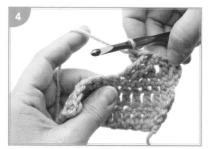

Dc in the next 2 sts. Rep the Row 1 pattern across the row, ending by working dc in the last 2 sts of the row, turn.

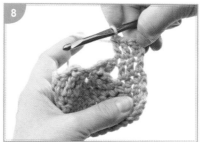

Row 2: With WS facing, ch 2, dc in the 1st 2 dcs.

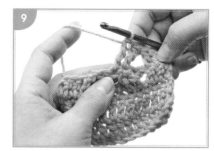

Sk 2 tr, tr in the next 2 tr.

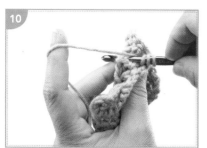

Working behind the tr just worked, tr in each of the 2 skipped tr.

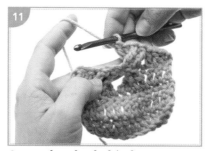

2 completed tr behind 2 tr.

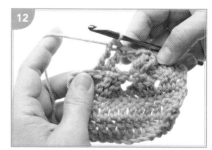

Sk 2 tr, tr in the next 2 tr.

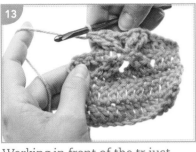

Working in front of the tr just worked, tr in 2 skipped tr.

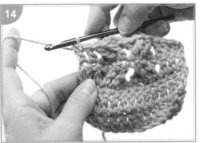

Dc in the next 2 dc. Rep Row 2 pattern across the row, ending by working dc in the last 2 sts of the row, turn.

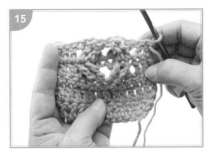

Sample of a completed Shadow Box.

SHELL WITH PICOT

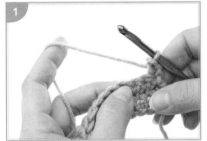

Ch 1, sk 2 sts.

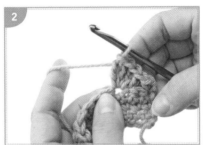

Work 4 dc in the next st.

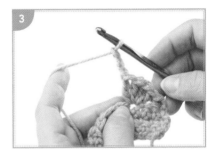

Ch 3.

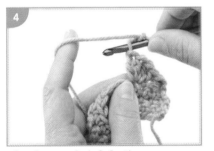

Sl st in 1st ch (of ch-3).

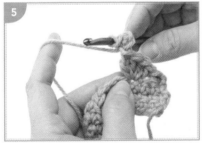

Picot made.

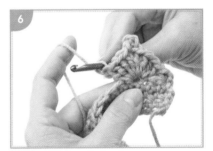

Work 4 more dc in the same sp.

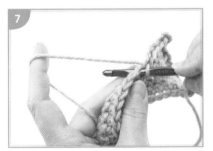

Sk 2 sts, sc in the next st.

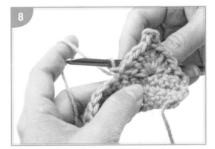

Shell with picot completed.

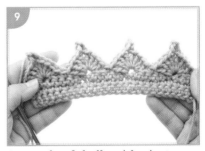

A sample of shells with picots.

SINGLE CROCHET (SC)

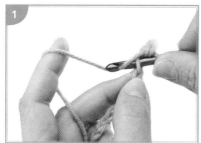

Working along a foundation ch, insert the hook into the 2nd ch from the hook.

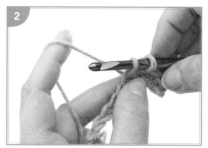

Pull up a lp.

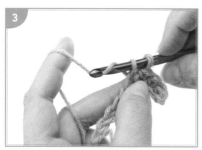

Yo the back of the hook.

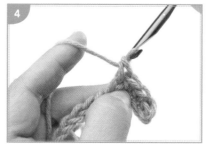

Pull through both lps on the hook. Sc completed.

SINGLE CROCHET RIBBING

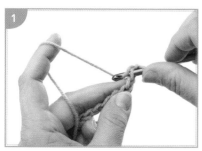

Working along a foundation ch, insert the hook into the 2nd ch from the hook.

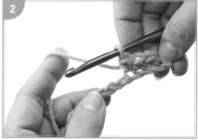

Sc across the row.

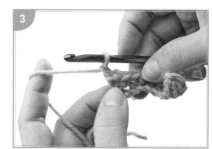

Ch 1 and turn.

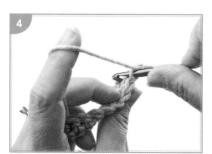

Work in the blps only.

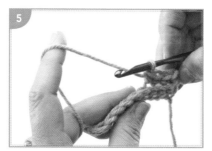

Sc across the row.

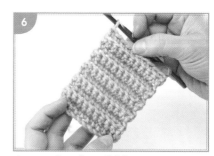

A sample of sc ribbing.

SLIP KNOT

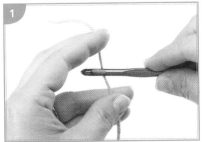

Holding the yarn with the small end up and the ball (or skein) down, place the hook as shown.

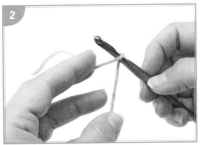

Push forward with the hook and twist to the left.

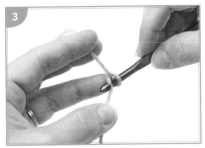

Place the long end over the back of the hook.

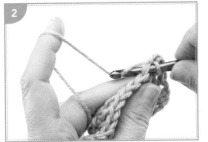

Gently pull through the lp and tighten by pulling on the small end of the yarn.

SLIP STITCH (SLIP ST)

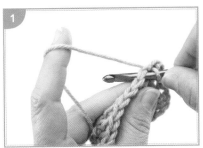

Insert the hook into both lps at the top of the st.

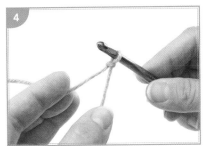

Yo.

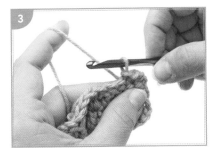

Pull through both lps.

TREBLE CROCHET (TR)

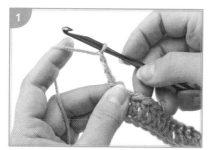

Ch 3.

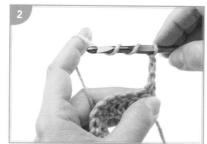

Yo the back of the hook twice.

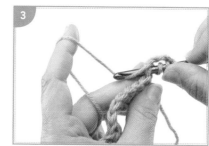

Insert the hook through the top lps of the st.

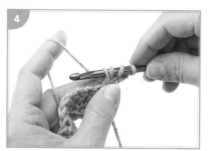

Pull up a lp.

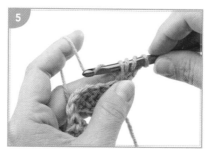

Yo the back of the hook.

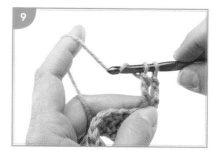

Pull through 2 lps.

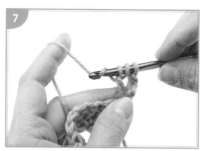

Yo the back of the hook.

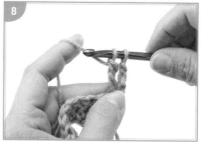

Pull through 2 lps for the 2nd time.

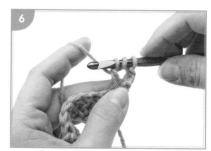

Yo the back of the hook.

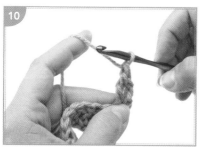

Pull through 2 lps for the 3rd time, completing the st.

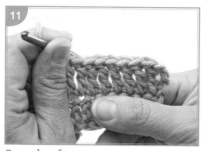

Sample of tr sts.

WHEAT

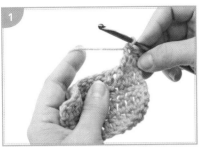

Row 1: Sk the 1st 3 sts (when starting from the edge, sk only 2 sts when working across the row). Work a fptr around the next st.

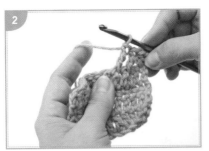

Fptr around the next st.

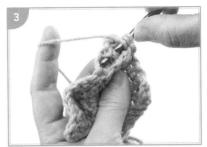

Working behind the last 2 fptr sts, fptr in the 2nd st skipped.

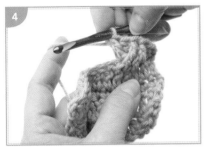

Fptr in the next st (3rd st skipped).

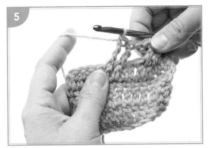

Sk 2 sts, fptr around the next 2 sts.

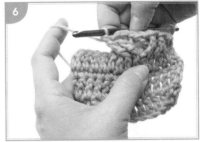

Working in front of the last 2 sts, fptr in the 2 skipped sts. Rep from step 1 to cont Wheat st across the row. Turn at the end of the row.

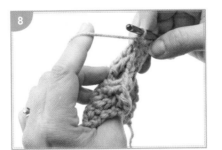

Row 2: Beg next row with the WS facing, ch 2. Work a bpdc in the next st (don't work the end post).

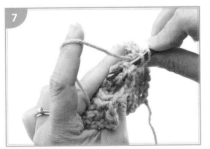

Work bpdc across the row. Dc in the turning ch. Ch 2 at the end of the row.

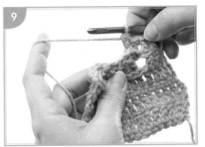

Row 3: *With RS facing, sk the 1st 3 sts, fptr around the next 2 sts.

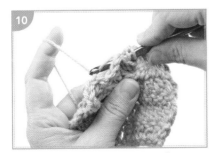

Working behind the last 2 fptr sts, fptr in the 2nd and 3rd sts skipped (do not work in the end post). Sk 2 sts. Ftpr in the next 2 sts. Working in front of the last 2 sts, fptr in the skipped sts. Rep from * to the end of the row. Turn.

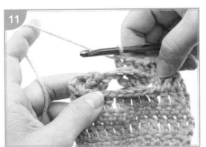

Row 4: Ch 2, bptr in next st and in each st across the row.

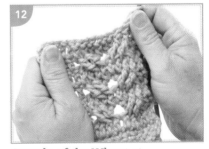

Sample of the Wheat st.

WOVEN

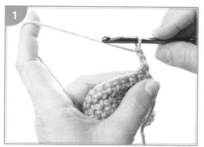

Row 1: (Foundation Row) Working into a row of sc or dc, ch 2.

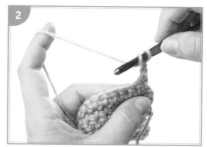

Yo the back of the hook.

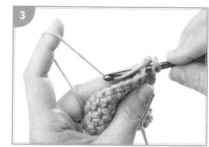

Insert the hook into the 2nd st of the row.

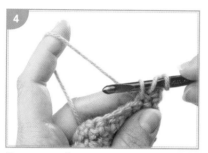

Draw up a lp.

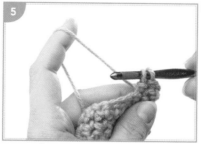

Draw through 1 lp on the hook (2 lps rem on the hook).

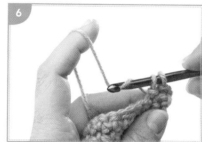

Yo the back of the hook. Draw through 2 lps on the hook.

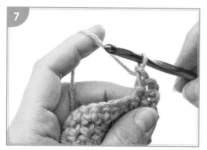

1st half of Woven st completed.

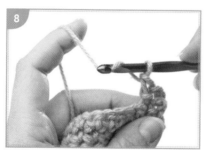

Yo the back of the hook.

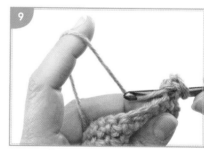

Insert the hook into the same st.

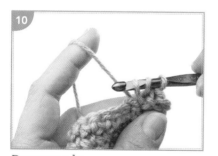

Draw up a lp.

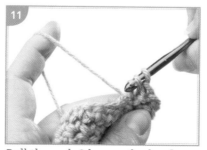

Pull through 2 lps on the hook.

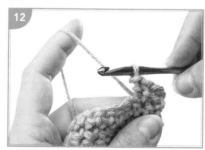

Completed Woven st.

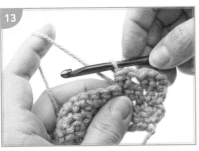

Sk the next sc, work a Woven st in the next sc. Cont to work a Woven st in every other st across the row, turn.

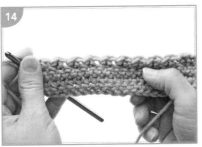

Completed row of Woven sts.

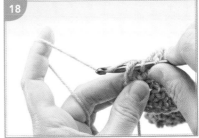

Row 2: Ch 2.

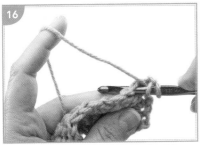

Sts of this row will be worked in between the Woven sts of the prev row rather than in the top lps.

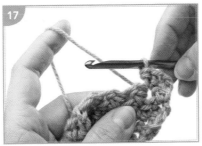

Woven st in between Woven sts across the row.

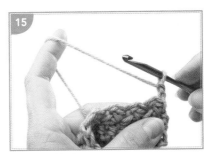

End by working a Woven st in the ch-2 sp.

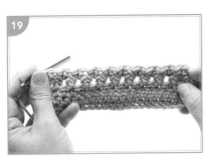

Completed sample of Woven st.

Row to discontinue Woven st (not shown): Ch 1, work 2 sc between Woven sts and in the turning ch.

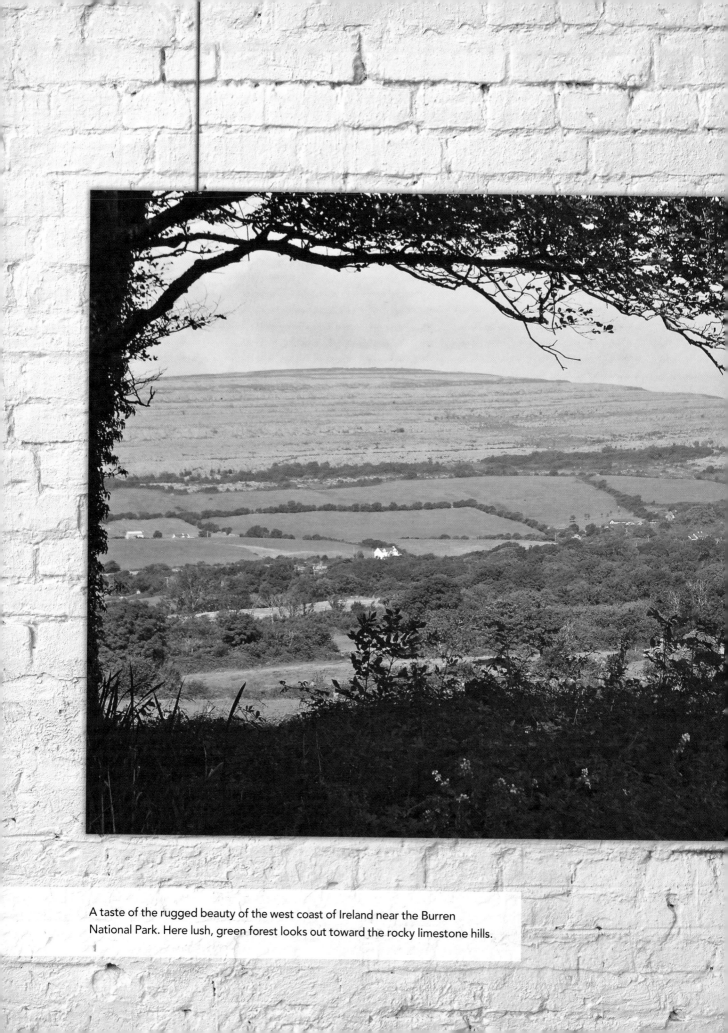

A taste of the rugged beauty of the west coast of Ireland near the Burren National Park. Here lush, green forest looks out toward the rocky limestone hills.

PROJECTS

This book is more than a dream come true for me. Many years ago when I was still in high school, I discovered a couple of crochet leaflets of what was called Fisherman Crochet by a woman named Annie Ough. I fell in love with these unique crochet stitches and made every pattern multiple times. I literally wore out the pages so that they had to be taped again and again. I perused craft books for decades looking for more patterns with these stitches, but without success. It has been said that if you can't find the book you are looking for, then perhaps you should write it. Well, this is that crochet book that I couldn't find.

In 2012, I received the amazing gift of traveling with my sweetheart on his business trip to Ireland! I never had an official "bucket list," but if I did, visiting Ireland would have been at the very top. Not only did I get to tag along with him in Dublin, but he added on a few extra days to travel to the west coast of the island, just across the way from the Aran Isles—the home of the inspiration for my crochet designs! Many of these designs have been given Irish names that have very special memories of Ireland attached to them.

You may notice that I didn't limit myself to the traditional, natural "Aran" color in these projects. My photos of Ireland's lovely countryside show the unlimited color spectrum that I mirrored when selecting the fibers for my Celtic crochet designs.

May the contents of this book be a blessing and inspiration to you!

Liffy in a Jiffy

If you're looking for a project that can be completed in a jiffy, you're on the right page! Using an oversized needle and bulky weight yarn, you can enjoy the warmth of this delightful stole before the weekend is over. Using front and back post stitches makes even bulky, curly yarns easy to use. Whether you prefer the look of a smooth, solid yarn or a yarn with a halo and a color-changing feature, it's hard to go wrong!

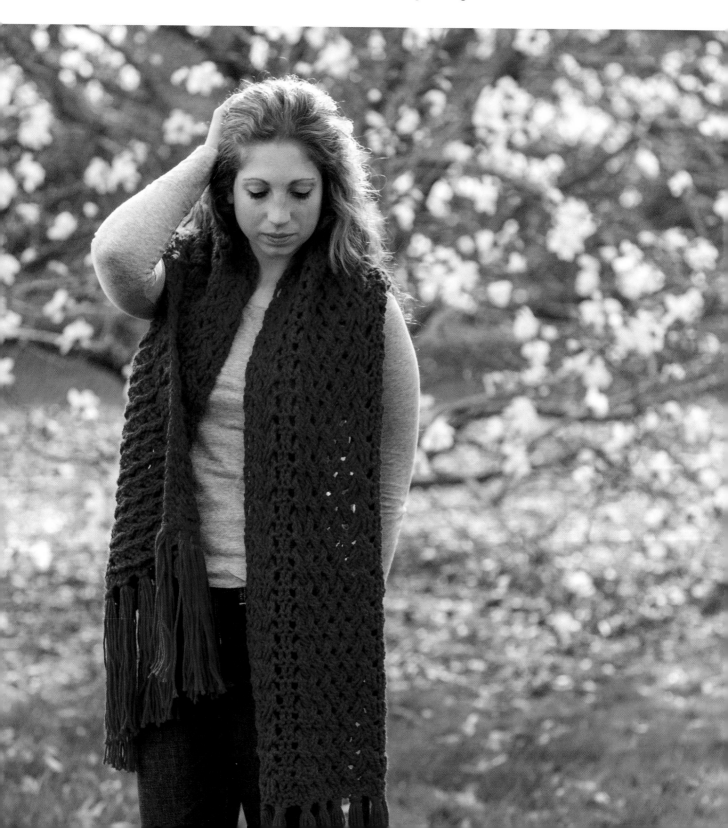

Skill Level

INTERMEDIATE

Materials

L/11 (8mm) crochet hook

7 skeins Bulky (#5) weight yarn (project shown uses Berroco Vintage Chunky [130 yds/120m per 3.5 oz/100g per skein] in color #6154 Crimson)

Finished Dimensions

60" × 17" (152.4cm × 43.2cm) without fringe

Gauge:

15 sts = 5¼" (13.3cm) and 5 rows = 4" (10.2cm) in Celtic Weave (see Crochet Stitch Guide)

Special Stitches

Celtic Weave (CW), Braided Cable (BC)

Pattern Notes

I recommend cutting the tassels first and leaving the remainder of the yarn for the body of the stole. I usually add 10–11 tassels on each end for a total of 20–22 tassels. This means you'll need 100–110 strands at double the length you want your finished fringe. This method ensures you don't run out of yarn for the fringe.

The best way to measure the tassels is to cut a 12" (30.5cm) piece of sturdy cardboard and wrap the yarn around it loosely. Be sure the tension is loose enough not to bend the cardboard. This will ensure even length. Cut the yarn at one end to create strands.

STOLE

Ch 42.

Row 1 (WS): Dc in 4th ch and in every ch across. Turn (40 dc).

Row 2 (RS): Ch 3 (counts as 1st st here and throughout). Dc in 1st dc, [sk 2 sts, fptr around next 2 sts, working in front of sts just made fptr around 2 skipped sts, 2 fptr around next 2 sts, BC made], dc in next 2 dc, [sk 2 sts, fptr around next 2 sts, working in front of sts just made fptr around 2 sts just skipped, CW made] 5 times, dc in next 2 dc, [sk 2 sts, fptr around next 2 sts, working in front of sts just made fptr around 2 skipped sts, fptr around next 2 sts, BC made], dc in last 2 sts. Turn.

Row 3 (WS): Ch 3. Dc in next dc [sk 2 sts, bptr around next 2 sts, working in back of sts just made, bptr around 2 sts just skipped, bptr around next 2 sts, BC made], dc in next 2 sts, [bptr around next 2 sts, *sk 2 sts, bptr around next 2 sts, working in back of sts just made, bptr around skipped sts, rep from * 4 more times, bptr around next 2 sts], dc in next 2 sts, [sk 2 sts, bptr around next 2 sts, working in back of sts just made, bptr around 2 sts just skipped, bptr around next 2 sts, BC made], dc in last 2 sts. Turn.

Rep Rows 2 and 3 until stole measures 59" (149.9cm) or desired length.

Last row (to discontinue CW): Ch 3. Bpdc around each st across. Finish off.

FINISHING

Weave in ends, then work Knotted Fringe.

FRINGE

Cut 110 24" (61cm) strands (to make 11 tassels of 5 strands each on both sides).

Use 5 strands per tassel in every other ch-1 sp across each end of the stole.

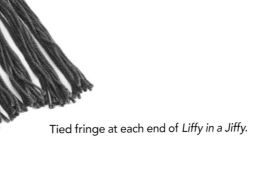

Tied fringe at each end of *Liffy in a Jiffy.*

Burren Braids Hat & Scarf

This is a great way to learn the Braided Cable stitch! Start with the scarf, especially if this is a new stitch for you, then move on to the hat since it's gauge sensitive.

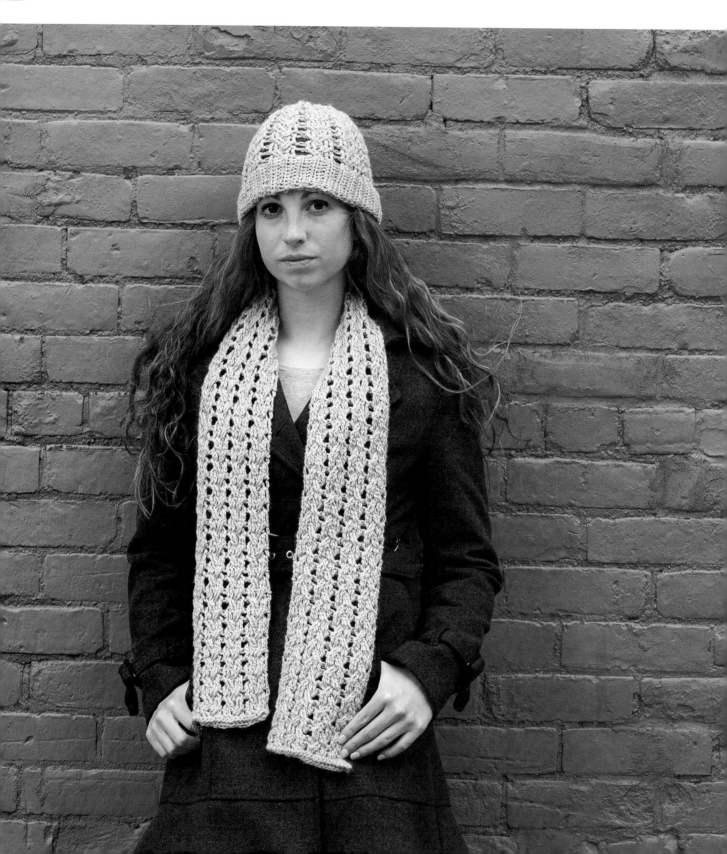

Skill Level

EASY

Materials

- H/8 (5mm) crochet hook
- I/9 (5.5mm) crochet hook or one hook size larger than gauge hook
- 5 skeins DK (#3) weight yarn (project shown uses Blue Sky Alpaca Silk [146 yds/133m per 1.8 oz/50g skein] in color #115 Oyster)

Finished Dimensions

Scarf: 54" × 6½" (137.2cm × 16.5cm)

Hat: 16½" (41.9cm) circumference and 8½" (21.6cm) from crown to brim (with folded brim)

Gauge

24 sts = 6" (15.2cm) and 9 rows = 4" (10.2cm) in Braided Cable pattern

Special Stitches

Braided Cable, Single Crochet Ribbing

SCARF

With smaller hook, ch 28.

Row 1 (WS): Dc in 4th ch from hook and in each ch across. Turn (26 dc).

Row 2 (RS): Ch 3 (counts as 1st dc here and throughout). *Sk next 2 sts, fptr around next 2 sts, working in front of sts just made fptr around 2 skipped sts, fptr around next 2 sts, (BC made). Rep from * 3 times more. Dc in last st. Turn.

Row 3: Ch 3. *Sk 2 sts, bptr around next 2 sts, working in back of sts just made, bptr around 2 sts just skipped, bptr around next 2 sts, (BC made). Rep from * 3 times more. Dc in last st. Turn.

Rep Rows 2 and 3 until scarf measures 53" (134.6cm), or 1" (2.5cm) from desired length. End on a rep of Row 2.

Last row: Ch 3. Bpdc around each st across to last st. Dc in last st. Finish off.

FINISHING

Weave in ends.

HAT

With smaller hook, ch 5. Join to form a ring with a sl st in 1st ch.

Rnd 1 (RS): Ch 1, work 8 sc in ring, join with a sl st (8 sc).

Rnd 2: Ch 1. Work 2 sc in each sc around. Join with a sl st (16 sc).

After Rnd 3 you will begin to turn after each rnd.

Rnd 3: Ch 1. Work 2 sc in each sc around. Join with a sl st to 1st sc. Turn (32 sc).

Rnd 4 (WS): Ch 2 (does *not* count as a st). Work 2 dc in each sc and in turning ch. Join with a sl st. Turn (66 dc).

Rnd 5 (RS): Ch 3. *Sk next 2 sts, fptr around next 2 sts, working in front of sts just made fptr around 2 skipped sts, fptr around next 2 sts, (BC made). Rep from * around. Join with a sl st. Turn.

Rnd 6: Ch 3. *Sk 2 sts, bptr around next 2 sts, working in back of sts just made, bptr around 2 sts just skipped, bptr around next 2 sts (BC made). Rep from * around. Join with a sl st. Turn.

Rnds 7–21: Rep Rnds 5 and 6 seven more times. Then rep Rnd 5 once more.

Rnd 22: Ch 3. Bpdc around each st. Join with a sl st. Turn. Do *not* finish off.

BRIM (RIBBING)

Using larger hook, ch 11.

Row 1: Sc in 2nd ch from hook and in each ch across. Sl st in 2 sts along hat edge. Turn (10 sc).

Row 2: Ch 1. Working in blps only, sc in each sc. Turn.

Row 3: Ch 1. Working in blps only, sc in each sc across. Sl st in 2 sts along hat edge. Turn.

Rep Rows 2 and 3 around hat.

Final Ribbing Row: With both edges held carefully tog, sl st both the 1st and last ribbing rows tog.

FINISHING

Weave in ends.

Pennywhistler's Purse & Pack

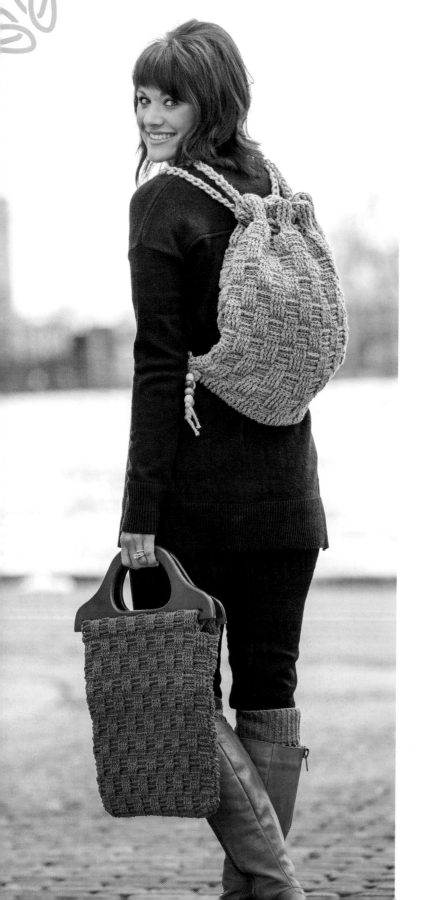

Named for one of my favorite Irish folk musical instruments (of which I am an avid player), I have walked the streets and countryside of Ireland with one of these backpacks comfortably on my shoulders. Made of 100% natural materials, it's washable and easy to crochet. Fill it with anything important to you. It can hold far more than pennywhistles!

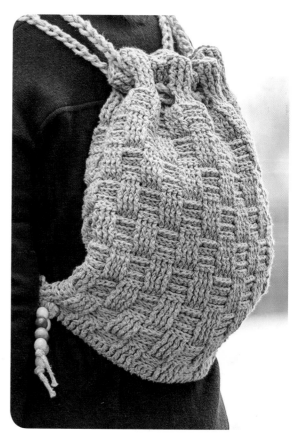

Skill Level

INTERMEDIATE

Materials

G/6 (4mm) crochet hook

P/Q (15mm) crochet hook (for hemp straps on backpack only)

For backpack: 6 skeins of Worsted (#4) weight cotton yarn (project shown uses Peaches and Creme [120 yds/109m per 2.5 oz/71g ball] in color #1118 Faded Denim Blue)

For handbag: 4 skeins Worsted (#4) weight yarn (project shown uses Ella Rae Phoenix [182 yds/164m per 3.5 oz/100g] in color #42 Copper Canyon)

For straps (backpack only): 18 yds (16.5m) hemp yarn with approx ⅛" (4mm) thickness (project shown uses Natural Polished Hemp [64.5 yds/59m per ball])

12 wooden beads (backpack only)

1 set of wooden handles (handbag only; project shown uses handles from Everything Mary)

Finished Dimensions

Backpack: 15¼" × 16" (38.7cm × 40.6cm)

Handbag: 12½" × 13¾" (31.8cm × 34.9cm)

Gauge

Backpack: 12 sts = 3¼" (8.3cm) and 10 rows = 4" (10.2cm) in Basketweave pattern

Handbag: 20 sts = 4½" (11.4cm) and 8 rows = 2¾" (7cm) in Basket Weave pattern

Special Stitches

Basket Weave

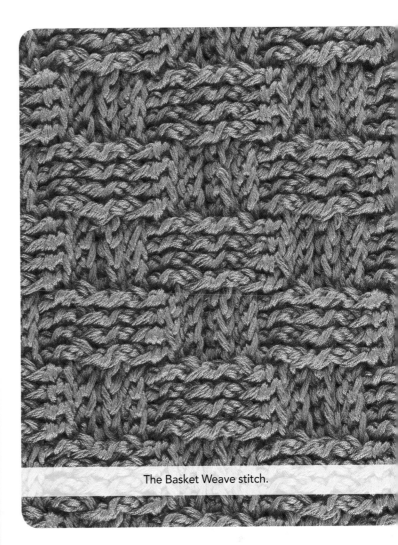

The Basket Weave stitch.

BAG

With smaller hook, ch 55.

Ch 2 does not count as the 1st st throughout the pattern.

Turn after every rnd so odd numbered rnds are worked with RS facing and even numbered rnds are worked with WS facing.

Rnd 1 (RS): Dc in 3rd ch from hook and in each ch across. Work 4 more dc in end ch (5 total in last ch). Rotate work and dc across to other side of ch in the rem lps. Work 4 dc in last ch. Join with a sl st to 1st dc. Turn (112 dc).

Rnd 2 (WS): Ch 2. Begin Basket Weave pattern by working [fpdc around next 4 sts, bpdc around next 4 sts] around. Join with a sl st to 1st dc. Turn.

Rnd 3: Ch 2. [Fpdc around next 4 sts, bpdc around next 4 sts] around. Join with a sl st to 1st dc. Turn.

Rnd 4: Rep Rnd 3.

The next rnd establishes the vertical Basket Weave pattern by working bpdc over fpdc and vice versa.

Rnd 5: Ch 2. [Bpdc around next 4 sts, fpdc around next 4 sts] around. Join with a sl st to 1st dc. Turn.

Rnd 6–8: Rep Rnd 5.

Rnds 9–12: Rep Rnd 3 four times.

Rnds 13–16: Rep Rnd 5 four times.

Rnds 17–36: Rep Rnds 9–16 twice, and then rep Rnds 9–12 once more. You should have 9 vertical clusters of Basket Weave.

FOR BACKPACK ONLY

Rnd 37 (openings for hemp straps): Ch 6, sk next 4 sts. Fpdc around next 4 sts, *ch 4, sk next 4 sts, fpdc around next 4 sts. Rep from * around. Join with a sl st to 2nd ch of beg ch-6. Turn (14 ch-4 sps, 56 dc).

Rnd 38: Ch 2. [Bpdc around next 4 sts, 4 dc in ch-4 sp] around. Join with a sl st to 1st st. Turn (112 dc).

Rnds 39 & 40: Ch 2. [Bpdc around next 4 sts, fpdc around next 4 sts] around. Connect with a sl st. Turn. At end of Rnd 40, finish off.

FOR HANDBAG ONLY

Row 37: Ch 1. Sl st in 1st 4 sts, ch 2 (counts as hdc). [Fpdc around next 4 sts, bpdc around next 4 sts] over next 48 sts. Hdc in next st. Turn, leaving rem sts un-worked (2 hdc, 48 dc).

Row 38: Ch 2 (counts as hdc). [Fpdc around next 4 sts, bpdc around next 4 sts] across. Hdc in beg ch-2. Turn.

Rows 39–40: Rep Row 38.

Rows 41–44: Ch 2. [Bpdc around next 4 sts, fpdc around next 4 sts] across. Hdc in beg ch-2. Turn.

At the end of Row 44, finish off leaving about 20" (50.8cm) of yarn for sewing after attaching handles.

Other side of bag:

On Rnd 36, sk 1st 7 unworked dc, join with a sl st in next dc, ch 2 (counts as hdc). [Fpdc around next 4 sts, bpdc around next 4 sts] over next 48 sts. Hdc in next st. Turn (2 hdc and 48 dc).

Rep Rows 38–44 of 1st side of bag to match.

HEMP STRAPS (MAKE 2)
For backpack only

Using larger crochet hook and hemp, crochet a ch that is 66" (167.6cm) long. (Be sure to leave about 12" (30.5cm) of extra hemp at the beg of the ch and at the end of the ch. This will be helpful when tying knots as well as adding beads.) As you crochet this ch, pull each st tightly to reduce any slack. Carefully check to be sure that both straps are the same size.

FINISHING

Weave straps into openings of backpack starting at sides. Thread strap ends into bottom corners of bag and double knot. Add beads to hemp end. Weave in rem yarn ends.

HANDLES
For handbag only

Attach bag to handles by gently pulling last rows of one side through wooden slit. Using yarn and yarn needle, sew to bag. Complete other side in same manner to match. Weave in ends. Refer to the *Celtic Carryall* project to see an image of attached handles.

OPTIONAL FOR BACKPACK AND HANDBAG
Highly recommended

A lining can be added and sewn to the inside of the bag. Cut fabric the size of the bag plus ½" (1.3cm) seam allowance. The top of the lining should be below the handles or hemp openings. Sew a hem on the top open edge. If pockets are desired, add to lining. Next, sew 3 sides, leaving the top open. Pin the lining to the bag and sew to the inside of the bag below the handles or hemp openings.

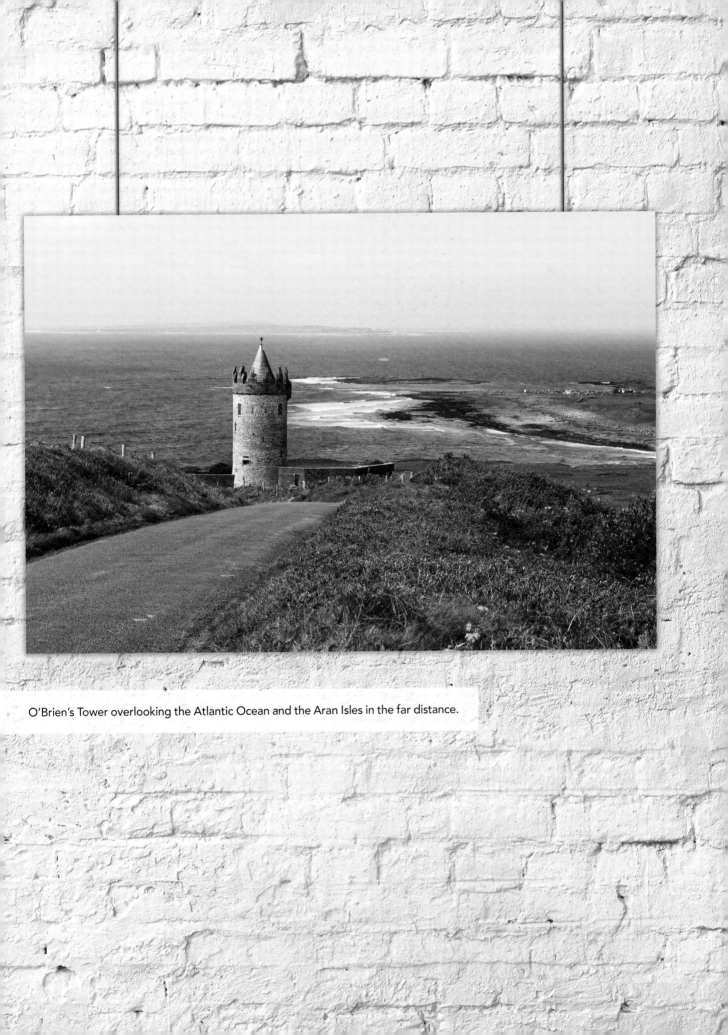

O'Brien's Tower overlooking the Atlantic Ocean and the Aran Isles in the far distance.

Jig Infinity Scarf & Headband

This is a fun beginner's pattern for learning the Woven stitch, and it should be much easier than doing a jig! Don't want an infinity scarf? Then don't connect the ends. This scarf and matching headband are reversible no matter what you decide.

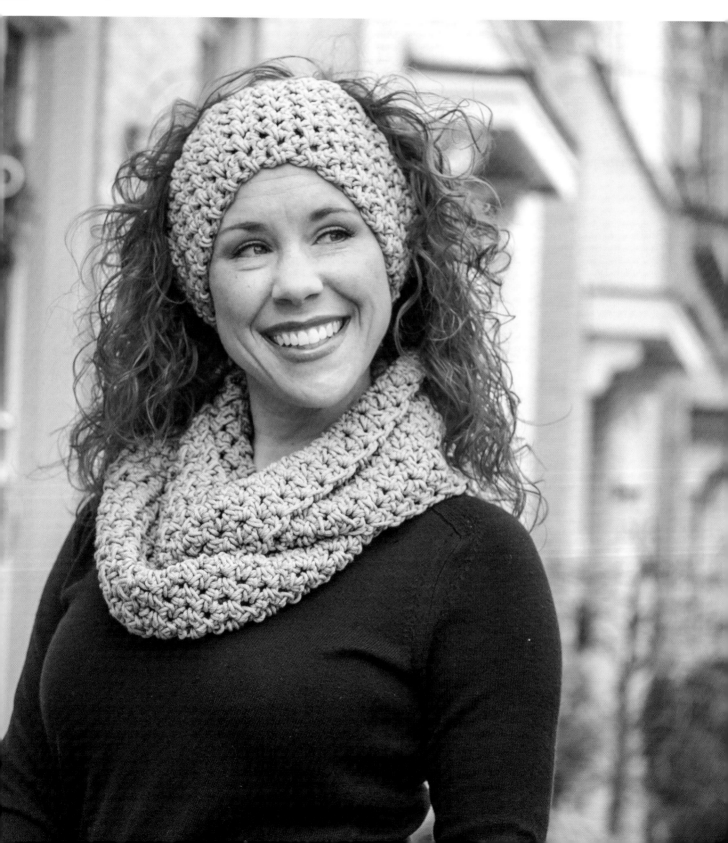

Skill Level

EASY

Materials

K/10½ (6.5mm) crochet hook

3 skeins Bulky (#5) weight yarn (project shown uses Berroco Weekend Chunky [119 yds/109m skein per 3.5 oz/100g] in color #6967 Lilac)

Finished Dimensions

Scarf: 6½" × 56" (16.5cm × 142.2cm) before connecting ends

Headband: 4¾" × 22" (12.1cm × 55.9cm) before connecting ends

Gauge

Not important for this project

Special Stitches

Woven Stitch

Pattern Notes

Where stitch numbers or repeats are different, the headband numbers will appear first, and the scarf numbers will appear second in parentheses.

HEADBAND AND SCARF

Ch 13 (17).

Row 1 (RS): Sc in 2nd ch from hook and in each ch across. Turn, (12 [16] sc).

Row 2 (WS): Ch 2. Sk 1st sc, work a Woven st in the next sc, [sk next sc, Woven st in next sc] across. Turn, (6 [8] Woven sts).

Row 3: Ch 2. Woven st in the sp between the 1st and 2nd Woven st. Woven st in the sp between each Woven st across, ending with a Woven st in turning ch. Turn.

For scarf: Rep Row 3 until scarf measures 56" (142.2cm) or desired length, leaving about 12" (30.5cm) of yarn to connect ends.

For headband: Rep Row 3 until piece measures 22" (55.9cm) or desired length for headband.

FINISHING

To connect ends, use the yarn needle to sew ends tog, making a continuous lp. Weave in ends.

Blarney Blanket

Here's a great blanket project that can travel with you no matter where you go since you're working on only one square at a time—and that's no blarney!

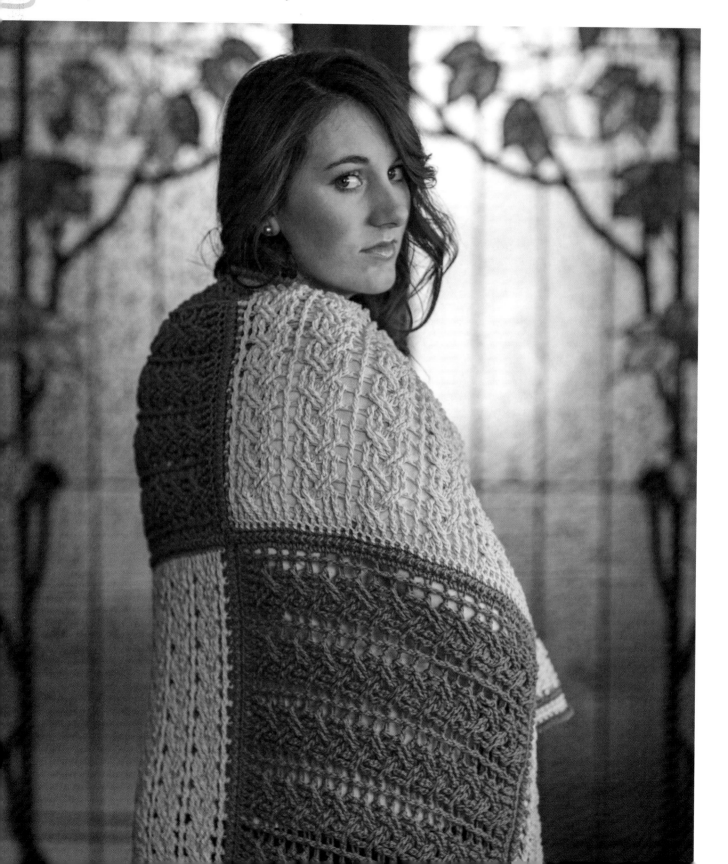

Skill Level

INTERMEDIATE

Materials

- J/10 (6mm) crochet hook
- I/9 (5.5mm) crochet hook or one hook size smaller than gauge hook
- 9 skeins Worsted (#4) weight yarn for MC
- 7 skeins Worsted (#4) weight yarn for CC (project shown uses Berroco Weekend [205 yds/187m skein per 3.5 oz/100g] in colors #5923 Tomatillo [MC] and #5925 Taffy [CC])

Finished Dimensions

43¼" × 57" (109.9cm × 144.8cm)

Gauge

7 sts = 2" (5.1cm) and 5 rows = 2¾" (7cm) in Braided Cable pattern (measure from WS)

Special Stitches

Braided Cable, Front Post Treble Crochet, Back Post Treble Crochet, Knurl

SQUARE PATTERN

With larger hook, ch 47.

Row 1 (WS): Dc in 4th ch from hook and in each ch across. Turn (45 dc).

Row 2 (RS): Ch 2 (counts as 1st dc here and throughout), fpdc around next dc, *sk next 2 sts, fptr around each of next 2 sts, working in front of sts just made, fptr in each of 2 skipped sts, fptr in each of next 2 sts, fpdc around next st. Rep from * across to last st, dc in last st. Turn.

Row 3: Ch 2, bpdc around next dc, *sk next 2 sts, bptr around each of next 2 sts, working behind sts just made, bptr in each of 2 skipped sts, bptr in each of next 2 sts, bpdc around next st. Rep from * across to last st, dc in last st. Turn.

Rows 4–21: Rep Rows 2 and 3 nine more times.

Row 22: Rep Row 2 once more.

Row 23: Ch 2, bpdc in each st across. Turn.

For CC squares (lighter color), finish off. Join MC (darker color) to complete edging. For MC squares, do not finish off, but continue on to edging.

EDGING

With MC, ch 1, *sc in each st across, ch 2 (for corner), turn square 90°, work 45 sc across side of square, ch 2, turn 90°, rep from * once more. Join with a sl st to 1st sc. Finish off (180 sc).

CONNECTING SQUARES

Follow the diagram for connecting squares, alternating the direction of the braids and the color of the squares. To connect one square to another (for columns), with MC and RS facing out, join with a sl st in the ch-2 in the upper left corner. Starting in the next st and working through all 4 lps, work the Knurl st from left to right across the row, ending with a sl st in the ch-2 corner on the right side of square. Finish off. Make 3 columns of 4 squares each, then connect the 3 columns.

BORDER

Rnd 1: Using smaller hook and MC, and with RS facing, join with a sl st in any corner. Sc in same st and along side of throw across to corner, work (sc, ch 2, sc) in ch-2 sp. *Sc in each st across to next corner, work (sc, ch 2, sc) in ch-2 sp. Rep from *, ending last rep with a sc, ch 2, join to 1st sc with a sl st. Finish off MC.

Rows 2 & 3: With CC, ch 1. *Sc in each sc around, working (sc, ch 2, sc) in each corner ch-2 sp. Join with a sl st.

Row 4: With MC, rep Row 2.

Row 5: Ch 1, work Knurl st around, from left to right, working 1 Knurl st in each sc and 2 Knurl st in each corner. Join with a sl st to the 1st st. Finish off.

FINISHING

Weave in ends and block if needed.

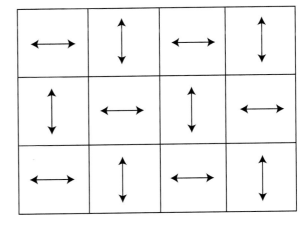

Assembly Diagram (alternating braids)

Tipperary Sweater & Vest

Don't let this sweater fool you. It works up much faster than it looks using the Woven stitch and worsted weight yarn. I recommend this pattern to anyone who has never constructed a sweater before since it is less complicated and sews together simply. Just be sure to make a gauge swatch to determine the proper hook size. You want to be sure the sweater fits when you're finished!

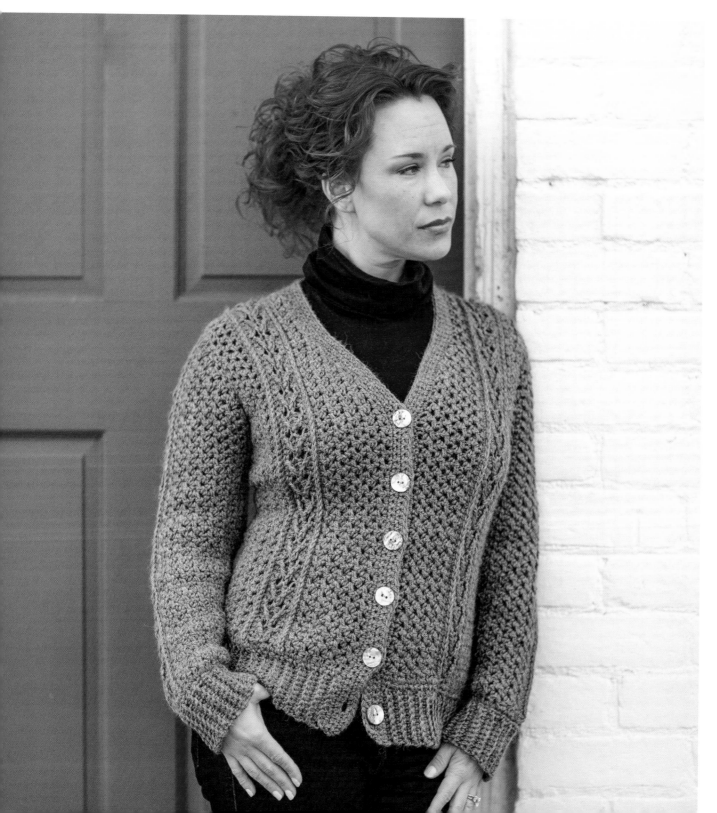

Skill Level

INTERMEDIATE

Materials

- I/9 (5.5mm) crochet hook
- **Sweater:** 8 (9, 10, 10) skeins of Worsted (#4) weight yarn (project shown uses Berroco Ultra Alpaca [215 yds/198m per 3.5 oz/100g] in color #6283 Lavender Mix)
- **Vest:** 5 (6, 7, 7) skeins of Worsted (#4) weight yarn (project shown uses Berroco Ultra Alpaca [215 yds/198m per 3.5 oz/100g] in color #6285 Oceanic Mix)
- Six 1" (2.5cm) Buttons
- Needle
- Matching thread

Finished Dimensions

Instructions for these sizes are listed in order in parentheses S (M, L, XL). Be careful to read the correct numbers for the size you are making.

Finished Sizes:

- **Bust:** 33¼ (37¼, 41¼, 45¼)" (84.5 [94.6, 104.8, 115]cm)
- **Length:** 19¼ (20¼, 20¼, 21½)" (48.9 [51.4, 51.4, 54.6]cm), excluding ribbing

Gauge:

5 Woven sts = 2¾" (7.6cm) and 6 rows = 2" (5.1cm) in Woven stitch pattern

Special Stitches

Low Front Ridge (LFR), Low Back Ridge (LBR), Arrow, Woven

RIGHT FRONT PANEL

Starting from center of right front.

Ch 71 (75, 75, 79).

Row 1 (WS): Sc in 2nd ch from hook and in each ch across. Turn, (70 [74, 74, 78] sc).

Rows 2 & 3 form the LFR pattern.

Row 2 (RS): Ch 1. Working in flps only, sl st in 2nd sc and in each sc across. Sl st in turning ch. Turn.

Row 3: Ch 1. Working in rem lps of last sc row, sc in each sc across. Turn.

Row 4 & 5 form the Arrow pattern.

Row 4: Ch 2 (counts as 1st dc). Dc in next st, *sk next 3 sc, tr in next st. Working behind tr just worked, dc in each of the 3 sts just skipped. Rep from * across row to last st. Dc in last st. Turn.

Row 5: Ch 2. *Sk next 3 dc, tr in next tr, working in front of tr just worked, dc in each of 3 skipped dc. Rep from * across to last st. Dc in last st. Turn.

Row 6: Ch 1. Sc in each st across. Turn.

Rows 7 & 8 form the LBR pattern.

Row 7: Ch 1. Working in blps only, sl st in 2nd sc and in each sc across. Sl st in turning ch. Turn.

Row 8: Ch 1. Working in rem lps of last sc row, sc in each sc across. Turn.

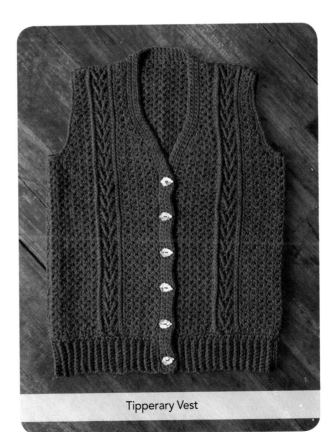

Tipperary Vest

RIGHT FRONT NECKLINE

Row 1 (WS): Ch 2. Work Woven st in 2nd st, *sk next st, work 1 Woven st in next st. Rep from * across row. Turn, (35 [37, 37, 39] Woven sts).

Rows 2–3 (5, 7, 7): Ch 2. Woven st in the sp between the 1st and 2nd Woven sts. Woven st in the sp between each Woven st across, ending with a Woven st in the turning ch. Turn.

Row 4 (6, 8, 8): Ch 2. Work 27 (29, 29, 31) Woven sts across row, leaving the rem 8 Woven st sps unworked. Turn, (27 [29, 29, 31] Woven sts).

Row 5 (7, 9, 9): Ch 2. Work 1 dec as follows: yo, pull up 1 lp in 1st Woven st sp, pull up 1 lp in next Woven st sp, pull through 1 lp, yo, pull through all lps on hook to complete 1st half of st. Complete 2nd part of Woven st as usual. Woven st in rem sp across row and turning ch. Turn, (26 [28, 28, 30] Woven sts).

Row 6 (8, 10, 10): Ch 2. Work Woven sts across to last sp and turning ch. Work 1 dec over last sp and turning ch. Turn, (25 [27, 27, 29] Woven sts).

Rep Rows 5 (7, 9, 9) & 6 (8, 10, 10) once. Rep Row 5 (7, 9, 9) once more, (22 [24, 24, 26] Woven sts). Finish off.

RIGHT FRONT ARMHOLE

Row 1 (RS): With RS facing, join yarn along the foundation ch with a sl st in the 1st st. Ch 2, Woven st in next st. [Sk next st, Woven st in next st] across. Turn, (35 [37, 37, 39] Woven sts).

Row 2 (WS): Ch 2. Woven st in the sp between the 1st and 2nd Woven sts. Woven st in the sp between each Woven st across, ending with a Woven st in turning ch. Turn.

Row 3 (Dec Row): Ch 1. Sl st in 1st Woven st sp, [ch 1, sl st in next Woven st sp] 1 (2, 3, 4) times, ch 1, work 1 dec over next 2 Woven st sps. Work Woven st across on rem sps and turning ch. Turn, (32 [33, 32, 33] Woven sts).

Row 4: Ch 2. Work Woven sts across row until you reach the last 3 sps (not counting turning ch). Work a Woven st dec over the next 2 sps. Turn, leaving 1 sp and the turning ch unworked (29 [30, 29, 30] Woven sts).

Row 5: Ch 1. Sl st in 1st Woven st sp, [ch 1, sl st in next Woven st sp] twice, ch 1, work 1 dec over next 2 Woven st sps. Work Woven st across on rem sps and turning ch. Turn, (25 [26, 25, 26] Woven sts).

Row 6: Ch 2. Work Woven sts across row until you reach the last 2 sps (not counting turning ch). Work 1 dec over these 2 sps. Turn, leaving turning ch unworked (23 [24, 23, 24] Woven sts).

Row 7: Ch 2. Work WS dec over 1st 2 sps, work in WS across row. Turn (22 [23, 22, 23] Woven sts).

Row 8: Ch 2. Woven st in the sp between the 1st and 2nd Woven sts. Woven st in the sp between each Woven st across, ending with a Woven st dec in last sp and turning ch. Turn, (21 [22, 21, 22] Woven sts).

Size S only, finish off.

Row 9: Ch 2. Woven st in the sp between the 1st and 2nd Woven sts. Woven st in the sp between each Woven st across, ending with a Woven st in turning ch. Turn.

Size M only, finish off.

Sizes L and XL, rep Row 9 – (–, one, four) more times. Finish off.

LEFT FRONT PANEL

Work Rows 1–8 of Right Front Panel. Work the Right Front Armhole. (Note that WS rows are now RS rows and vice versa.) Finish off. With RS facing, connect yarn with a sl st in upper corner. Work Neckline same as Right Front Neckline. (Note that WS rows are now RS rows and vice versa.)

BACK

Follow instructions for Right Front Panel, Rows 1–8.

Woven Stitch Rows:

Row 1: Ch 2, Woven st in next st. [Sk next st, Woven st in next st] across. Turn, (35 [37, 37, 39] Woven sts).

Row 2: Ch 2. Woven st in the sp between the 1st and 2nd Woven sts. Woven st in the sp between each Woven st across, ending with a Woven st in turning ch. Turn.

Rep Row 2 an additional 20 (24, 28, 28) times.

Row 23 (27, 31, 31): Ch 1. Work 2 sc in each WS sp across row and in turning ch. Turn, (70 [74, 74, 78] sc).

Rep Right Front Panel Rows 1–8.

Right Arm Hole: Work as for Right Front Panel Arm Hole. Finish off.

Left Arm Hole: With RS facing, connect yarn with a sl st in the upper right corner on the foundation row. Work as for Left Front Panel Arm Hole. Finish off.

SLEEVES (MAKE 2—FOR SWEATER)
Ch 67 (71, 75, 83). This is the foundation ch for pattern in center of arm.

Row 1 (WS): Sc in 2nd ch from hook and in each ch across. Turn, (66 [70, 74, 82] sc).

Rows 2–8: Work Right Front Panel Rows 2–8.

Row 9: Ch 2. Work Woven st in 2nd st, *sk next st, work 1 Woven st in next st. Rep from * across row. Turn, (33 [35, 37, 41] Woven st).

Row 10 begins the decs on the sleeve cap end.

Row 10: Ch 2. Woven st in the sp between the 1st and 2nd Woven sts. Woven st in the sp between each Woven st across to last sp and turning ch, ending with a Woven st dec as follows: yo, pull up 1 lp in next Woven st sp, pull up 1 lp in turning ch, pull through 1 lp, yo, pull through all lps on hook to complete 1st half of st. Complete 2nd part of Woven st as usual. Turn, (32 [34, 36, 40] Woven st).

Row 11: Ch 2. Work 1 Woven st dec. Work Woven st over rem sps and turning ch. Turn (31 [33, 35, 39] Woven st).

Row 12: Ch 2. Woven st in the sp between the 1st and 2nd Woven st. Woven st in the sp between each Woven st across, ending with a Woven st in turning ch. Turn.

Rows 13 & 14: Rep Rows 11 & 12, (30 [32, 34, 38] Woven st).

Row 15: Rep Row 12 (11, 11, 11), (30 [31, 33, 37] Woven st).

Sizes M, L, and XL only: Rep Row 12. Then Rep Row 11, (– [30, 32, 36] Woven st).

Row 16 (18, 18, 18) begins the decs that taper the cuff end of the sleeve.

Row 16 (18, 18, 18): Ch 2. Work 1 WS dec over 1st 2 sts. Work Woven st over rem sts and turning ch. Turn, (29 [29, 31, 35] Woven st).

Row 17 (19, 19, 19): Ch 2. Work 1 Woven st dec over 1st 2 sts, Woven st across to last 4 sps and turning ch. Work 1 dec over next 2 sps. Leave rem sp and turning ch unworked. Turn, (24 [24, 26, 30] Woven st).

Row 18 (20, 20, 20): Ch 2. Work 1 Woven st dec over 1st 2 sts, work Woven st over rem sts and turning ch. Turn (23 [23, 25, 29] Woven st).

Row 19 (21, 21, 21): Rep Row 17 (19, 19, 19), (18 [18, 20, 24] Woven st).

Row 20 (22, 22, 22): Ch 2. Work 1 Woven st dec over 1st 2 sts. Work Woven st across to last sp and turning ch, end with a Woven st dec. Turn, (16 [16, 18, 22] Woven st).

Row 21 (23, 23, 23): Ch 2. Work 1 (1, 2, 2) Woven st dec. Work Woven st across to last 5 sps and turning ch. Work 1 dec over next 2 sps. Leave rem sps and turning ch unworked. Turn, (10 [10, 11, 15] Woven st).

Row 22 (24, 24, 24): Rep Row 20 (22, 22, 22), (8 [8, 9, 13] Woven st).

Row 23 (25, 25, 25): Ch 2. Work 1 (1, 2, 2) Woven st dec. Work Woven st across to last sp and turning ch, end with a Woven st dec. Turn, (6 [6, 6, 10] Woven st).

Sizes S, M and L only: Finish off.

Row – (–, –, 26): Ch 2. Woven st in the sp between the 1st and 2nd Woven sts. Woven st in the sp between each Woven st across, ending with a Woven st in turning ch. Finish off.

With RS facing, attach yarn with a sl st to work along the foundation ch. Rep Rows 9–26 to match other side of sleeve. Finish off.

FINISHING CARDIGAN/VEST

Note: When sewing panels together, I prefer to use sewing needles and thread rather than using yarn and a yarn needle. This creates less bulky seams. Be sure to use thread color that matches your yarn color.

With RS facing, sew shoulder seams tog (for vest, sew shoulder and side seams only). Next, sew the sleeves in place using the center shoulder seam to center the sleeve. Sew the side and sleeve arm seams. Work bottom ribbing across the end of the sweater as well as on ends of the sleeves (9 sc for all ribbing).

RIBBING (FOR BOTTOM)

With gauge hook, join yarn to bottom of sweater with a sl st. Sc evenly around edge. Turn. Ch 10.

Row 1: Sc in 2nd ch from hook and in each ch. Connect to edge by working a sl st in the next 2 sc. Turn, (9 sc).

Row 2: Ch 1, working in the blps only, 1 sc in each sc. Turn.

Row 3: Ch 1, working in the blps only, 1 sc in each sc. Turn.

Rep Rows 2 & 3 around edge. Finish off.

RIBBING FOR CUFFS (SWEATER ONLY)

With gauge hook, join yarn to the bottom of the sleeve with a sl st. Sc evenly around edge. Join with a sl st. Ch 10.

Work ribbing as in ribbing for bottom and collar.

End by connecting the 1st row of the cuff to the last row with a row of sl sts, working toward the original foundation row. Finish off.

NECKBAND (WITH BUTTONHOLES)

Row 1: Attach yarn with a sl st at bottom right of the sweater. Ch 1. Sc in end of next row and in each end sp across front opening of sweater, being careful to crochet evenly. Cont the row by crocheting around neck and down the left side to the other end of the sweater. Turn.

Row 2: Ch 1. Sc in each sc across. Turn.

Mark places for 6 evenly spaced buttonholes on the RS. (I set the 1st buttonhole 1" (2.5cm) from the bottom.)

Row 3 (buttonhole row): Ch 1. Sc in each sc across, being careful to [ch 2, sk 2 sts] at the locations of the place holders for buttonholes. Turn.

Row 4: Ch 1. Work sc in each sc, and 2 sc in each ch-2 sp across row. Turn.

Row 5: Rep Row 2. Finish off.

ARM HOLE EDGING (VEST ONLY)

Row 1: With RS of vest facing, join with a sl st at underarm seam. Sc evenly around opening of arm. Join to 1st sc with a sl st.

Row 2: Sl st in each sc around. Finish off.

Sew buttons in place to correspond to the buttonholes.

Weave in ends.

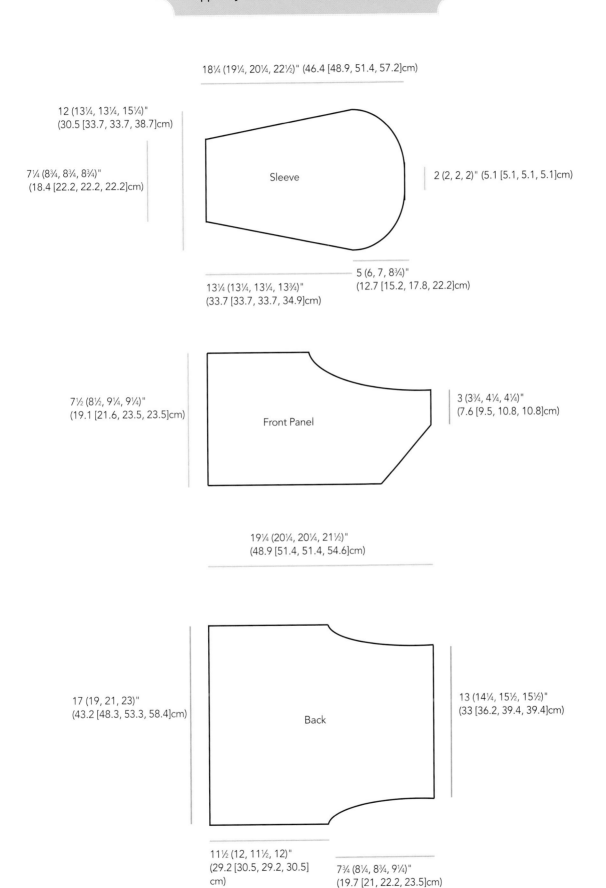

18¼ (19¼, 20¼, 22½)" (46.4 [48.9, 51.4, 57.2]cm)

12 (13¼, 13¼, 15¼)"
(30.5 [33.7, 33.7, 38.7]cm)

7¼ (8¾, 8¾, 8¾)"
(18.4 [22.2, 22.2, 22.2]cm)

Sleeve

2 (2, 2, 2)" (5.1 [5.1, 5.1, 5.1]cm)

5 (6, 7, 8¾)"
(12.7 [15.2, 17.8, 22.2]cm)

13¼ (13¼, 13¼, 13¾)"
(33.7 [33.7, 33.7, 34.9]cm)

7½ (8½, 9¼, 9¼)"
(19.1 [21.6, 23.5, 23.5]cm)

Front Panel

3 (3¾, 4¼, 4¼)"
(7.6 [9.5, 10.8, 10.8]cm)

19¼ (20¼, 20¼, 21½)"
(48.9 [51.4, 51.4, 54.6]cm)

17 (19, 21, 23)"
(43.2 [48.3, 53.3, 58.4]cm)

Back

13 (14¼, 15½, 15½)"
(33 [36.2, 39.4, 39.4]cm)

11½ (12, 11½, 12)"
(29.2 [30.5, 29.2, 30.5]
cm)

7¾ (8¼, 8¾, 9¼)"
(19.7 [21, 22.2, 23.5]cm)

Hialeah Honey Baby Blanket

Named for my Florida hometown (which is a long way from Ireland!), this is the first project in which I experimented with lighter weight yarns. I instantly became an enthusiastic believer. Not only does this yarn help keep down the bulkiness of the post stitches, but it also produces a beautiful drape to the finished project. Be sure to use a yarn that can easily be washed for your special little honey!

Skill Level

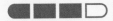

INTERMEDIATE

Materials

G/6 (4mm) crochet hook

3 skeins DK (#3) weight yarn (project shown uses Caron Simply Soft Light [330 yds/302m per 3 oz/85g skein] in color #0003 Honey)

Finished Dimensions

21½" × 23½" (54.6cm × 59.7cm), excluding edging

Gauge

24 sts = 4½" (11.4cm) and 7 rows = 3" (7.6cm) in Celtic Weave pattern (measure from back)

Special Stitches

Braided Cable (worked over 6 sts)

On a RS row: [sk 2 sts, 2 fptr over next 2 sts, working in front of sts just made, fptr in each of 2 sts just skipped, fptr in each of next 2 sts (BC made)].

On a WS row: [sk 2 sts, 2 bptr over next 2 sts, working in back of sts just made, bptr in each of 2 sts just skipped, bptr in each of next 2 sts (BC made)].

Celtic Weave (worked over a multiple of 4 sts)

On a RS row: [Sk 2 sts, fptr in each of next 2 sts, working in front of sts just made, fptr in 2 skipped sts (CW made)] across.

On a WS row: Bptr in 2 sts, [sk 2 sts, bptr in each of next 2 sts, working in back of sts just made, bptr in 2 skipped sts] until 2 sts remain, bptr in next 2 sts.

Pattern Notes

The double crochet stitches in between the Braided Cable and Celtic Weave stitches are worked in the top loops of the stitches, not as front posts. All other stitches are front or back post stitches.

BLANKET

Ch 106.

Row 1: Dc in the 4th ch from hook and in each ch across. Turn, (104 dc).

Row 2 (RS): Ch 3 (counts as 1st dc here and throughout). Dc in 2nd dc, *work BC over next 6 sts, dc in next 2 sts. Work CW over next 12 sts. Dc in next 2 sts. Work BC over next 6 sts; **dc in next 2 sts; work BC over next 6 sts; dc in next 2 sts; work CW over next 24 sts; dc in next 2 sts; work BC over next 6 sts; dc in next 2 sts. Rep * to ** once more. Dc in last 2 sts. Turn.

Row 3 (WS): Rep Row 2, working the WS version of the indicated st patterns.

Rows 4–53: Rep Rows 2 & 3 twenty-five times more, or to within 2" (5.1cm) of desired length.

Row 54: Rep Row 2.

Row 55: Ch 3, bpdc in each post st and dc in each dc across. Turn.

BORDER

Rnd 1: Ch 1. *Sc in each st across row, ch 1, turn 90°, sc in same sp (corner made). Sc evenly along row edges, ch 1, turn 90°, rep from * around. Join with a sl st to 1st sc of row. Turn.

Rnd 2 (shell with picot): Ch 1, sc in 1st st, * sk 2 sts, [4 dc, ch 4, sl st in 1st ch (picot made), 4 dc] in next st, sk 2 sts, sc in next st. Rep from * around perimeter of blanket. You may need to adjust the number of sts skipped occasionally in order for the shells to appear uniform around the corners. End by joining with sl st to 1st sc of row. Finish off.

FINISHING

Weave in ends and block if needed.

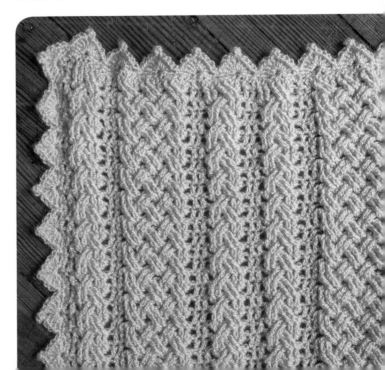

Shell picot edging adds a touch of elegance to this baby blanket.

Cables Meet Lace Cape

Great for casual wear or that special evening out on the town.

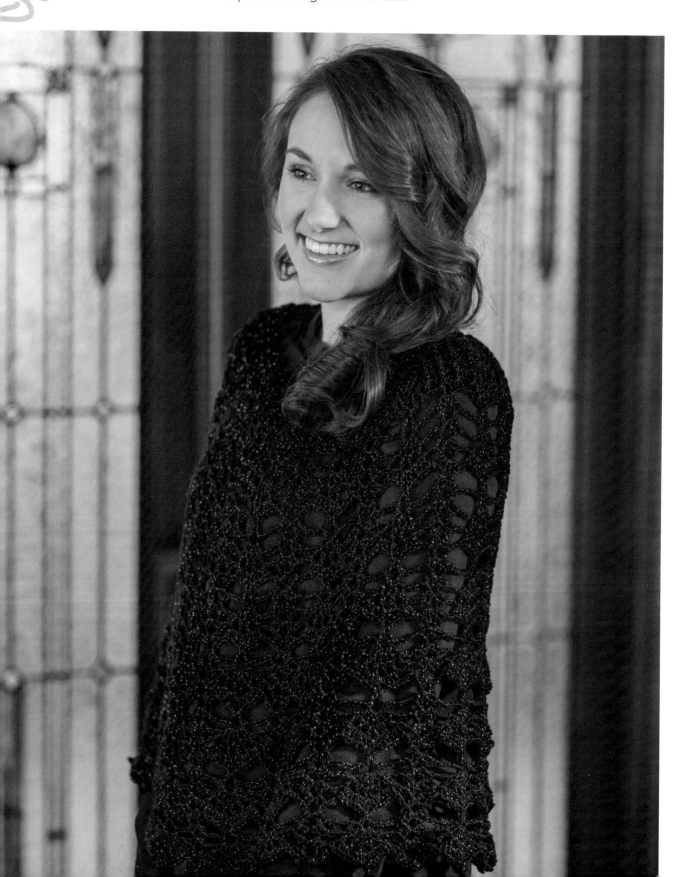

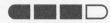

Skill Level

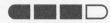

INTERMEDIATE

Materials

H/8 (5mm) crochet hook

5 skeins Fine (#2) weight yarn (project shown uses Lion Brand Vanna's Glamour [202 yds/185m per 1.75 oz/50g skein] in color #109 Sapphire)

Finished Dimensions

24½" (62.2cm) at neck opening and 17½" (44.5cm) long

Gauge

16 sts = 4" (10.2cm) and 9 rows = 4" (10.2cm) in dc

Special Stitches

Braided Cable, Front Post Double Crochet, Back Post Double Crochet, Front Post Treble Crochet, Back Post Treble Crochet

COLLAR

Ch 98. Join with a sl st to 1st ch to form a ring, being careful not to twist ch.

Rnd 1 (RS): Ch 3 (does *not* count as 1st st here and throughout), dc in each ch around. Join to turning ch with sl st (98 dc).

Rnd 2: Ch 3, work [fpdc around next st, bpdc around next st] around. Join with sl st.

You will end the next rnds with only a partial rep.

Rnd 3: Ch 2 (does *not* count as 1st st), work fpdc around next st, bpdc around next st, fpdc around next st, *work 2 dc in each of next 3 dc, [fpdc around next st, bpdc around next st] twice, 2 dc in each of next 3 dc, [bpdc around next st, fpdc around next st] twice. Rep from * around. Join to turning ch with sl st (140 sts).

Rnd 4: Ch 2 (does *not* count as 1st st), work fpdc around next st, bpdc around next st, fpdc around next st, *sk 2 sts, fptr around next 2 sts, working in front of sts just made, fptr around each of 2 sts just skipped, fptr in each of next 2 sts (BC made), [fpdc around next st, bpdc around next st] twice, sk 2 sts, 2 fptr around next 2 sts, working in front of sts just made, fptr around each of 2 sts just skipped, fptr around each of next 2 sts (BC made), [bpdc around next st, fpdc around next st] twice. Rep from * around. Join with sl st. Turn.

Rnd 5 (WS): Ch 2. Fpdc around 1st st, *dc in sp between prev and next st, [sk 2 tr, bptr around next 2 tr, working in back of sts just made, bptr around 2 sts just skipped, bptr around next 2 tr], dc in sp between prev and next st, [fpdc around next st, bpdc around next st] twice, dc in sp between prev and next st, [sk 2 tr, bptr around next 2 tr, working in back of sts just made, bptr around 2 sts just skipped, bptr around next 2 tr], dc in sp between prev and next st, [bpdc around next st, fpdc around next st] twice. Rep from * around. Join with sl st. Turn (168 sts).

The collar of this cape is a beautiful circle of braids worked in the round, making this garment seamless and worked in one piece.

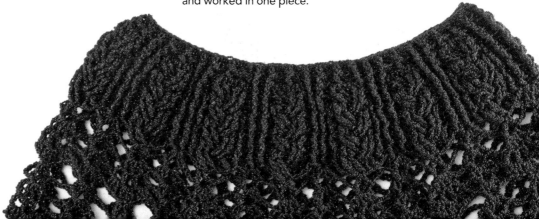

Rnd 6 (RS): Ch 2. [Fpdc around next st, bpdc around next st] twice, *sk 2 sts, fptr around next 2 sts, working in front of sts just made, fptr around each of 2 sts just skipped, fptr around each of next 2 sts (BC made)**, [bpdc around next st, fpdc around next st] 3 times, rep instructions from * to ** once, [fpdc around next st, bpdc around next st] 3 times, rep instructions from * to ** once. Rep from * around. Join with sl st. Turn.

Rnd 7: Ch 2. Fpdc around next st, bpdc around next st, [sk 2 tr, bptr around next 2 tr, working in back of sts just made, bptr around 2 sts just skipped, bptr around next 2 tr], *[bpdc around next st, fpdc around next st] 3 times, [sk 2 tr, bptr around next 2 tr, working in back of sts just made, bptr around 2 sts just skipped, bptr around next 2 tr], [fpdc around next st, bpdc around next st] 3 times, [sk 2 tr, bptr around next 2 tr, working in back of sts just made, bptr around 2 sts just skipped, bptr around next 2 tr]. Rep from * around. Join with sl st. Turn.

Rnds 8 & 9: Rep Rnds 6 & 7.

Rnd 10 (RS): Ch 2. Fpdc around every st in the round. Join with sl st. *Do not turn.*

CAPE

For the cape rnds, you will end each rnd with only a partial rep.

Rnd 1: Ch 3. Dc in same sp as ch 3. Ch 3, 2 dc in next st. *Ch 4, sk 5 sts, [dc, ch 3, dc] in next st, ch 4, sk 5 sts, [2 dc, ch 3, 2 dc] in next st. Rep from * around. Join with sl st (28 ch-3 sps).

Rnd 2: Sl st in next dc and in next ch-3 sp. [Ch 3, dc, ch 3, 2 dc] in ch-3 sp, *ch 3, sk next ch sp, 4 dc in next ch-3 sp, ch 3, sk next ch sp, [2 dc, ch 3, 2 dc] in next ch-3 sp. Rep from * around. Join with sl st (42 ch-3 sps).

Rnd 3: Sl st in next dc and in next ch-3 sp. [Ch 3, dc, ch 3, 2 dc] in same ch-3 sp. *Sk next ch-3 sp, [ch 1, dc in next dc] 4 times, ch 1, sk next ch-3 sp, [2 dc, ch 3, 2 dc] in next ch-3 sp. Rep from * around. Join with sl st (70 ch-1 sps).

Rnd 4: Sl st in next dc and in next ch-3 sp. [Ch 3, dc, ch 3, 2 dc] in same ch-3 sp. *Ch 1, sk next ch-1, [3 dc in next ch-1 sp, ch 1] 3 times, sk next ch-1 sp, [2 dc, ch 3, 2 dc] in next ch-3 sp. Rep from * around. Join with sl st (42 3-dc CL).

Rnd 5: Sl st in next dc and in next ch-3 sp. [Ch 3, dc, ch 3, 2 dc] in same ch-3 sp. *Ch 5, sk 4 dc, [dc, ch 3, dc] in center dc of center 3-dc CL sk 4 dc, ch 5, work [2dc, ch 3, 2 dc] in next ch-3 sp. Rep from * around. Join with sl st (28 ch-3 sps).

Rnd 6: Sl st in next dc and in next ch-3 sp. [Ch 3, dc, ch 3, 2 dc] in same ch-3 sp. *Ch 4, sk next ch sp, 4 dc in next ch-3 sp, ch 4, sk next ch sp, [2 dc, ch 3, 2 dc] in next ch-3 sp. Rep from * around. Join with sl st (28 ch-3 sps).

Rnd 7: Sl st in next dc and in next ch-3 sp. [Ch 3, dc, ch 3, 2 dc] in same ch-3 sp. *Ch 2, sk next ch sp, [dc in next dc, ch 1] 3 times, dc in next dc, ch 2, sk next ch sp, [2 dc, ch 3, 2 dc] in next ch-3 sp. Rep from * around. Join with sl st (42 ch-1 sps).

Rnd 8: Sl st in next dc and in next ch-3 sp. [Ch 3, dc, ch 3, 2 dc] in same ch-3 sp. *Ch 2, sk next ch sp, [3 dc in next ch-1 sp] 3 times, ch 2, sk next ch sp, [2 dc, ch 3, 2 dc] in next ch-3 sp. Rep from * around. Join with sl st (42 3-dc CL).

Rnd 9–13: Rep Rnds 5–8 once. Rep Rnd 5 once more.

Rnd 14: Sl st in dc and in next ch-3 sp. [Ch 3, dc, ch 3, 2 dc] in same ch-3 sp. *Ch 3, sk next ch sp, 6 dc in next ch-3 sp. Ch 3, sk next ch sp, [2 dc, ch 3, 2 dc] in next ch-3 sp. Rep from * around. Join with sl st (42 ch-3 sps).

Rnd 15: Sl st in dc and in next ch-3 sp. [Ch 3, dc, ch 3, 2 dc] in same ch-3 sp. *Sk next ch sp, ch 2, [dc in dc, ch 1] 5 times, dc in next dc, ch 2, sk next ch sp, [2 dc, ch 3, 2 dc] in next ch-3 sp. Rep from * around. Join with sl st (70 ch-1 sps).

Rnd 16: Sl st in dc and in next ch-3 sp. [Ch 3, dc, ch 3, 2 dc] in same ch-3 sp, *Sk next ch sp, ch 2, [3 dc in next ch-1 sp] 5 times, ch 2, sk next ch sp, [2 dc, ch 3, 2 dc] in next ch-3 sp. Rep from * around. Join with sl st (70 3-dc CL).

Rnd 17: Sl st in dc and in next ch-3 sp. [Ch 3, dc, ch 3, 2 dc] in same ch-3 sp, *sk next ch sp, ch 6, [dc, ch 3, dc] in center dc of center 3-dc CL (8th dc), ch 6, sk next ch sp, [2 dc, ch 3, 2 dc] in next ch-3 sp. Rep from * around. Join with sl st (28 ch-3 sps).

Rnd 18: Sl st in dc and in next ch-3 sp. [Ch 3, dc, ch 3, 2 dc] in same ch-3 sp. *Ch 4, sk next ch sp, 6 dc in next ch-3 sp. Ch 4, sk next ch sp, [2 dc, ch 3, 2 dc] in next ch-3 sp. Rep from * around. Join with sl st (42 ch-3 sps).

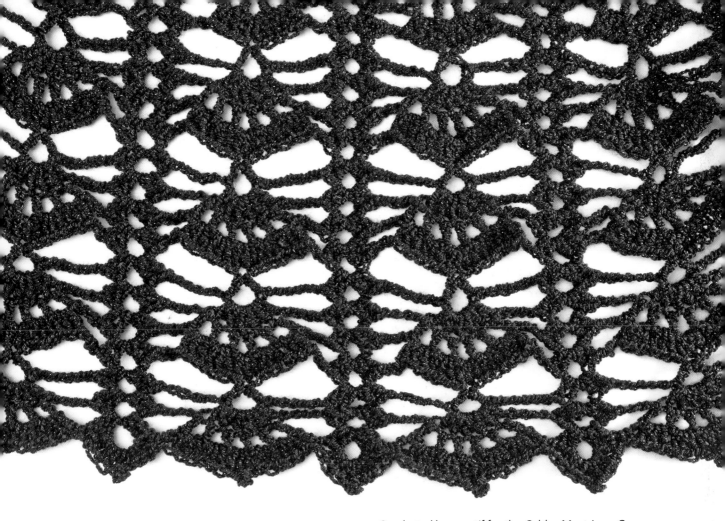

Crocheted lace motif for the *Cables Meet Lace Cape*.

Rnd 19: Sl st in dc and in next ch-3 sp. [Ch 3, dc, ch 3, 2 dc] in same ch-3 sp. *Sk next ch sp, ch 3, [dc in dc, ch 1] 5 times, dc in next dc, ch 3, sk next ch sp, [2 dc, ch 3, 2 dc] in next ch-3 sp. Rep from * around. Join with sl st (70 ch-1 sps).

Rnd 20: Rep Rnd 16.

Rnd 21–27: Rep Rnds 17–20. Rep Rnds 17–19 once more.

Rnd 28: Sl st in dc and in next ch-3 sp. [Ch 3, 3 dc, ch 3, sl st in top of last dc made, 4 dc] in same ch-3 sp, *Sc in next ch sp, [3 dc in next ch-1 sp] 2 times, [2 dc, ch 3, sl st in top of last dc made, 1 dc] in next ch-1 sp, [3 dc in next ch-1 sp] 2 times, sc in next ch sp. [4 dc, ch 3, sl st in last dc made, 4 dc] in next ch-3 sp. Rep from * around. Join with a sl st (70 3-dc CL). Finish off.

Weave in ends.

Celtic Carryall

Here's another version of what has become an essential carryall in my life. Keep your possessions and valuables comfortably secured and your hands free as you travel about, whether you're a student on a school campus, a mom needing a snack bag, a hiker on the trail or if you're just out shopping. If you're looking for a handled bag, simply follow the finishing instructions and you're ready to go!

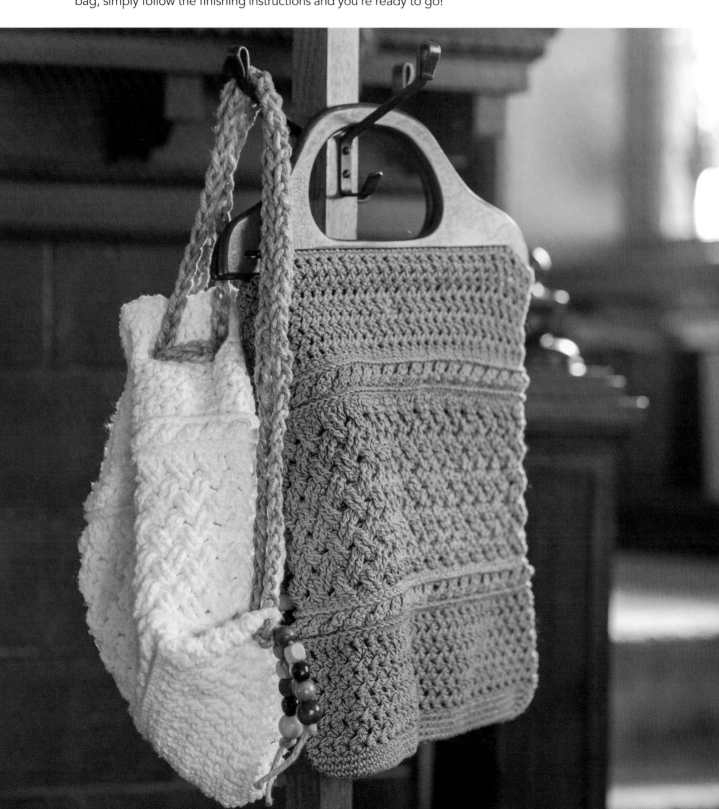

Skill Level

INTERMEDIATE

Materials

- G/6 (4mm) crochet hook
- L/11 (8mm) crochet hook (for hemp straps on backpack only)
- **For backpack:** 6 skeins Worsted (#4) weight cotton yarn (project shown uses Peaches and Creme [120 yds/109m per 2.5 oz/71g ball] in color #1005 White)
- **For handbag:** 5 skeins Worsted (#4) weight cotton yarn (project shown uses Reynolds Saucy [186 yds/167m per 3.5 oz/100g skein] in color #292)
- **For straps (backback only):** 18 yds (16.5m) hemp yarn with approx. ⅛" (4mm) thickness (project shown uses Natural Polished Hemp [64.5yds/59m per ball])
- 20 wooden beads (backpack only; must be large enough for the hemp to pass through the center)
- 1 set of wooden handles (handbag only; project shown uses handles from Everything Mary)

Finished Dimensions

15½" × 16" (39.5cm × 40.5cm)

Gauge

5 sts = 2¾" (7cm) and 7 rows = 3" (7.6cm)

Special Stitches

Low Front Ridge, Cable, Celtic Weave

Woven St: Yo, insert hook into indicated st, pull up a lp, pull hook through 1 lp on hook, yo, pull through both lps on hook (1st half complete). Yo, insert hook into same st, pull up a lp, pull through both lps on hook (2nd half and Woven st completed).

CARRYALL

Ch 2 does not count as 1st throughout entire pattern.

Turn after every rnd so that odd numbered rnds are worked with RS facing and even numbered rnds are worked with WS facing.

With smaller hook, ch 55.

Rnd 1 (RS): 2 sc in 2nd ch from hook, 1 sc in each ch across, 4 sc in last ch. Turn to work along other side of ch, 1 sc in each ch across. End by working 2 sc in last ch. Join with a sl st. Turn (112 sc).

Rnd 2 (WS): Ch 1. Sc in each sc around. Join with a sl st. Turn.

Optional: For a wider base, work 2 inc at each end of Rnd 2. This will add 4 sts to total st count. Then you can rep Rnd 2 twice more for added width on the bottom of the bag. This will inc st count by 12 sts.

Rnd 3 (RS): Ch 2. Sk 1st st, Woven st in next st, *sk next st, Woven st in next st. Rep from * around. Join with a sl st to turning ch. Turn (56 Woven st).

Rnds 4–11: Ch 2. Woven st in the sp between 1st and 2nd Woven sts. Woven st in the sp between each Woven st around, ending with a Woven st in top of turning ch. Join with a sl st. Turn.

Rnd 12: Ch 1. Work 2 sc in each sp between the Woven sts and in the turning ch. Join with a sl st. Turn (112 sc).

Rnds 13 & 14 form the LFR pattern.

Rnd 13 (RS): Ch 1. Working in flps only, sl st in next sc and in each sc around. Join with a sl st in turning ch. Turn.

Rnd 14: Ch 1. Working in rem lps of last sc rnd, sc in each sc around. Join with a sl st. Turn.

Rnds 15 & 16 form the Cable pattern. On Rnd 15, you will turn the work each time a cable is made.

Rnd 15: Ch 1. Sc in 1st st, *ch 3, sk 2 sc, sc in next sc. Turn and work 1 sc in each ch of ch-3 just made. Join to next sc with a sl st (cable made). Turn and, working behind the cable, 1 sc in each sc that was skipped, sk the sc that was made after ch-3. Rep from * around. Join with sl st to 1st sc. Turn (37 cables).

Note: In the next rnd, you will work a sc in the last st, and 3 sc evenly spaced behind each cable (on WS). The 3 sc behind each cable are worked into the sc that were worked into the 2 skipped sc. Work 1 sc in one of these skipped sc and 2 sc into the other. Do not work into the sc of the cables. Push the cables towards the RS as you work.

Rnd 16: Ch 1, *2 sc in next sc, sc in next sc; rep from *. across. Join with sl st to 1st sc. Turn.

Rnds 17 & 18: Rep Rnds 13 & 14.

Rnd 19: Ch 3. [Sk 2 sts, fptr around next 2 sts, working in front of sts just made fptr around 2 sts just skipped (CW made)] around. Join with a sl st. Turn.

Rnd 20: Sk 4 sts, work bptr over next 2 tr, working in back of sts just made, bptr around 3rd & 4th skipped sts (leave 1st & 2nd skipped sts for end of rnd), sk 2 sts, bptr around next 2 sts, working in back of sts just made, bptr around skipped sts, rep from * around to last 2 sts, bptr around last 2 sts. Join with a sl st. Turn.

Rnds 21–27: Rep Rnds 19 & 20 three times. Rep Rnd 19 once more.

Rnd 28: Ch 3. Bpdc around each st around. Join with a sl st. Turn.

Rnds 29–34: Rep Rnds 13–18.

Rnd 35: Rep Rnd 3.

Rnds 36–40: Rep Rnd 4.

For handbag only: Work 3 additional reps of Rnd 4. Then work Rnd 12 once. Go to finishing instructions for bag.

Rnd 41: Rep Rnd 12.

Rnd 42: Ch 3 (does count as 1st st). Dc in 4 sc, ch 4, sk 4 sc, *dc in next 4 sc, ch 4, sk next 4 sc, rep from * around. Join with a sl st. Turn.

Rnd 43: Ch 3. Work 4 dc in ch-4 sp, work 1 dc in each dc an 4 dc in each ch-4 sp around. Join with a sl st. Turn.

Rnd 44: Rep Rnd 3.

Rnd 45: Rep Rnd 4. Finish off.

HEMP STRAPS (MAKE 2)
For backpack only

Using larger crochet hook and hemp, crochet a ch 60" (152.4cm) long. (Be sure to leave about 12" (30.5cm) of extra hemp at the beg of the ch and at the end of the ch. This will be helpful when tying knots as well as adding beads.) As you crochet the ch, pull each st tightly to reduce any slack. Carefully check to be sure that both straps are the same size.

FINISHING

For backpack only: Weave in loose ends. Weave 1 ch into slits at the top of the bag and weave around 360° so that the other end is near the entry point. Weave the other ch starting on the other side of the bag in the same manner, but on the other side. When the ropes are pulled, the bag should close.

Push ends of ropes through the bottom corner on each side of bag. Tie both strands of hemp in a single knot. Add beads as desired.

For handbag only: Place bag on flat surface to determine the center of each side. From one end, count 8 sts. Join yarn with a sl st in next st. Sc in same st and in next 45 sts. Turn (46 sc).

Rows 2–5: Ch 1. Sc in each sc across. Turn. Finish off leaving a 20" (50.8cm) strand to attach handles.

Sk 16 sts on rnd where yarn was joined. Join in next st. Rep Rows 1–5 as for 1st side.

Carefully push last sections crocheted through wooden slots and sew in place with yarn and yarn needle. Weave in all ends.

Optional for bag and backpack (highly recommended): A lining can be added and sewn to the inside. Cut fabric the size of the bag plus ½" (1.3cm) seam allowance. The top of the lining should be below the handles or hemp openings. Sew a hem on the top open edge. If pockets are desired, add to lining. Next, sew 3 sides, leaving top open. Pin lining to bag and sew to inside of bag below handles or hemp openings.

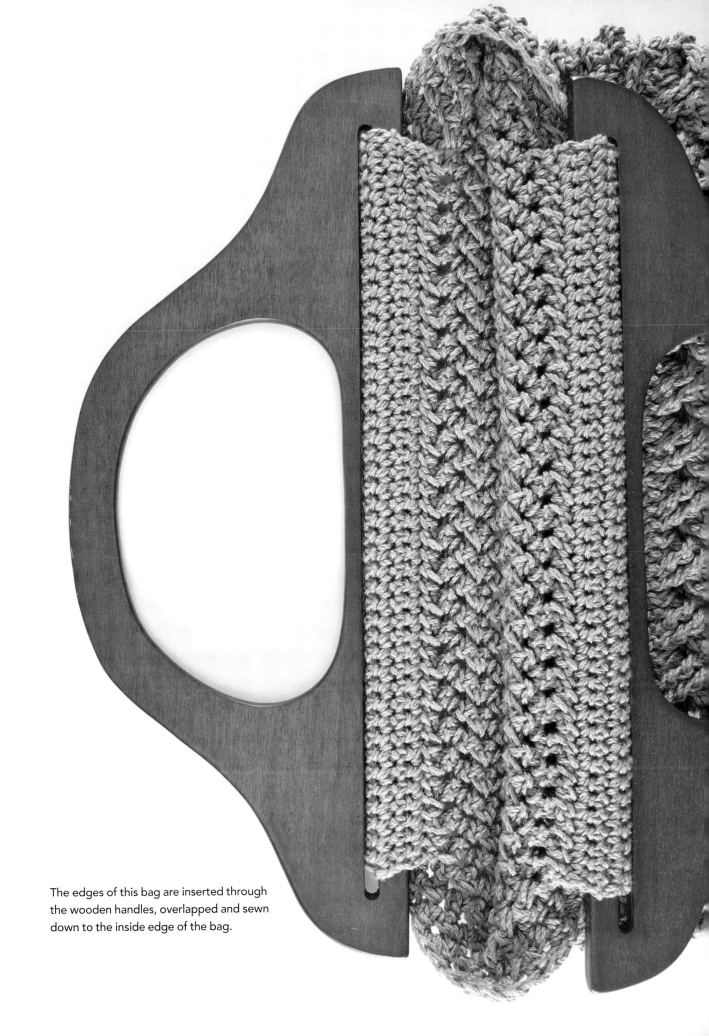

The edges of this bag are inserted through the wooden handles, overlapped and sewn down to the inside edge of the bag.

Gaithersburg Stole

Named for the place I now call home, this stole contains just enough stitch variety to keep the project interesting without becoming overwhelming. Be sure to check the stitch guide for instructions to help you over the hump should you get stuck.

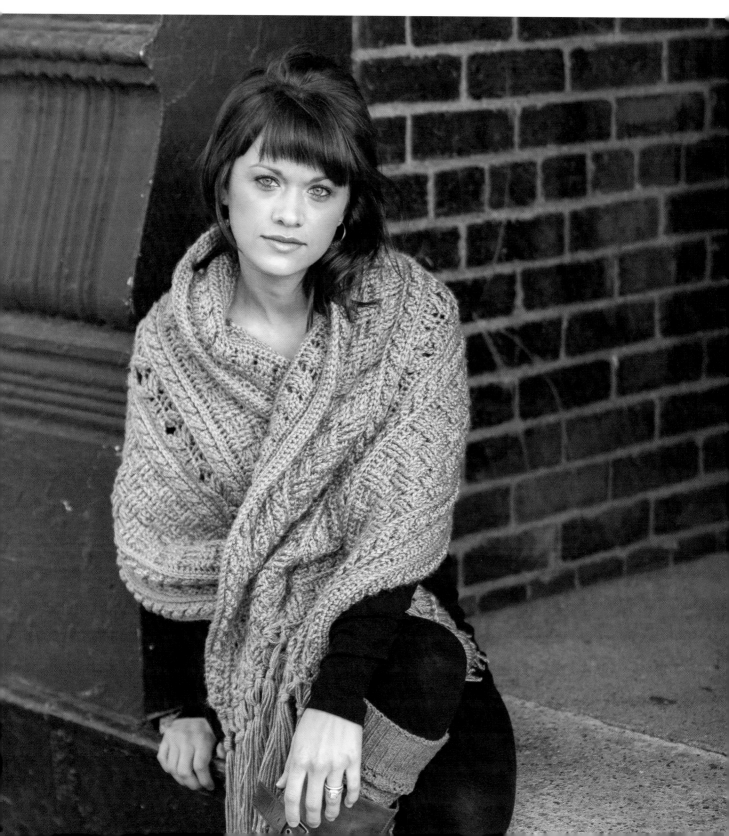

Skill Level

INTERMEDIATE

Materials

J/10 (6mm) crochet hook

4 skeins Worsted (#4) weight yarn (project shown uses Caron Simply Soft [315 yds/288m per 6 oz/170g skein] in color Sand)

Finished Dimensions

58¾" × 21" (149.2cm × 53.3cm), excluding fringe

Gauge

18 sts = 5" (12.7cm) and 6 rows = 2½" (6.4cm) long in Basket Weave pattern

Special Stitches

Cable, Arrow, Low Front Ridge, Basket Weave, Shadow Box

Pattern Notes

The even rows are worked with RS facing; the odd numbered rows are worked with WS facing. Turning chains do not count as the first stitch of the next row.

I recommend cutting the tassels first and leaving the remainder of the yarn for the body of the stole. The best way to do this is by cutting a 10" (25.4cm) piece of sturdy cardboard and wrapping the string loosely around the cardboard. Be sure your tension is loose enough so as not to bend the cardboard. This will ensure even length of the strands. Cut the yarn at one end to create the strands.

STOLE

Ch 213.

Row 1 (WS): Sc in 2nd ch from hook and in each ch across. Turn (212 sc).

Rows 2 & 3 form the LFR pattern.

Row 2 (RS): Ch 1. Working in flps only, sl st in next sc and in each sc across. Sl st in turning ch. Turn (213 sl st).

Row 3: Ch 1. Working in rem lps of last sc row, sc in each sc across. Turn (212 sc).

Rows 4 & 5 form the Cable pattern. On Row 4, you will turn the work each time a Cable is made.

Row 4: Ch 1. Sc in 1st st, *ch 3, sk 2 sc, sc in next sc. Turn and work 1 sc in each ch of ch-3 just made. Join to next sc with a sl st (Cable made). Turn and, working behind the cable, 1 sc in each row 3 sc that was skipped, sk the sc that was made after ch-3. Rep from * across row. End by working sc in last st. Turn (70 Cables).

Note: In the next row, you will work a sc in the 1st and last st, and 3 sc evenly spaced behind each Cable (on WS). The 3 sc behind each cable are worked into the sc that were worked into the 2 skipped sc. Work 1 sc in one of these skipped sc and 2 sc into the other. Do not work into the sc of the cables. Push the Cables towards the RS as you work.

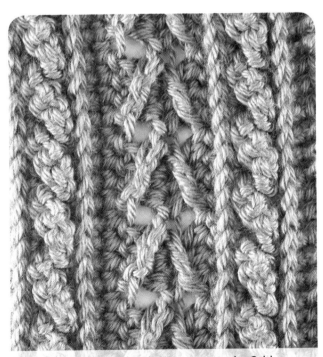

This lovely border incorporates the Cable, Low Front Ridge and Arrow stitches.

Row 5: Ch 1. Sc in 1st sc, *2 sc in next sc, sc in next sc; rep from * across to last sc, sc in last sc. Turn (212 sc).

Rows 6 & 7: Rep Rows 2 & 3 to form LFR pattern.

Rows 8 & 9 form the Arrow pattern.

Row 8: Ch 2. Dc in 1st 2 sc, *sk next 3 sc, tr in next sc. Working behind tr just made, dc in each of the 3 skipped sc. Rep from * across row. End by working dc in each of last 2 sts. Turn (52 tr and 160 dc).

Row 9: Ch 2. Dc in 1st 2 dc, *sk next 3 dc, tr in next tr. Working in front of tr just made, dc in each of 3 skipped dc. Rep from * across row. End by working dc in last 2 dc. Turn.

Rows 10 & 11: Ch 1. Sc in each st across. Turn (212 sc).

Rows 12–17: Rep Rows 2–7 (LFR pattern, Cable pattern, LFR pattern).

Rows 18–23 form the Basket Weave pattern.

Rows 18–20: Ch 2 (does count as 1st st). Hdc in the 1st st, *fpdc around the next 3 sts, bpdc around the next 3 sts. Rep from * across. End by working 1 hdc in last st. Turn.

Rows 21–23: Ch 2. Hdc in the 1st st, *bpdc around the next 3 sts, fpdc around the next 3 sts. Rep from * across. End by working 1 hdc in last st. Turn.

Rows 24–26: Rep Rows 18–20.

Row 27: Ch 1. Sc in each st across. Turn (212 sc).

Rows 28–33: Rep Rows 2–7 (LFR pattern, Cable pattern, LFR pattern).

Rows 34 & 35 form the Shadow Box pattern.

Row 34: Ch 2. Dc in 1st 2 sts, *sk next 2 sts, work tr in each of next 2 sts. Working behind tr just made, tr in each of 2 skipped sts. Sk next 2 sts, tr in each of next 2 sts, working in front of 2 tr just made, tr in each of 2 skipped sts. Dc in each of next 2 sts. Rep from * across row. Turn

Row 35: Ch 2. Dc in 1st 2 dc, *sk next 2 tr, tr in each of next 2 tr. Working behind tr just made, tr in each of 2 skipped tr. Sk next 2 tr, tr in each of next 2 tr. Working in front of tr just made, tr in each skipped tr. Dc in each of next 2 dc. Rep from * across. Turn.

Rows 36 & 37: Ch 1. Sc in each st across. Turn.

Rows 38–43: Rep Rows 2–7 (LFR pattern, Cable pattern, LFR pattern).

Rows 44–53: Rep Rows 18–27.

Rows 54–69: Rep Rows 2–17.

Row 70: Sc across row. At end of row, do not finish off and continue to Edging section.

EDGING

Ch 1, sc in same sp as last sc. Working along edge of stole, work [ch 1, sc] evenly across edge to next corner. Ch 1, sc in same sp, working in opposite side of foundation ch, sc in each ch across to next corner. Ch 1, sc in same sp as last sc, work [ch 1, sc] evenly along edge to next corner. Join with a sl st to corner, finish off.

FINISHING

Weave in ends.

ADD KNOTTED FRINGE

Cut 230 24" (61cm) strands. Use 5 strands per tassel in every other ch-1 sp across ends. Knot each group of strands. Knot again, approx 1" (2.5cm) lower, using half of each tassel. For tassels on the ends, use all strands of end tassel plus half of the strands of the next tassel. After knotting all knots, carefully trim strands with sharp scissors to even all strands.

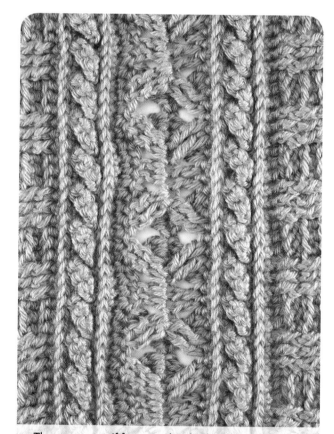

The center motif features the shadow box stitch bordered by the low front ridge and the cable stitch.

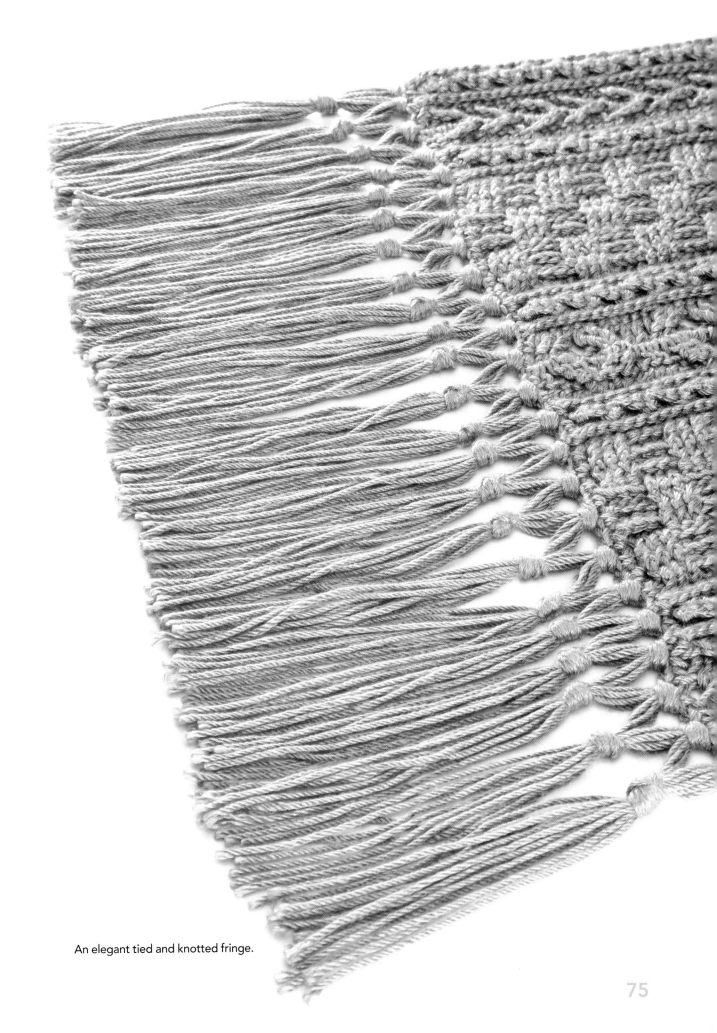

An elegant tied and knotted fringe.

Inisheer Sweater Wrap

Named for the smallest of the Aran Isles, Inisheer is the first of what I call a "Sweater Wrap," a wrap that thinks and acts like a sweater! I first saw this style of garment while visiting the west coast of Ireland. It is a practical choice when you don't want to wear a sweater, yet a stole alone is just not quite warm enough. The added back panel attached to the stole keeps you just as warm as you want to be.

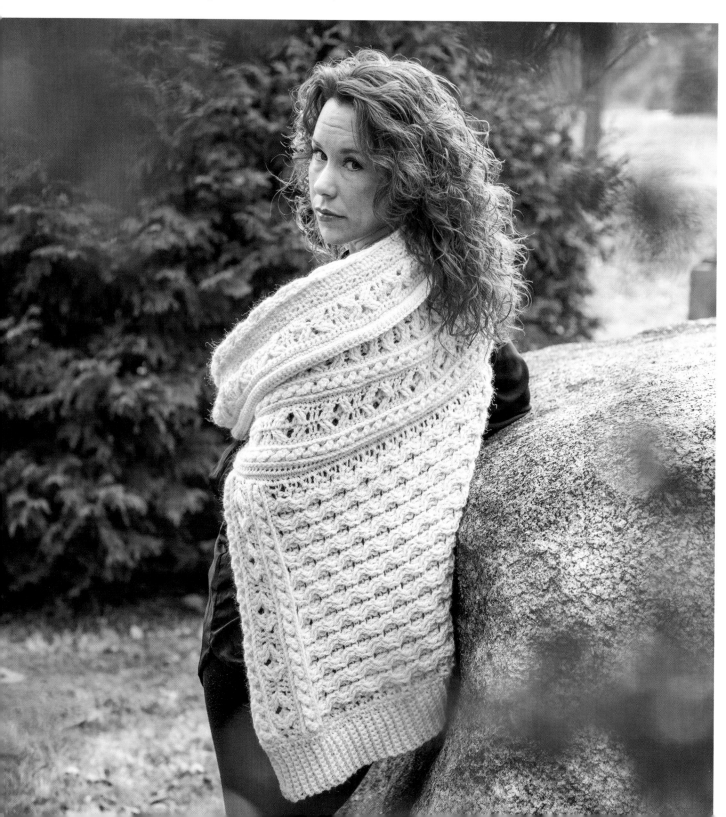

Skill Level

INTERMEDIATE

Materials

K/10½ (6.5mm) crochet hook
I/9 (5.5mm) crochet hook or two hook sizes
smaller than gauge hook
7 skeins Worsted (#4) weight yarn (project
shown uses Fibra Natura Shepherd's Own
[252 yds/230m per 3.5 oz/100g hank] in
color #40001)

Finished Dimensions

Stole: Approx 60" × 15" (152.4cm × 38.1cm)
not including fringe
Back: Approx 15½" × 24" (39.5cm × 61cm)

One size fits most

Gauge

With larger hook, 24 sts = 6½" (16.5cm) and 7
rows = 3" (7.6cm) in Honeycomb pattern

Special Stitches

Low Front Ridge, Cable Stitch, Shadow Box,
Honeycomb, Ribbing

Pattern Notes

The even rows are worked with RS facing; odd
numbered rows are worked with WS facing.
Turning chains *do not* count as the first stitch
of the next row.

I recommend cutting the tassels first and leav-
ing the remainder of the yarn for the body of
the stole. The best way to do this is by cut-
ting a 12" (30.5cm) piece of sturdy cardboard
and wrapping the string loosely around the
cardboard. Be sure your tension is loose
enough so as not to bend the cardboard. This
will ensure even length of the strands. Cut the
yarn at one end to create the strands.

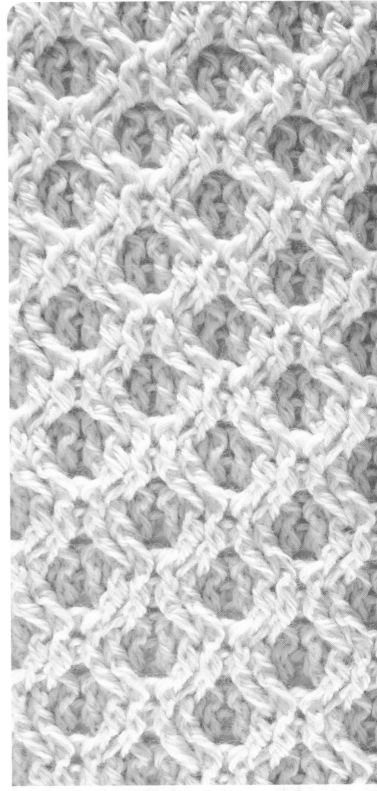

The Honeycomb stitch.

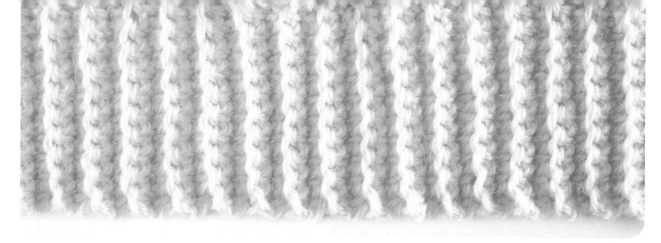

Single crochet ribbing frames the honeycomb on the back panel of the Inisheer Sweater Wrap.

STOLE

With smaller hook, ch 223.

Row 1 (WS): Sc in 2nd ch from hook and in each ch across (222 sc).

Rows 2 & 3 form the LFR pattern.

Row 2 (RS): Ch 1. Working in flps only, sl st in next sc and in each sc across. Sl st in turning ch. Turn (223 sl st).

Row 3: Ch 1. Working in rem lps of last sc row, sc in each sc across. Turn (222 sc).

Rows 4 & 5 form the Cable pattern. On Row 4, you will turn the work each time a Cable is made.

Row 4: Ch 1. Sc in 1st st, *ch 3, sk 2 sc, sc in next sc. Turn and work 1 sc in each ch of ch-3 just made. Join to next sc with a sl st (Cable made). Turn and, working behind the cable, 1 sc in each row 3 sc that was skipped, sk the sc that was made after ch-3. Rep from * across to last 2 sts. End by working sc in last 2 sts. Turn (73 Cables).

Note: In the next row, you will work a sc in the 1st 2 and last st, and 3 sc evenly spaced behind each Cable (on WS). The 3 sc behind each cable are worked into the sc that were worked into the 2 skipped sc. Work 1 sc in one of these skipped sc and 2 sc into the other. Do not work into the sc of the Cables. Push the Cables towards the RS as you work.

Row 5: Ch 1. Sc in 1st 2 sc, *2 sc in next sc, sc in next sc; rep from * across to last sc, sc in last sc. Turn (222 sc).

Rows 6 & 7: Rep Rows 2 & 3 to form LFR pattern.

Rows 8 & 9 form the Shadow Box pattern.

Row 8: Ch 2 (does *not* count as 1st st here and throughout). Dc in 1st 2 sts, *sk next 2 sts, work tr in each of next 2 sts. Working behind tr just made, tr in each of 2 skipped sts. Sk next 2 sts, tr in each of next 2 sts, working in front of 2 tr just made, tr in each of 2 skipped sts. Dc in each of next 2 sts (Shadow Box

made). Rep from * across row. Turn (22 Shadow Boxes).

Row 9: Ch 2. Dc in 1st 2 dc, *sk next 2 tr, tr in each of next 2 tr. Working behind tr just made, tr in each of 2 skipped tr. Sk next 2 tr, tr in each of next 2 tr. Working in front of tr just made, tr in each skipped tr. Dc in each of next 2 dc. Rep from * across. Turn.

Rows 10 & 11: Ch 1. Sc in each dc and tr across. Turn.

Rows 12–17: Rep Rows 2–5 once. Rep Rows 2 & 3 once more.

Change to larger hook.

Row 18: Ch 2. Dc in the 1st 3 sts, *sk 2 sts, fpdc over next 2 sts, working behind sts just worked, fpdc in 2 sts just skipped. Sk 2 sts, fpdc over next 2 sts, working in front of sts just worked, fpdc in 2 sts just skipped. Rep from * across to last 3 sts. Dc in last 3 sts. Turn.

Row 19: Ch 1. Dc in 1st 3 sts. Bpdc across to last 3 sts. Dc in last 3 sts. Turn.

Row 20: Ch 2. Dc in 1st 3 sts. *sk 2 sts, fpdc over next 2 sts, working in front of sts just worked, fpdc in 2 sts just skipped. Sk 2 sts, fpdc over next 2 sts, working behind sts just worked, fpdc in 2 sts just skipped. Rep from * across to last 3 sts. Dc in last 3 sts. Turn.

Row 21: Rep Row 19.

Rows 22–33: Rep Rows 18–21 a total of 3 times. Change to the smaller hook.

Rows 34–49: Rep Rows 2–17.

You will now work a sc border around the Stole section.

Rnd 50: Ch 1. Sc in each st across. *At the corner, ch 1, turn 90°, sc in same sp as last sc. Work sc evenly along the edge of the rows. **At next corner, ch 1, turn 90°, sc in same sp as last sc. Work sc across rem lps of foundation ch. Rep from * to ** once more. Join to 1st st of rnd with a sl st. Finish off.

BACK SECTION

Using smaller hook, ch 55.

Row 1: Sc in 2nd ch and in each ch across. Turn (54 sc).

Rows 2–21: Work same as Stole section Rows 2–21. (You will have 17 Cables and 5 Shadow Boxes.)

Rows 22–57: Rep Stole section Rows 18–21 nine times more.

Rows 58–73: Rep Stole section Rows 2–17.

You will now work a sc border around the Stole section.

Rnd 74: Ch 1. Sc in each st across. *At the corner, ch 1, turn 90°, sc in same sp as last sc. Work 90 sc evenly along the edge of the rows.**At next corner, ch 1, turn 90°, sc in same sp as last sc. Work sc across rem lps of foundation ch. Rep from * to ** once more. Join to 1st st of rnd with a sl st. Finish off.

CONNECTING BACK SECTION TO STOLE

With smaller hook, and working along foundation row of stole, sk 65 sts. With RS of stole and RS of back piece facing, join yarn with a sl st in the next st on the stole and the ch-1 sp on the back piece. Sl st across the next 90 sts, being careful to work through both lps of both pieces. Sl st in corner ch-1 sp of back. Finish off.

RIBBING (BOTTOM OF BACK SECTION)

Join with a sl st to the bottom left corner. Ch 11.

Row 1: Sc in 2nd ch from hook and in each ch across. Sl st in 1st sc along bottom of Back section, sl st in next sc of Back section, turn.

Row 2: Ch 1. Working in blps only, sc in each sc of ribbing across. Turn.

Row 3: Ch 1. Working in blps only, sc in each sc across. Sl st in each of next 2 sc of Back section, turn.

Rep Rows 2 & 3 for a total of 91 rows. End by working last row towards Back section and with a sl st in ch-1 corner of back. Finish off.

Weave in ends.

KNOTTED FRINGE

Cut 24" (61cm) strands for fringe.

Place 12 tassels evenly across each end of the stole. Be sure to use the ch-1 sps at each corner. Use 5 strands per tassel in every other ch-1 sp across ends. Knot again, approx 1" (2.5cm) lower, using half of each tassel. For tassels on the ends, use all strands of end tassel plus half of the strands of the next tassel. After knotting all knots, carefully trim strands with sharp scissors to even all strands.

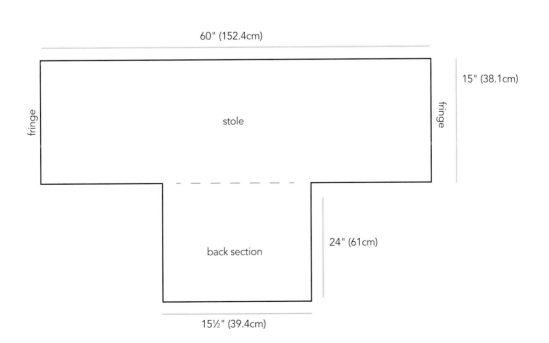

Inisheer Sweater Wrap Assembly Diagram

60" (152.4cm)

15" (38.1cm)

fringe

stole

fringe

back section

24" (61cm)

15½" (39.4cm)

Sailboats Baby Blanket

Here's a fun crochet project for that precious little one in your life! The textures of this nautical themed blanket will not only be stimulating for baby to see, but also to touch. Be sure to use yarn than can handle the waves of the washing machine!

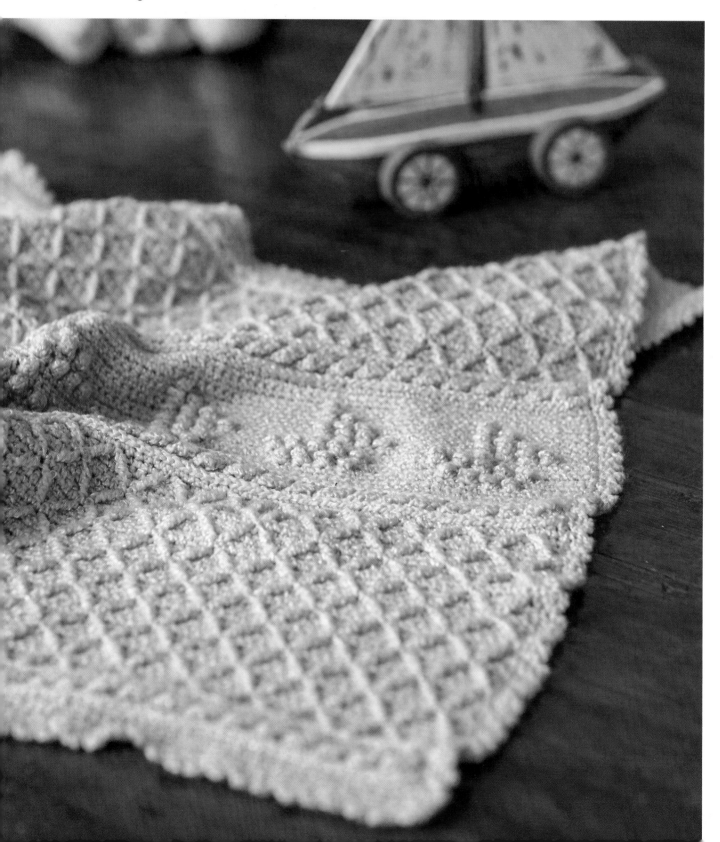

Skill Level

INTERMEDIATE

Materials

- H/8 (5mm) crochet hook
- G/6 (4mm) crochet hook or one hook size smaller than gauge hook
- E/4 (3.5mm) crochet hook or two hook sizes smaller than gauge hook
- 5 skeins DK (#3) yarn (project shown uses Bernat Baby Coordinates [388 yds/355m per 5 oz/140g skein] in color #48128 Soft Blue)

Finished Dimensions

33" × 26" (83.8cm × 66cm), including edging

Gauge

11 sts = 2½" (6.4cm) and 9 rows = 2" (5.1cm) in sc

Special Stitches

Low Front Ridge, Cable, Diamond Stitch

Popcorn (pc): Work 4 sc in same st. Remove hook and insert hook in the 1st sc of CL *from the front,* or from the front side of the st. (This will help the pc to puff out on the RS of the blanket.) Pull the lp through and ch 1.

BOTTOM PANEL

Using gauge hook, ch 135.

Row 1 (RS): Sc in 2nd ch from hook and in each ch across. Turn (134 sc).

Row 2 (WS): Ch 1. Sc in each sc across. Turn.

Rows 3 & 4 form the LFR pattern.

Row 3: Ch 1. Working in flps only, sl st in 2nd sc and in each sc across. Sl st in turning ch. Turn.

Row 4: Ch 1. Working in rem lps of last sc row, sc in each sc across. Turn.

Rows 5 & 6 form the Cable pattern. On Row 5, you will turn the work each time a Cable is made.

Row 5: Sc in 1st st, *ch 3, sk 2 sc, sc in next sc. Turn and work 1 sc in each ch of ch-3 just made. Join to next sc with a sl st (Cable made). Turn and, working behind the Cable, 1 sc in each Row 3 sc that was skipped, sk the sc that was made after ch-3. Rep from * across row. End by working sc in last st. Ch 1, turn (44 Cables).

Note: In the next row, you will work a sc in the 1st and last sts, and 3 sc evenly spaced behind each Cable (on WS). The 3 sc behind each Cable are worked into the sc that were worked into the 2 skipped sc. Work 1 sc in one of these skipped sc and 2 sc into the other. Do not work into the sc of the Cables. Push the Cables towards the RS as you work.

Row 6: Sc in 1st sc, *2 sc in next sc, sc in next sc; rep from * across to last sc, sc in last sc. Ch 1, turn (134 sc).

Rows 7 & 8: Rep Rows 3 & 4.

DIAMOND PATTERN

Rows 9 & 10: Ch 1. Sc in each sc across row. Turn.

The Diamond stitch and Cable stitch.

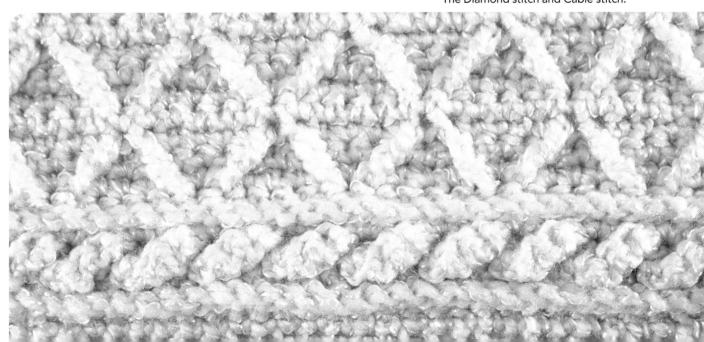

Popcorn sailboats provide fun for your baby's eyes and fingers with three-dimensional textures.

Row 7: Ch 1. Sc in 7 sc, *[pc in next st, sc in next st] 4 times, pc in next st, 1 sc in next 7 sc. Rep from * across row, ending last rep with sc in last 6 sc. Turn.

Row 8: Rep Row 6.

Row 9: Ch 1. Sc in 11 sc, *1 pc in next sc, 1 sc in next 15 sc. Rep from * across row, ending last rep with 1 pc in next st, sc in last 10 sc. Turn.

Row 10: Rep Row 6.

Row 11: Ch 1. Sc in 5 sc, *[pc in next st, sc in next st] 3 times, pc in next st, 1 sc in next 9 sc. Rep from * across to last st. Sc in last st. Turn.

Row 12: Rep Row 6.

Row 13: Ch 1. Sc in 7 sc, *[pc in next st, sc in next st] twice, pc in next st, 1 sc in next 11 sc. Rep from * across row, ending last rep with sc in last 10 sc. Turn.

Row 14: Rep Row 6.

Row 15: Ch 1. Sc in 9 sc, *pc in next st, sc in next st, pc in next st, 1 sc in next 13 sc. Rep from * across row, ending last rep with sc in last 10 sc. Turn.

Row 16: Rep Row 6.

Row 17: Ch 1. Sc in 11 sc, *pc in next sc, 1 sc in next 15 sc. Rep from * across row, ending last rep with sc in last 10 sc. Turn.

Row 18: Rep Row 6.

Rows 19–22: Ch 1. Sc in each st across row. Turn.

TOP PANEL
Change to gauge hook.

Rep Rows 3–54 of Bottom Panel instructions. Do not finish off.

EDGING
Rnd 1: Ch 1. *Sc in each sc across row. At end of row, ch 1, sc again in same sp (corner made). Sc evenly across edge of blanket. At corner, ch 1 and sc in same sp as last sc. Rep from * once around the perimeter of blanket. Connect with a sl st to 1st sc of perimeter rnd. *Do not turn.*

Change to smallest hook.

Rnd 2: Ch 1. Sc in 1st st, ch 3, dc in same st as 1st sc, *sk next st, sc in next st, ch 3, dc in same st as sc. Rep from * around the edge of the blanket. Connect with a sl st to 1st sc of rnd. Finish off.

FINISHING
Weave in ends and block if needed.

Row 11: Ch 1. Sc in 1st st, fptr in the 4th sc on Row 8. Sk next Row 10 st, sc in the next 4 sts. [Fptr in Row 8 sc next to last fptr made, sk next 4 sc on Row 8, fptr in next st. On current row sk 2 Row 10 sts, sc in next 4 sts] across row, fptr in sc next to last fptr made. Sk next Row 10 st, sc in last st. Turn.

Rows 12–14: Ch 1. Sc in each st across. Turn.

Row 15: Ch 1. Sc in 1st 3 sc. Fptr around sc 3 rows below and directly above 1st fptr of Row 11, fptr around sc 3 rows below and directly above next fptr of Row 11. *Sc in next 4 sts. *[Fptr around sc 3 rows below and directly above next fptr of Row 11] twice. Sc in next 4 sts. Rep from * across row, ending last rep by working sc in last 3 sts. Turn.

Rows 16–18: Ch 1. Sc in each st across. Turn.

Row 19: Ch 1. Sc in 1st sc, fptr around sc 3 rows below and directly above 1st fptr of Row 15. Sk next Row 19 sts, sc in next 4 sts. Fptr around sc 3 rows below and directly above next Row 15 fptr around next sc. *Fptr around sc 3 rows below and directly above next fptr of Row 15. Sc in next 4 sts. Fptr around sc 3 rows below and directly above next fptr of Row 15. Rep from * across row, sk next Row 19 st, 1 sc in last st. Turn.

Rows 20–47: Rep Rows 12–19 three more times, then rep Rows 12–15 once more.

Blanket should measure 5 Diamonds long and 22 Diamonds across.

Row 48: Ch 1. Sc in each st across row. Turn.

Rows 49–54: Rep Rows 3–8.

CENTER SAILBOAT PATTERN
Change to medium hook.

Rows 1–4: Ch 1. Sc in each sc across row. Turn.

Row 5 (RS): Ch 1. Sc in 8 sc, *[pc in next st, sc in next st] 3 times, pc in next st, 1 sc in next 9 sc. Rep from * across row, ending last rep with sc in last 7 sc. Turn.

Row 6: Ch 1. Sc in each sc and pc across row. Turn.

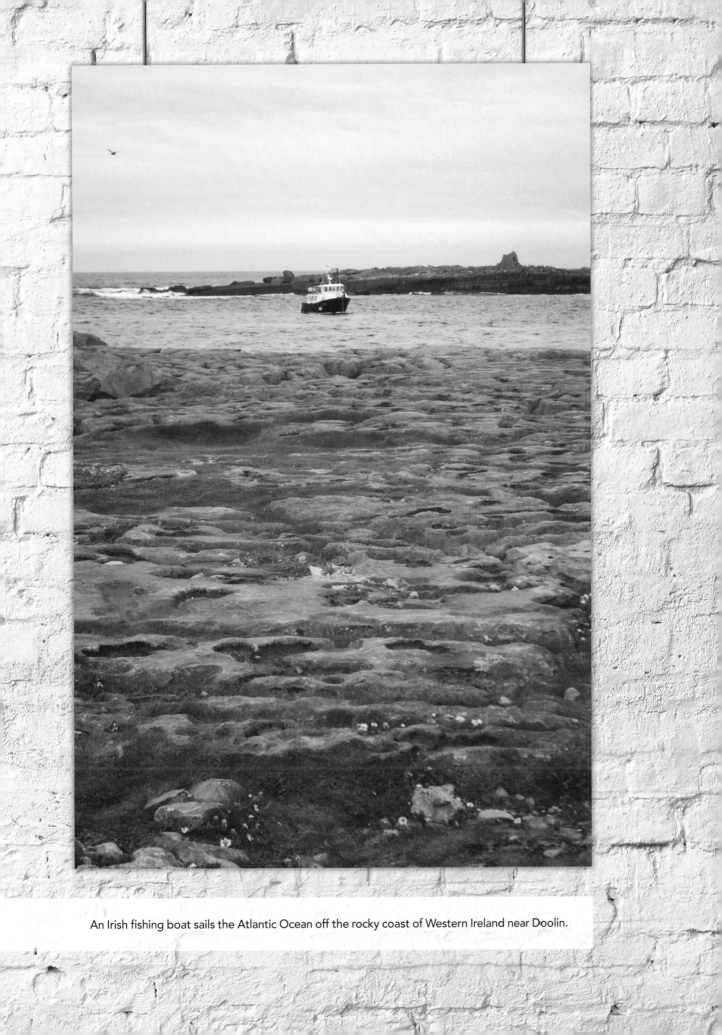

An Irish fishing boat sails the Atlantic Ocean off the rocky coast of Western Ireland near Doolin.

Knockardakin Wrap

This sweater wrap is a fun project with which to learn the Honeycomb and Wheat post stitches. These stitches can be mildly challenging at first, but once you pass through the learning curve, you're home free!

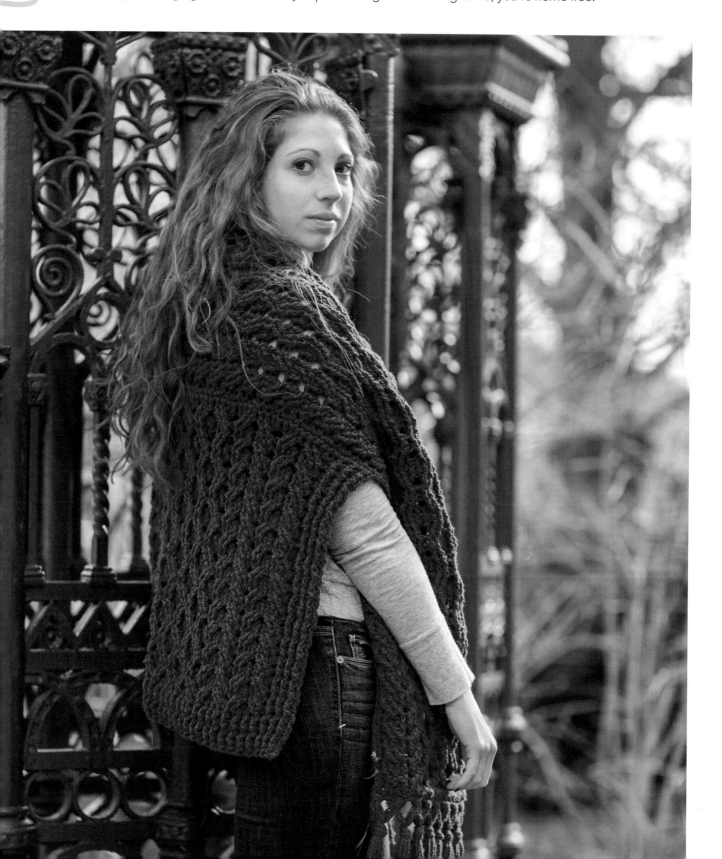

Skill Level

Materials

K/10½ (6.5mm) crochet hook
10 skeins Worsted (#4) weight yarn (project shown uses Cestari [170 yds/153m per 3.5 oz/100g hank] in color #179116 Coxcomb)

Finished Dimensions

Stole: 66" × 13" (167.6cm × 33cm)
Back: 18½" × 24¼" (47cm × 61.6cm)

Gauge

8 sts = 2½" (6.4cm) and 8 rows = 4¾" (12.1cm) in Honeycomb pattern

Pattern Notes

Honeycomb, Wheat stitch

Pattern Notes

Even rows are with RS facing.

I recommend cutting the tassels first and leaving the remainder of the yarn for the body of the stole. Cut a 10" (25.4cm) piece of sturdy cardboard and wrap the string loosely around the cardboard. Be sure your tension is loose enough so as not to bend the cardboard. This will ensure even length of the strands. Cut the yarn at one end to create the strands.

WRAP

Using largest hook, ch 44.

Row 1 (WS): Dc in 4th ch and in each ch across. Turn (42 dc).

Row 2 (RS): Ch 3 (counts as dc here and throughout). *Sk next 2 dc, fptr around next 2 dc, working behind 2 fptr just worked, fptr around 2 skipped dc, sk next 2 dc, fptr around next 2 dc, working in front of 2 fptr just worked, fptr around 2 skipped sts, rep from * across to last st. Dc in last st. Turn.

Row 3: Ch 3. Bpdc around each st across. Turn.

Row 4: Ch 3 (counts as dc here and throughout). Sk next 2 dc, fptr around next 2 dc, working behind 2 fptr just worked, fptr around 2 skipped dc, sk next 2 dc, fptr around next 2 dc, working in front of 2 fptr just worked, fptr around 2 skipped sts. [Sk next 2 dc, fptr around next 2 dc, working in front of 2 fptr just worked, fptr around 2 skipped dc, sk next 2 dc, fptr around next 2 dc, working behind 2 fptr just worked, fptr around 2 skipped sts] 3 times. Sk next 2 dc, fptr around next 2 dc, working behind 2 fptr just worked, fptr around 2 skipped dc, sk next 2 dc, fptr around next 2 dc, working in front of 2 fptr just worked, fptr around 2 skipped sts. Dc in last st. Turn.

Row 5: Rep Row 3.

Rows 6–111: Rep Rows 2–5 twenty-six times. Rep Rows 2 & 3 once more. Piece should measure approx 66" (167.6cm). Do not finish off.

EDGING

Rnd 1 (RS): Ch 1. *[Sc in next st, sk 1 st, ch 1] across. Ch 2, turn 90°, work 166 sc evenly along edge of back, ch 2, turn 90° at corner, rep from * once more. Join with a sl st to 1st sc. Finish off.

BACK SECTION

Row 1 (WS): With WS facing, join with a sl st along side of wrap in the 45th sc, ch 2 (counts as dc here and throughout), dc in each of next 77 sc. Leave rem 44 sts unworked. Turn (78 dc).

Row 2 (RS): Ch 2, [fpdc around next st, bpdc around next st] 3 times. [Sk next 2 dc, fptr around next 2 dc, working behind 2 fptr just worked, fptr around 2 skipped dc, sk next 2 dc, fptr around next 2 dc, working in front of 2 fptr just worked, fptr around 2 skipped sts] 8 times. [Bpdc around next st, fpdc around next st] 3 times, dc in last st. Turn.

Row 3: Ch 2, [bpdc around next st, fpdc around next st] 3 times, bpdc across to last 7 sts. [Fpdc around next st, bpdc around next st] 3 times, dc in last st. Turn.

Row 4: Ch 2, [fpdc around next st, bpdc around next st] 3 times. [Sk next 2 dc, fptr around next 2 dc, working behind 2 fptr just worked, fptr around 2 skipped dc, sk next 2 dc, fptr around next 2 dc, working in front of 2 fptr just worked, fptr around 2 skipped sts] 2 times. [Sk next 2 dc, fptr around next 2 dc, working in front of 2 fptr just worked, fptr around 2 skipped dc, sk next 2 dc, fptr around next 2 dc, working behind 2 fptr just worked, fptr around 2 skipped sts] 4 times. [Sk next 2 dc, fptr around next 2 dc, working behind 2 fptr just worked, fptr around 2 skipped dc, sk next 2 dc, fptr around next 2 dc, working in front of 2 fptr just worked, fptr around 2 skipped sts] 2 times. [Bpdc around next st, fpdc around next st] 3 times, dc in last st. Turn.

Row 5: Rep Row 3.

Rows 6–27: Rep Rows 2–5 five times more, and then Rows 2 & 3 once more. Do not finish off. Cont to ribbing rows.

RIBBING ROWS

Row 28: Ch 2. [Fpdc around next st, bpdc around next st] across to last 7 sts. Sk next bpdc from prev row (in order to cont alternating pattern), [fpdc around next st, bpdc around next st] to last 2 sts, fpdc around next st, dc in last st. Turn.

Row 29: Ch 2. [Bpdc around next st, fpdc around next st] across to last 2 sts, bpdc around next st, dc in last st. Turn.

Row 30: Ch 2. [Fpdc around next st, bpdc around next st] across to last 2 sts, fpdc around next st, dc in last st. Turn.

Row 31: Rep Row 29 once more. Finish off.

FINISHING:

Weave in loose ends. Follow directions for knotted fringe. Add fringe to both ends of the stole portions only.

KNOTTED FRINGE

Cut 110 20" (50.8cm) strands. Use 5 strands per tassel in every other ch-1 sp across the ends. Knot again, approx 1" (2.5cm) lower, using half of each tassel. For tassels on the ends, use all strands of the end tassel plus half of the strands of the next tassel. After knotting all knots, carefully trim strands with sharp scissors to even all strands.

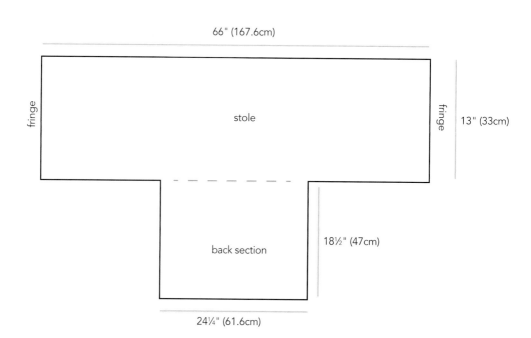

Knockardakin Wrap Assembly Diagram

66" (167.6cm)

fringe

stole

fringe

13" (33cm)

back section

18½" (47cm)

24¼" (61.6cm)

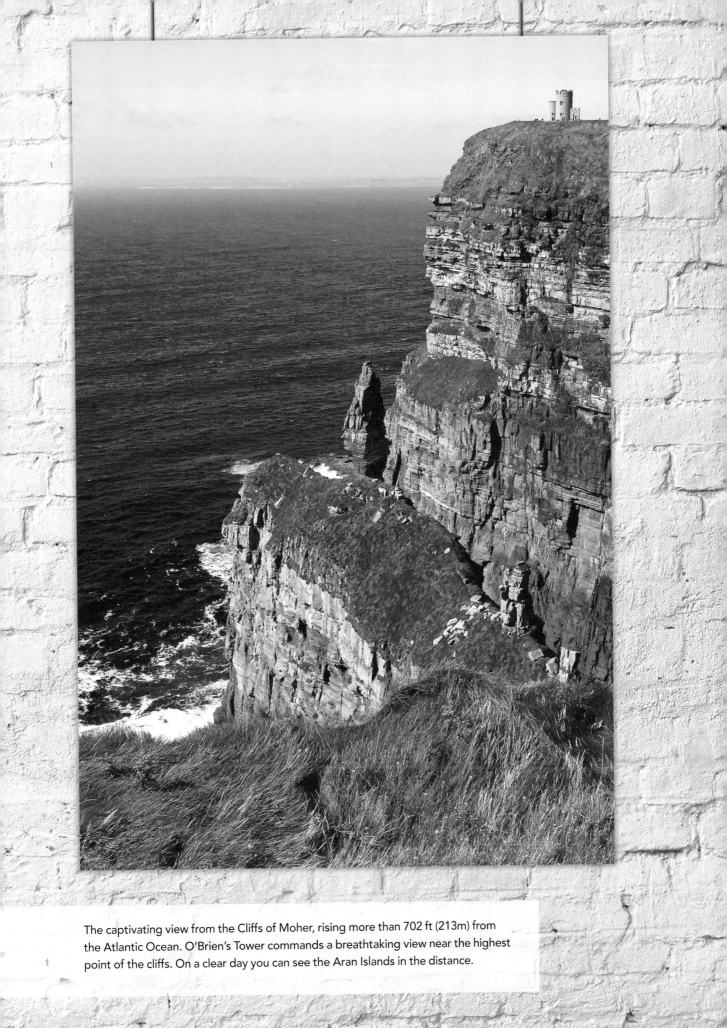

The captivating view from the Cliffs of Moher, rising more than 702 ft (213m) from the Atlantic Ocean. O'Brien's Tower commands a breathtaking view near the highest point of the cliffs. On a clear day you can see the Aran Islands in the distance.

Gavotte Gigs

This is the perfect project for the geek in your life, or for the tablet or MP3 player on your desk or in your bag. These unique cabled covers will add a beautiful layer of protection and style to all your computing.

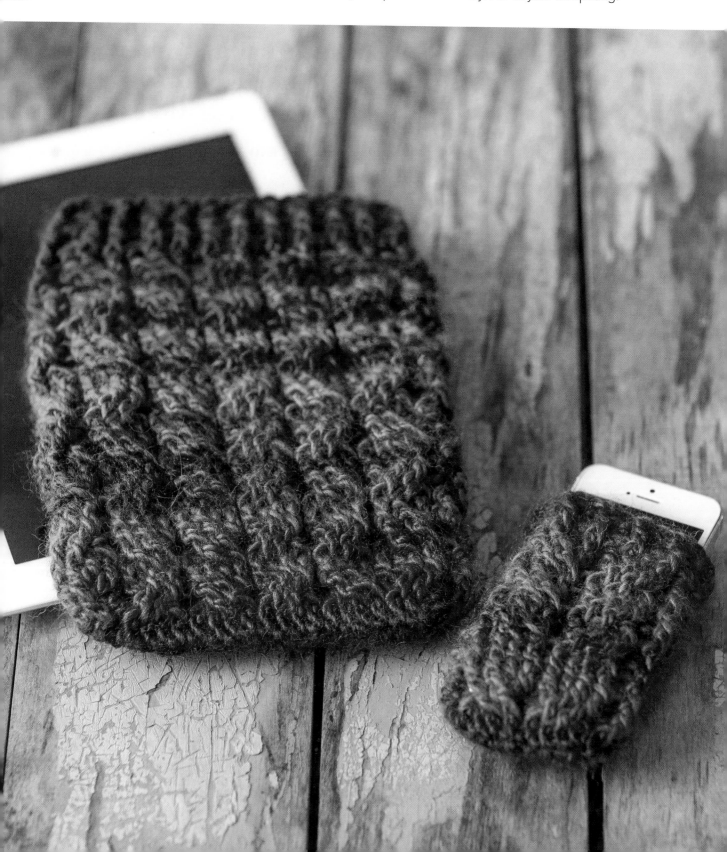

Skill Level

INTERMEDIATE

Materials

Phone/MP3 Player

H/8 (5mm) crochet hook

1 skein Worsted (#4) weight yarn (project uses
Universal Yarn Classic Shades [197 yds/179m
per 3.5 oz/100g skein] in color #710 Wine)

2 lobster clasps for strap (optional)

iPad Mini/iPad

H/8 (5mm) crochet hook

1 skein Worsted (#4) weight yarn (project uses
Universal Yarn Classic Shades [197 yds/179m
per 3.5 oz/100g skein] in color #711 Grape-
vine [Mini] and #723 Stained Glass [iPad])

2 lobster clasps for strap (optional)

Dimensions

Phone/MP3 Player

3" × 4½" (7.6cm × 11.4cm) before stretching

iPad Mini/iPad

iPad Mini: 6½" × 8¾" (16.5cm × 22.2cm);
iPad: 8¾" × 11¼" (22.2cm × 28.6cm)

Gauge

Phone/MP3 Player

10 sts = 3" (7.6cm), 4 rows = 1½" (3.8cm) in
pattern stitch

iPad Mini/iPad

11 sts = 3" (7.6cm) and 4 rows = 1¾" (4.4cm)
in dc

Special Stitches

Honeycomb, Wheat stitches

Pattern Notes

Even though the cover is worked in the
round, turn after each round as if working
back and forth.

PHONE/MP3 PLAYER

*Note: Beg ch 2 does not count as a 1st st throughout
the pattern.*

Ch 10.

Rnd 1 (RS): 2 dc in 3rd ch from hook, 1 dc next ch and
in each ch across. Work 3 more dc in last ch (for a
total of 4 dc), working along other side of foundation
ch, dc in each ch across, 2 dc in last ch. Join with sl st.
Turn (20 dc).

Rnd 2: Ch 2. Bpdc around 1st dc, *sk 2 sts, fptr
around next 2 sts, working behind 2 sts just made,
fptr around skipped sts. Sk 2 sts, fptr around next 2
sts, working in front of 2 sts just made, fptr around
skipped sts.** Bpdc around each of next 2 sts, rep *
to ** once more, bpdc around last st. Join with a sl st.
Turn.

Rnd 3: Ch 2. Fpdc around 1st st, bpdc around next 8
sts; fpdc around next 2 sts, bpdc around next 8 sts,
fpdc in last st. Join with a sl st. Turn.

Rnds 4–9: Rep Rows 2 and 3 three times more.

Rnds 10–12: Ch 2. [Bpdc around next st, fpdc around
next st] around. Turn.

Finish off.

DETACHABLE STRAP (OPTIONAL)

Ch 131 (or to length desired). Sl st in 2nd ch from
hook and in each ch across. Finish off, leaving at least
a 4" (10.2cm) strand for connecting. Put one end of
strap through hole of clasp and secure to strap (about
1" [2.5cm] above clasp) using yarn and yarn needle.
Secure other end in same manner. Connect directly
to 2 rows of ribbing. You may choose to add a small
ring to MP3 cover and connect clasp to ring.

FINISHING

Weave in ends.

IPAD MINI/IPAD

Note: Where st numbers or reps are different, the iPad Mini numbers will appear first, and the iPad numbers second in parentheses. The rnds with the RS facing will be using fptr. The rnds with the WS (inside of cozy) will use bpdc.

Ch 24 (32).

Beg ch does *not* count as 1st st throughout pattern.

Rnd 1 (WS): 2 dc in 3rd ch from hook, 1 dc next ch and in each ch across. Work 3 more dc in last ch (for a total of 4), working along other side of foundation ch dc in each ch across, 3 dc in last ch. Join with sl st (48 [64] dc).

Rnd 2 (RS): Ch 2. [Sk 2 sts, fptr around next 2 sts, working in front of sts just made, fptr around 2 skipped sts] 0 (1) time. *Sk 2 sts, fptr around next 2 sts, working in back of sts just made, fptr around 2 skipped sts. Sk 2 sts, fptr around next 2 sts, working in front of sts just made, fptr around 2 skipped sts. Rep from * 5 (6) times more. [Sk 2 sts, fptr around next 2 sts, working in back of sts just made, fptr around 2 skipped sts] 0 (1) time. Join with sl st. Turn.

Rnd 3 (WS): Ch 2. Bpdc around each st around. Join with sl st. Turn.

Rnd 4: Ch 2. *[Sk 2 sts, fptr around next 2 sts, working in back of sts just made, fptr around 2 skipped sts] 0 (1) time. Sk 2 sts, fptr around next 2 sts, working in front of sts just made, fptr around 2 skipped sts. [Sk 2 sts, fptr around next 2 sts, working in back of sts just made, fptr around 2 skipped sts] twice. [Sk 2 sts, fptr around next 2 sts, working in front of sts just made, fptr around 2 skipped sts] twice. Sk 2 sts, fptr around next 2 sts, working in back of sts just made, fptr around 2 skipped sts. [Sk 2 sts, fptr around next 2 sts, working in front of sts just made, fptr around 2 skipped sts] 0 (1) time. Rep from * 1 time. Join with sl st. Turn.

Rnd 5: Rep Rnd 3.

Rnds 6–17 (21): Rep Rnd 2 and Rnds 3–5 an additional 3 (4) times more.

TOP RIBBING

Rnds 1–3 (5): Ch 2. Work [fpdc around next st, bpdc around next st] around. Join with sl st. Do *not* turn.

Finish off. Weave in ends.

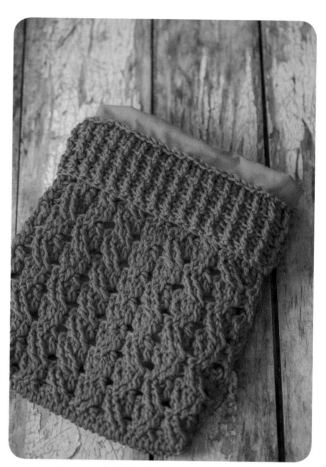

You can always add a fabric lining to custom fit your device cover. Attach the lining by hand sewing it into the cover below the ribbing.

DETACHABLE STRAP (OPTIONAL)

Ch 161 (or to length desired). Sl st in 2nd ch from hook and in each ch across. Finish off, leaving at least a 4" (10.2cm) strand for connecting. Put one end of strap through hole of clasp and secure to strap (about 1" [2.5cm] above clasp) using yarn and yarn needle. Secure other end in same manner. Weave in ends. Connect directly to 2 rows of ribbing. You may choose to add a small ring to cover and connect clasp to ring.

FINISHING

Weave in ends.

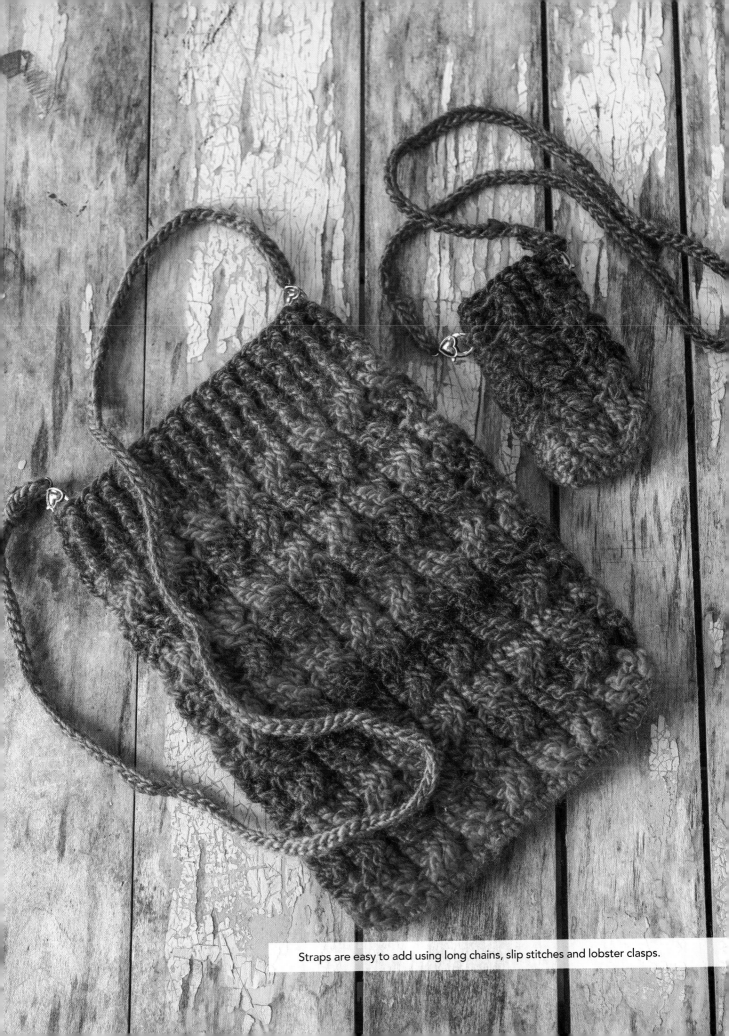

Straps are easy to add using long chains, slip stitches and lobster clasps.

Aran Diamonds Cardigan & Vest

This sweater duo is as much fun to crochet as it is to wear, since there's plenty of stitch variety. Whenever I wear this sweater out and about, I'm almost certain to hear the question, "Is that knit?" To which I can delightedly respond, "Nope. It's crocheted!"

Skill Level

EXPERIENCED

Materials

- I/9 (5.5mm) crochet hook
- H/8 (5mm) crochet hook or one hook size smaller than gauge hook
- **Sweater:** 5 (6, 6, 7) skeins of Worsted (#4) weight yarn (project uses Caron Simply Soft [315 yds/288m per 6 oz/170g skein] in color #9702 Off White)
- **Vest:** 4 (4, 5, 6) skeins of Worsted (#4) weight yarn (project uses Caron Simply Soft [315 yds/288m per 6 oz/170g skein] in color #9722 Plum Wine)
- Eight (S, M) or nine (L, XL) 1" (2.5cm) buttons
- Needle
- Matching thread

Finished Dimensions

Instructions for these sizes are listed in order in parentheses S (M, L, XL). Be careful to read the correct numbers for the size you are making.

Bust: 32¼ (41¾, 46¼, 51)"/(81.9 [106, 117.5, 129.5]cm)

Length: 23 (23, 23, 24½)"/(58.4 [58.4, 58.5, 62.2] cm), including ribbing

Gauge

12 sts = 3" (7.6cm) and 4 rows = 1" (2.5cm) in Diamond stitch

Special Stitches

Cable, Low Ridge Front, Diamond, Knurl, Single Crochet Ribbing

Decrease (dec): [insert hook into next st, yo, pull up a lp] twice, yo, pull through all 3 lps on hook (1 st dec).

BACK

With gauge hook, ch 81 (81, 81, 87).

Row 1 (WS): Sc in 2nd ch from hook and in each ch across. Turn (80 [80, 80, 86] sc).

Rows 2 & 3 form the LFR pattern.

Row 2 (RS): Ch 1. Working in flps only, sl st in 2nd sc and in each sc across. Sl st in turning ch. Turn.

Row 3: Ch 1. Working in rem lps of last sc row, sc in each sc across. Turn.

Rows 4 & 5 form the Cable pattern. On Row 4, you will turn the work each time a Cable is made.

Row 4: Ch 1. Sc in 1st st, *ch 3, sk 2 sc, sc in next sc. Turn and work 1 sc in each ch of ch-3 just made. Join to next sc with a sl st (Cable made). Turn and, working behind the Cable, 1 sc in each Row 3 sc that was skipped, sk the sc that was made after ch-3. Rep from * across to last st. Sc in last st. Turn (26 [26, 26, 28] Cables).

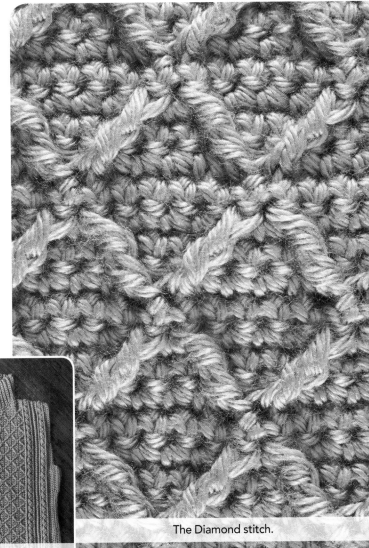

The Diamond stitch.

Aran Diamonds Vest

Note: In the next row, you will work a sc in the 1st, 2nd and last sts, and make 3 sc evenly spaced behind each Cable (on WS). The 3 sc behind each Cable are worked into the sc that were worked into the 2 skipped sc. Work 1 sc in one of these skipped sc and 2 sc into the other. Do not work into the sc of the Cables. Push the Cables towards the RS as you work.

Row 5: Ch 1. Sc in 1st sc, *2 sc in next sc, sc in next sc; rep from * across to last sc, sc in last sc. Turn (80 [80, 80, 86] sc).

Rows 6 & 7: Rep Rows 2 & 3.

Row 8: Ch 1. Sc in each sc across. Do not turn.

Rows 9 & 10 form the Knurl pattern. Row 9 is worked from left to right.

Row 9: Ch 1. Working in the flps only of the prev sc row, *insert hook in sc to the right of hook. Hook yarn and pull through under and to the left of the lp on hook. Yo and draw yarn through both lps on hook (1 knurl completed.) Rep from * across row. End by working a sl st in last sc of row. Do not turn.

Row 10: Ch 1. Working in the rem blps of Row 8, and from right to left, sc in 1st sc and in each sc across. Turn.

Row 11: Ch 1. Sc in each sc across. Turn.

Rows 12–17: Rep Rows 2–5 once. Rep Rows 2 & 3 once more.

Rows 18–19: Ch 1. Sc in each sc across. Turn.

Note: Row 20 is Row 4 of the Diamond stitch pattern.

Row 20: Ch 1. Sc in 1st st, fptr in the 4th sc on Row 17. Sk next Row 19 st, sc in the next 4 sts. [Fptr in Row 17 sc next to last fptr made, sk next 4 sc on Row 17, fptr in next st. On current row sk 2 Row 19 sts, sc in next 4 sts] across to last 2 sts, fptr in sc next to last fptr made. Sk next Row 19 st, sc in last st. Turn.

Rows 21–23: Ch 1. Sc in each sc across. Turn.

Row 24: Ch 1. Sc in next 3 sts, [fptr in sc above next fptr 3 rows below, fptr in sc above next fptr 3 rows below. Sk 2 Row 23 sts, sc in 4 sts] twice. Fptr in sc above next to last fptr. Fptr in last sc 3 rows below, sk 2 Row 23 sts, sc in last st. Turn.

Continue working established pattern by rep Diamond pattern Rows 1–8 for an additional 16 (24, 28, 32) rows.

Rep Row 11, then rep Rows 2–17.

Do not finish off. Cont on to Side Shaping for RS of Back.

SIDE SHAPING FOR RS OF BACK

Change to smaller hook.

Row 1 (RS): Ch 1, hdc in next 12 (14, 16, 18) sts, sc in next 14 (16, 18, 20) sts, hdc in next 20 (22, 24, 26) sts, sc in next 20 sts. Turn leaving rem sts unworked (66 [72, 78, 84] sts).

Row 2 (WS): Ch 1. Sc in each sc and hdc in each hdc across. Turn.

Row 3: Ch 1. Hdc in next 16 (16, 16, 16) sts, sc in next 16 (16, 18, 20) sts, hdc in next 16 (16, 14, 15) hdc. Turn, leaving rem sts unworked (48 [48, 48, 51] sts).

Row 4: Ch 1. Dec over 2 sts, hdc in rem sts across row. Turn (47 [47, 47, 50]).

Row 5: Ch 1. Hdc in next 16 (16, 16, 16) sts, sc in next 16 (16, 18, 20) sts, hdc across to last 2 sts. Dec over last 2 sts. Turn (46 [46, 46, 49] sts).

Row 6: Ch 1. Dec over 2 sts, hdc in each hdc and sc in each sc across. Turn (45 [45, 45, 48] sts).

Size S only: Finish off.

Row 7: Ch 1. Hdc across to last 2 sts. Dec over last 2 sts. Turn – (44, 44, 47 sts).

Size M only: Finish off.

Row 8: Rep Row 6 (– [–, 43, 46] sts).

Size L only: Finish off.

Row 9: Rep Row 7 (– [–, –, 45] sts).

Size XL only: Finish off.

SIDE SHAPING FOR LEFT SIDE OF BACK

With WS of panel facing, attach with a sl st to the bottom at 1st ch of the foundation row. Work 1st hdc in next st for Row 1. (Do not work in same st as sl st.) Work Rows 1–6 (7, 8, 9) of Side Shaping for RS. Note that WS rows are now RS rows and vice versa.

LEFT FRONT PANEL

With gauge hook, ch 81 (81, 81, 87).

Rows 1–17: Work same as instructions for Back (80 [80, 80, 86] sts).

Work Side Shaping as for RS of Back. Finish off.

DIAMOND ROWS

Row 1 (RS): With RS facing, attach with a sl st to top of piece. Working along foundation ch, ch 1, dec over 1st 2 sts, sc in rem sts across. Turn (79 [79, 79, 85] sc).

Row 2 (WS): Ch 1. Sc across row to last 2 sts. Dec over last 2 sts. Turn (78 [78, 78, 84] sc).

Row 3: Ch 1. Sc in the next 4 sts. Fptr around the 4th sc of foundation row (3 rows below). Fptr around sc 3 rows below next to last fptr made. On current row sk 2 sts, sc in next 4 sts. [Fptr around sc 3 rows below next to last fptr made, sk next 4 sc on same row, fptr around next sc. On current row sk 2 sts, sc in next 4 sts] across to last 2 sts, fptr around sc 3 rows below next to last fptr made. Sk next st on current row, sc in last st. Turn.

Row 4: Ch 1. Sc across row to last 2 sts. Dec over last 2 sts. Turn (77 [77, 77, 83] sc).

Row 5: Ch 1. Sc in each st across. Turn.

Row 6: Rep Row 4 (76 [76, 76, 82] sc).

Row 7: Ch 1. Sk 1st st, sc in the next 4 sts. Cont in established Diamond pattern across row. Turn (75 [75, 75, 81] sts).

Row 8: Rep Row 4 (74 [74, 74, 80] sc).

Row 9: Rep Row 5.

Row 10: Rep Row 4 (73 [73, 73, 79] sc).

Row 11: Ch 1. Sk 1st st, sc in the next 4 sts. Cont in established Diamond pattern across row. Turn (72 [72, 72, 78] sts).

Rows 12–14: Ch 1. Sc in each st across. Turn.

Row 15: Ch 1. Sc in 1st 2 sts. Cont in established Diamond pattern across row. Turn.

Rows 16–18: Ch 1. Sc in each st across. Turn.

Row 19: Ch 1. Sc in first 4 sts. Cont in established Diamond pattern across row. Turn.

Sizes S and M only: Finish off.

Sizes L and XL only: Rep Rows 12–15. Finish off.

RIGHT FRONT PANEL
With gauge hook, ch 81 (81, 81, 87).

Rows 1–17: Work same as instructions for Back (80 [80, 80, 86] sts).

DIAMOND ROWS
Row 1 (RS): Ch 1. Sc across row to last 2 sts. Dec over last 2 sts. Turn (79 [79, 79, 85] sc).

Row 2: Ch 1. Dec over 1st 2 sts, sc in rem sts across. Turn (78 [78, 78, 84] sc).

Row 3: Ch 1. Sc in 1st st, fptr around the 4th sc 3 rows below (Row 17 of back). Sk next st on current row, sc in the next 4 sts. [Fptr around sc 3 rows below next to last fptr made, sk next 4 sc on same row, fptr around next sc. On current row sk 2 sts, sc in next 4 sts] across. Turn.

Row 4: Ch 1. Dec over 1st 2 sts, sc in rem sts across. Turn (77 [77, 77, 83] sc).

Row 5: Ch 1. Sc in each st across. Turn.

Row 6: Rep Row 4 (76 [76, 76, 82] sc).

Row 7: Work established Diamond pattern across until 1 st remains. Turn, leaving rem st unworked (75 [75, 75, 81] sts).

Row 8: Rep Row 4 (74 [74, 74, 80] sc).

Row 9: Rep Row 5.

Row 10: Rep Row 4 (73 [73, 73, 79] sc).

Row 11: Work established Diamond pattern across until 1 st remains. Turn, leaving rem st unworked (72 [72, 72, 78] sts).

Rows 12–14: Ch 1. Sc in each st across. Turn.

Row 15: Ch 1. Continue in established Diamond pattern across, ending with sc in last 2 sts. Turn.

Rows 16–18: Ch 1. Sc in each st across. Turn.

Row 19: Ch 1. Continue in established Diamond pattern across row, ending with sc in last 4 sts. Turn.

Size S and M only: Finish off.

Size L and XL only: Rep Rows 12–15. Finish off.

Work Side Shaping as for Left Side of Back. Finish off.

SLEEVES (MAKE 2—FOR CARDIGAN)
With gauge hook, ch 69 (69, 75, 81).

Row 1 (WS): Sc in 2nd ch from hook and in each ch across. Turn (68 [68, 74, 80] sc).

Rows 2–7: Work Rows 2–7 of Back.

Row 8 begins with Diamond pattern Row 2.

Rows 8 & 9: Ch 1. Sc in each sc across. Turn.

Row 10: Ch 1. Sc in 1st st, fptr around the 4th sc 3 rows below (on Row 7). Sk next current row (Row 9) st, sc in the next 4 sts. [Fptr around sc 3 rows below next to last fptr made, sk next 4 sc on same row, fptr around next st. On current row sk 2 sts, sc in next 4 sts] across to last 2 sts, fptr around sc 3 rows below next to last fptr made. Sk next current row st, sc in last st. Turn.

Rows 11–13: Ch 1. Sc in each sc across. Turn.

Row 14: Ch 1. Sc in next 3 sts, [fptr around sc above next fptr 3 rows below, fptr around sc above next fptr 3 rows below. Sk 2 current row (Row 13) sts, sc in 4 sts] across to last 3 sts. Fptr around sc 3 rows below above next to last fptr. Fptr around last sc 3 rows below, sk 2 current row sts, sc in last 3 sts. Turn.

Rows 15–17: Ch 1. Sc in each sc across. Turn.

Row 18–22: Rep Rows 10–14.

Row 23: Ch 1. Sc in each sc across. Turn.

Rows 24–29: Rep Rows 2–7.

Row 30 begins the dec that taper the cuff end of the sleeve.

Row 30: Ch 1. Sc across row to last 4 sts. Work 2 dec. Turn (66 [66, 72, 78] sc).

Row 31: Ch 1. Work 2 dec over 1st 4 sts, sc across row. Turn (64 [64, 70, 76] sc).

Rows 32–35: Rep Rows 30 & 31 twice. Turn (56 [56, 62, 68] sc).

Row 36 begins the dec on the sleeve cap end while cont the tapering on the cuff end.

Row 36: Ch 1. Sl st in 1st 6 sc, sc across row to last 2 sts. Work 1 dec. Turn (49 [49, 55, 61] sc).

Row 37: Ch 1. Work 1 dec over 1st 2 sts. Sc across row to last 2 sc, work 1 dec. Turn (47 [47, 53, 59] sc).

Row 38: Ch 1. Sl st in 1st 9 (7, 7, 9) sc, sc across row to last 2 sts. Work 1 dec. Turn (37 [39, 45, 49] sc).

Rows 39 & 40: Rep Row 37 (33 [35, 41, 45] sc).

Size S only: Sk to Row 46. Do not work Rows 41–45.

Rows 41–43: Rep Row 37 (– [29, 35, 39] sc).

Size M only: Sk to Row 46. Do not work Rows 44 & 45.

Rows 44 & 45: Rep Row 37. – (–, 31, 35) sc.

Row 46: Ch 1. Sc in each st across. Turn.

Sizes S, M and L: Finish off.

Size XL only:

Rows 47 & 48: Rep Row 46 twice. Finish off.

With WS of arm facing, join yarn to foundation ch. Ch 1, work Rows 30–48 to match other side of arm.

FINISHING:
With RS facing, sew shoulder seams. Next, center sleeves (if making cardigan), pin and sew into place. Finally, sew arm and side seams.

Work ribbing around bottom, neck and sleeves of sweater as follows:

ARM HOLE EDGING (VEST ONLY)
Row 1: With RS of vest facing, join with a sl st at underarm seam. Sc evenly around opening of arm. Join to 1st sc with a sl st.

Row 2: Sl st in each sc around. Finish off.

RIBBING FOR BOTTOM AND COLLAR
With gauge hook, join yarn to bottom of sweater (or edge of neckline) with a sl st. Sc evenly around edge. Turn. Ch 13.

Row 1: Sc in 2nd ch from hook and in each ch. Connect to edge by working a sl st in the next 2 sc. Turn (12 sc).

Row 2: Ch 1, working in the blps only, 1 sc in each sc. Turn.

Row 3: Ch 1, working in the blps only, 1 sc in each sc. Turn.

Rep Rows 2 & 3 around edge. Finish off.

RIBBING FOR CUFFS (CARDIGAN ONLY)
With gauge hook, join yarn to bottom of sleeve with a sl st. Sc evenly around edge. Join with a sl st. Ch 13.

Work ribbing as in Ribbing for Bottom and Collar.

End by connecting 1st row of cuff to last row with a row of sl sts, working towards original foundation row. Finish off.

BUTTON BAND—LEFT SIDE
(Buttons will later be sewn on this side.)

Row 1: Join with a sl st to bottom left ribbing. Ch 1. Working through both lps, sc along front and along edge of panel across, through last st of left side of collar. Turn.

Rows 2–5: Ch 1. Sc in each sc across row. Turn. At the end of Row 5, finish off.

BUTTON BAND—RIGHT SIDE
(Buttonhole side.)

Row 1: Join with a sl st to bottom right ribbing. Ch 1. Working through both lps, sc along front and along edge of panel across, through last st of right side of collar. Turn.

Row 2: Ch 1. Sc in each sc across row. Turn.

Using st markers or pieces of contrasting yarn, place holders (2 sts wide) in the desired locations for the buttons. Be careful to space 8 (8, 9, 9) buttons evenly along the band.

Row 3: Ch 1. Sc in each sc across row, being careful to [ch 2, sk 2 sts] at the locations of the place holders for buttonholes. Turn.

Row 4: Ch 1. Work sc in each sc, and 2 sc in each ch-2 sp across row. Turn.

Row 5: Rep Row 2. Finish off.

Sew buttons in place to correspond to the buttonholes.

Weave in ends.

White Diamonds Cardigan and Vest Assembly Diagram
(diagram does not include ribbing)

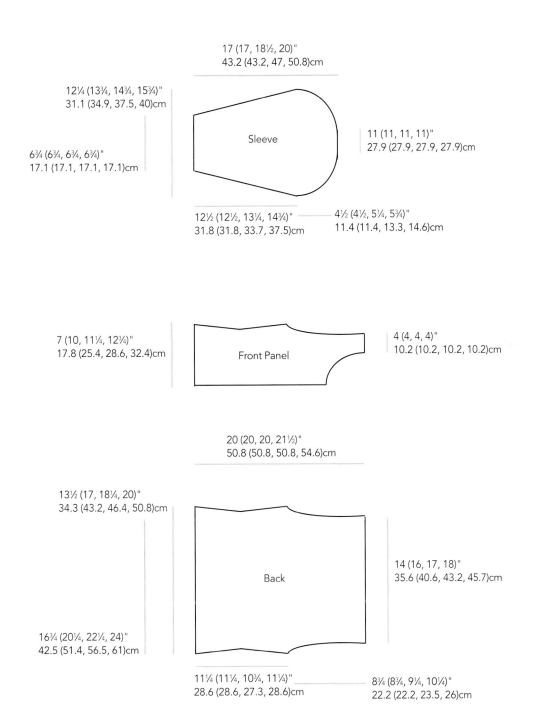

17 (17, 18½, 20)"
43.2 (43.2, 47, 50.8)cm

12¼ (13¾, 14¾, 15¾)"
31.1 (34.9, 37.5, 40)cm

Sleeve

11 (11, 11, 11)"
27.9 (27.9, 27.9, 27.9)cm

6¾ (6¾, 6¾, 6¾)"
17.1 (17.1, 17.1, 17.1)cm

12½ (12½, 13¼, 14¾)"
31.8 (31.8, 33.7, 37.5)cm

4½ (4½, 5¼, 5¾)"
11.4 (11.4, 13.3, 14.6)cm

7 (10, 11¼, 12¾)"
17.8 (25.4, 28.6, 32.4)cm

Front Panel

4 (4, 4, 4)"
10.2 (10.2, 10.2, 10.2)cm

20 (20, 20, 21½)"
50.8 (50.8, 50.8, 54.6)cm

13½ (17, 18¼, 20)"
34.3 (43.2, 46.4, 50.8)cm

Back

14 (16, 17, 18)"
35.6 (40.6, 43.2, 45.7)cm

16¾ (20¼, 22¼, 24)"
42.5 (51.4, 56.5, 61)cm

11¼ (11¼, 10¾, 11¼)"
28.6 (28.6, 27.3, 28.6)cm

8¾ (8¾, 9¼, 10¼)"
22.2 (22.2, 23.5, 26)cm

Busking Beauty Sweater Wrap

If you like big, ribbed collars, this wrap's for you!

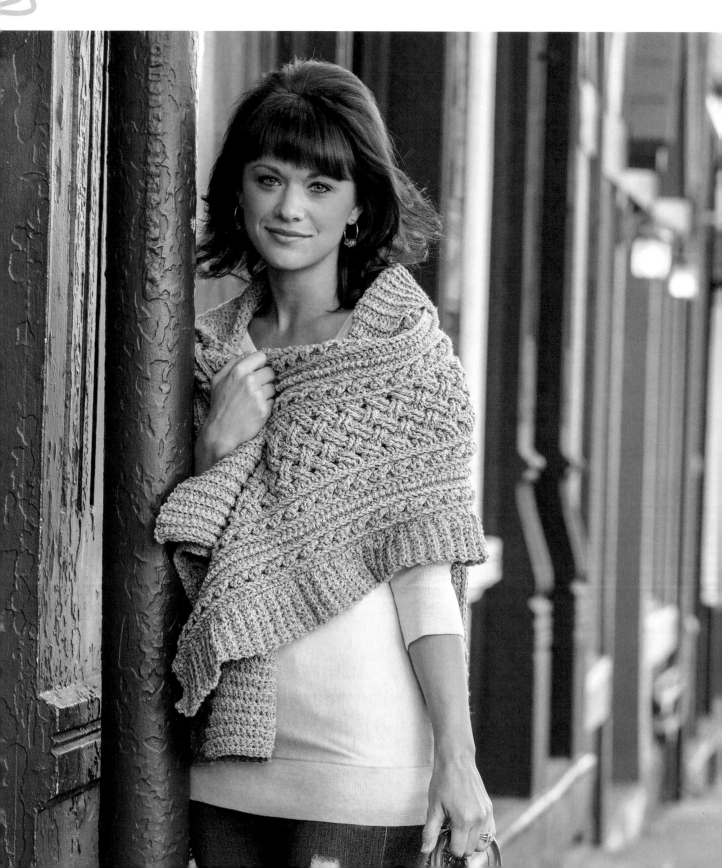

Skill Level

INTERMEDIATE

Materials

I/9 (5.5mm) crochet hook

G/6 (4mm) crochet hook or hook size 1.5mm smaller than gauge hook

6 skeins DK (#3) weight yarn (project shown uses Cestari Heather Collection [250 yds/228m per 3.5 oz/100g skein] in color Blue Denim)

Finished Dimensions

Stole: 60" × 17" (152.4cm × 43.2cm)

Back: 16½" × 22" (41.9cm × 55.9cm)

One size fits most

Gauge

10 sts = 3" (7.6cm) and 6 rows = 3½" (8.9cm) in Celtic Weave pattern

Pattern Notes

The even rows are worked with RS facing; odd numbered rows are worked with WS facing. Turning chains *do not* count as the first stitch of the next row.

STOLE

With larger hook, ch 201.

Row 1 (WS): Sc in 2nd ch from hook and in each ch across. Turn (200 sc).

Rows 2 & 3 form the LFR pattern.

Row 2 (RS): Ch 1. Working in flps only, sl st in 2nd sc and in each sc across. Sl st in turning ch. Turn.

Row 3: Ch 1. Working in rem lps of last sc row, sc in each sc across. Turn.

Rows 4 & 5 form the Cable pattern. On Row 4, you will turn the work each time a Cable is made.

Row 4: Ch 1. Sc in 1st st, *ch 3, sk 2 sc, sc in next sc. Turn and work 1 sc in each ch of ch-3 just made. Join to next sc with a sl st (Cable made). Turn and, working behind the Cable, 1 sc in each Row 3 sc that was skipped, sk the sc that was made after ch-3. Rep from * across to last st. End by working sc in last st. Turn (66 Cables).

Note: In the next row, you will work a sc in the 1st 2 and last st, and 3 sc evenly spaced behind each Cable (on WS). The 3 sc behind each Cable are worked into the sc that were worked into the 2 skipped sc. Work 1 sc in one of these skipped sc and 2 sc into the other. Do not work into the sc of the Cables. Push the Cables toward the RS as you work.

Row 5: Ch 1. Sc in 1st 2 sc, *2 sc in next sc, sc in next sc; rep from * across to last sc, sc in last sc. Turn (200 sc).

Rows 6 & 7: Rep Rows 2 & 3 to form LFR pattern.

Row 8: Ch 1. Sc in each sc across. Do not turn.

Row 9 forms the Knurl pattern and is worked from left to right with the RS facing.

Row 9: With smaller hook, ch 1. Working in the flps only of the prev sc row, *insert hook in sc to the right of hook. Hook yarn and pull through, under and to the left of the lp on hook. Yo and draw yarn through both lps on hook (1 Knurl completed). Rep from * across row. End by working a sl st in last sc of row. Do *not* turn.

Row 10 (RS): With larger hook, ch 1. Working in the rem blps of Row 8, and from right to left, sc in 1st sc and in each sc across. Turn.

Row 11: Ch 1. Sc in each sc across row. Turn.

Rows 12–17: Rep Rows 2–7.

Rows 18 & 19 form the CW pattern.

Row 18: Ch 2 (does count as 1st st here and through-out). Dc in 1st 2 sts, *sk next 2 sts, fptr around post of next 2 sts, fptr around each of skipped sts working in front of 1st 2 fptr just made (CW completed). Rep from * across row to last 2 sts. End by working 1 dc in the last 2 sts. Turn.

Row 19: Ch 2. Dc in the 1st 2 dc. Work a bptr around each of the next 2 tr, *sk next 2 tr, work a bptr around the next 2 tr. Working in back of the 2 bptr just made, work a bptr around the 2 skipped sts (CW). Rep from * across row to last 4 sts. End by working 2 bptr around last 2 tr, and dc in last 2 dc. Turn.

Rows 20 & 21: Rep Rows 18 & 19.

Row 22: Rep Row 18.

Row 23: Ch 2. Dc in 1st 2 dc, bpdc across row to last 2 sts. Dc in last 2 sts. Turn.

Rows 24–39: Rep Rows 2–17.

You will now work a sc border around the Stole section.

Rnd 40: Ch 1. Sc in each st across to corner. Ch 1, turn 90°, work sc evenly along edge of Stole to next corner. Ch 1, turn 90°, sc in rem lps along foundation ch across to next corner. Ch 1, turn 90°, work sc evenly along edge of Stole. Join with a sl st to 1st sc of rnd. Finish off.

BACK SECTION

With larger hook, ch 51.

Rows 1–17: Rep Rows 1–17 of the Stole section (50 sts per row).

Row 18: Ch 2 (does count as 1st st here and throughout). Dc in 1st st, *sk next 2 sts, fptr around post of next 2 sts, fptr around each of skipped sts working in front of 1st 2 fptr just made (CW completed). Rep from * across row. End by working 1 dc in the last st. Turn.

Row 19: Ch 2. Dc in the 1st dc. Work a bptr around each of the next 2 tr, *sk next 2 tr, work a bptr around the next 2 tr. Working in back of the 2 bptr just made, work a bptr around the 2 skipped sts (CW completed). Rep from * across row to last 3 sts. End by working 2 bptr around last 2 tr, and dc in last dc. Turn.

Rows 20–25: Rep Rows 18 & 19 three times.

Row 26: Rep Row 18 once more.

Row 27: Ch 2. Dc in 1st dc, bpdc across row to last st. Dc in last st. Turn.

Rows 28–53: Rep Rows 2–27.

Rows 54–69: Rep Rows 2–17.

You will now work a sc border around the Back section.

Rnd 70: Ch 1. Sl st across row to corner. Ch 1, turn 90°, work 64 sc evenly across edge of rows to next corner. Ch 1, turn 90°, sl st along rem lps of foundation ch to next corner. Ch 1, turn 90°, work 64 sts evenly across other edge of Stole. Finish off.

CONNECTING BACK SECTION TO STOLE

With RS facing, join with a sl st to one end of Stole. Sc in 67 sts. Place the RS of Back section facing the RS of the Stole (RS together). Beg with ch-1 sp on Back section, sl st together to Stole, being careful to work through both lps of each piece. Sl st across 64 sc and ch-1 sp. Cont and sc in other side of Stole to end. Do not finish off.

RIBBING

Row 1: Ch 9, sc in 2nd ch from hook and in rem 8 chs. Sl st to sc on Stole, ch 1, turn. * Working in blps only, sc across (9 sc). Turn.

Row 2: Working in blps only, sc across. Sl st in next 2 sc on Stole, ch 1, turn. Rep Rows 1 & 2 across to where Back section is attached to Stole. Attach to Back section using a sl st. Finish off.

Still working on the bottom side of Stole (where Back joins to Stole), but on the other side of the Back section, join with a sl st to next sc on Stole section. * Work 8 sc along Back section, ch 1, working in blps only, sc across. Sl st in next 2 sc on Stole, ch 1, turn. Rep from * to end of Stole. Work last row, going toward Stole, and cont across edge of Stole to top of Stole section. Do not finish off.

COLLAR RIBBING

At end of row, ch 17. Sc in 2nd ch from hook and in next 15 ch (16 sc). *Sl st in next 2 sc on Stole, ch 1, turn, working in blps only, sc across 16 sc, ch 1, turn, sc across 16 sc. Rep from * across length of Stole. For last row of ribbing, cont to sc across edge of Stole and over 8 sts of ribbing on the other side of Stole. Finish off.

RIBBING ACROSS BOTTOM OF BACK SECTION

Join with a sl st to bottom edge of Back section. Ch 9, work 8 sc ribbing across bottom of section same as the above instructions. Work last row towards Back section. Finish off.

FINISHING

Weave in ends. Block if needed.

Busking Beauty Wrap Assembly Diagram

60" (152.4cm)

17" (43.2cm)

collar ribbing

stole

back

16½" (41.9cm)

back section ribbing

22" (55.9cm)

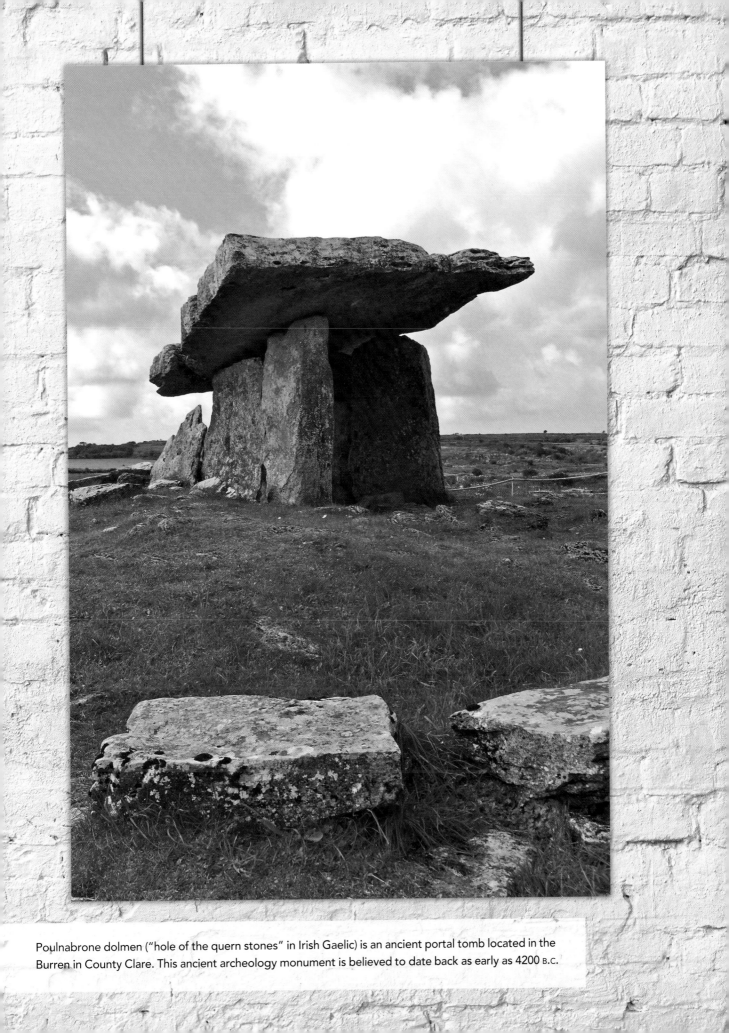

Poulnabrone dolmen ("hole of the quern stones" in Irish Gaelic) is an ancient portal tomb located in the Burren in County Clare. This ancient archeology monument is believed to date back as early as 4200 B.C.

Doolin Delight Sweater Wrap

Some of my sweetest memories of Ireland are from the quaint village of Doolin. It was there that I saw my first sweater wrap in an Irish sweater store. This sweater wrap isn't for beginners, but it will be enjoyed by the seasoned crocheter.

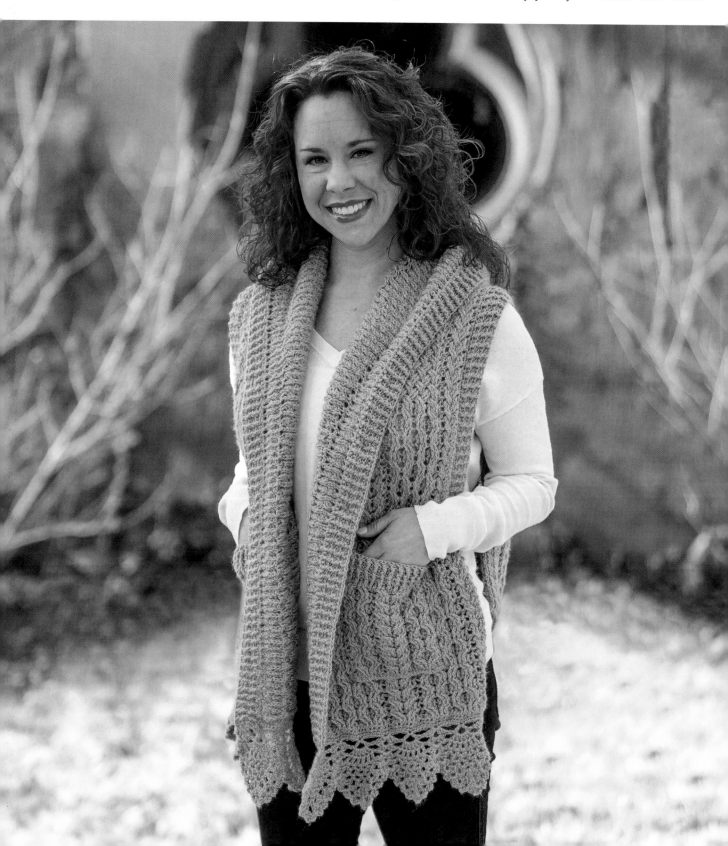

Skill Level

EXPERIENCED

Materials

H/8 (5mm) crochet hook

F/5 (3.75mm) crochet hook or two hook sizes smaller than gauge hook

8 skeins of DK (#3) weight yarn (project shown uses Caron Simply Soft Light [330 yds/302m per 3 oz/85g skein] in color #0007 Capri)

Three 1" (2.5cm) buttons

Finished Dimensions

Stole: 65" × 13½" (165.1cm × 34.3cm), excluding pineapples

Back: 15¾" × 19¼" (40cm × 48.9cm)

Gauge

18 sts = 3¼" (8.3cm) and 7 rows = 2¼" (5.7cm) in Honeycomb pattern

Special Stitches

Braided Cable, Celtic Weave, Honeycomb, Post Ribbing, Pineapple Lace (in text)

Fishbone:

Row 1: Sk next 2 sts, fpdc in next 2 sts, working in front of 2 sts just made, fpdc around skipped sts, sk 2 sts, fpdc around next 2 sts, working in back of 2 sts just made, fpdc around skipped sts (each Fishbone is formed over 8 sts).

Row 2: Ch 2, bpdc around next 8 sts.

Pattern Notes

Please be aware of when and where to change your hook sizes. I have tried to highlight this in the pattern, but I know too well how easy it is to forget. Be sure to leave at least 6" (15.2cm) of thread when finishing off. This leaves enough yarn to easily thread into a yarn needle when hiding loose ends.

WRAP

Using gauge hook, ch 60.

Row 1: Dc in 4th ch from hook and in each ch across. Turn (58 dc).

Row 2 (RS): Ch 2 (counts as hdc here and throughout). [Sk 1st 2 sts, fpdc around next 2 sts, working in front of sts just made, fpdc around 2 skipped sts, fpdc around next 2 sts, 1 BC begun], hdc in next st, [sk 2 sts, fpdc around next 2 sts, working behind sts just made, fpdc around skipped sts, sk 2 sts, fpdc around next 2 sts, working in front of 2 sts just made, fpdc around skipped sts (Honeycomb begun)] twice. Hdc in next st, sk next 2 sts, fpdc in next 2 sts, working in front of 2 sts just made, fpdc around skipped sts, sk 2 sts, fpdc around next 2 sts, working in back of 2 sts just made, fpdc around skipped sts (Fishbone begun). Hdc in next st, [sk 2 sts, fpdc around next 2 sts, working behind sts just made, fpdc around skipped sts, sk 2 sts, fpdc around next 2 sts, working in front of 2 sts just made, fpdc around skipped sts (Honeycomb begun)] twice. Hdc in next st, [sk next 2 sts, fpdc around next 2 sts, working in front of sts just made, fpdc around 2 skipped sts, fpdc around next 2 sts (1 BC begun)]. Hdc in turning ch. Turn.

Row 3 (WS): Ch 2. Sk 1st 2 sts, bpdc around next 2 sts, working behind sts just made, bpdc around 2 skipped sts, bpdc in next 2 sts (1 BC), hdc in next st, bpdc around next 16 sts (back of Honeycomb), hdc, bpdc around next 8 sts (back of Fishbone), hdc, bpdc around next 16 sts (Honeycomb), hdc, sk next 2 sts, bpdc around next 2 sts, working behind sts just made, bpdc around 2 skipped sts, bpdc in next 2 sts (1 BC), hdc in last st. Turn.

Row 4: Ch 2. Sk 1st 2 sts, fpdc around next 2 sts, working in front of sts just made, fpdc around 2 skipped sts, fpdc around next 2 sts (BC made), hdc in next st, [sk 2 sts, fpdc around next 2 sts, working in front of sts just made, fpdc around skipped sts, sk 2 sts, fpdc around next 2 sts, working in back of 2 sts just made, fpdc around skipped sts (Honeycomb made)] twice. Hdc in next st, sk next 2 sts, fpdc in next 2 sts, working in front of 2 sts just made, fpdc around skipped sts, sk 2 sts, fpdc around next 2 sts, working in back of 2 sts just made, fpdc around skipped sts (Fishbone made). Hdc in next st, [sk 2 sts, fpdc around next 2 sts, working in front of sts just made, fpdc around skipped sts, sk 2 sts, fpdc around next 2 sts, working in back of 2 sts just made, fpdc around skipped sts (Honeycomb made)] twice. Hdc in next st, [sk next 2 sts, fpdc around next 2 sts, working in front of sts just made, fpdc around 2 skipped sts, fpdc around next 2 sts (BC made)]. Hdc in last st. Turn.

Row 5: Rep Row 3.

Rows 6–45: Rep Rows 2–5 ten times more.

Row 46: Ch 2. [Sk 1st 2 sts, fpdc around next 2 sts, working in front of sts just made, fpdc around 2 skipped sts, fpdc around next 2 sts (BC made)], hdc in next st, [sk 2 sts, fpdc in next 2 sts, working in front of sts just made, fpdc in skipped sts (CW begun)] 4 times. Hdc in next st, sk next 2 sts, fpdc in next 2 sts, working in front of 2 sts just made, fpdc around skipped sts, sk 2 sts, fpdc around next 2 sts, working in back of 2 sts just made, fpdc around skipped sts (Fishbone begun). Hdc in next st, [sk 2 sts, fpdc in next 2 sts, working in front of sts just made, fpdc in skipped sts (CW begun)] 4 times. Hdc in next st, [sk next 2 sts, fpdc around next 2 sts, working in front of sts just made, fpdc around 2 skipped sts, fpdc around next 2 sts (BC made)]. Hdc in last st. Turn.

Row 47: Ch 2. Sk 1st 2 sts, bpdc around next 2 sts, working behind sts just made, bpdc around 2 skipped sts, bpdc in next 2 sts (BC made), hdc in next st. Bpdc in next 2 sts, [sk 2 sts, bpdc in next 2 sts, working behind sts just made, bpdc in 2 sts just skipped] 3 times, bpdc in next 2 sts (CW made), hdc in next st, bpdc around next 8 sts (back of Fishbone), hdc. Bpdc in next 2 sts, [sk 2 sts, bpdc in next 2 sts, working behind sts just made, bpdc in 2 sts just skipped] 3 times, bpdc in next 2 sts (CW made), hdc in next st, sk next 2 sts, bpdc around next 2 sts, working behind sts just made, bpdc around 2 skipped sts, bpdc in next 2 sts (BC made), hdc in last st. Turn.

Rows 48–78: Rep Rows 46 & 47 fifteen times, then Row 46 once more.

Row 79: Rep Row 3.

Row 80: Rep Rows 2–79.

Row 81–158: Rep Rows 2–45.

Last Row: Ch 2. Bpdc around each post st and hdc in each hdc across. Turn. Do not finish off.

Change to smaller hook.

EDGING

Ch 1. Sc in each st across. Ch 2, turn to work along long edge. Sc evenly along edge (work 3 sc for every 2 row ends for 303 sc). Ch 2, sc in each st along foundation row. Ch 2, turn to work along long edge. Sc evenly along edge (work 3 sc for every 2 row ends for 303 sc). Do not finish off.

RIBBING

Row 1: Ch 2 (counts as hdc). Work [fpdc around next st, bpdc around next st] across. Hdc in last st. Turn (303 sts).

Row 2: Ch 2. Work fpdc around fpdc and bpdc around bpdc. Hdc in last st. Turn.

Place st markers for buttonholes where desired on right side of band.

Row 3: Ch 2. Work fpdc around fpdc and bpdc around bpdc as in Row 2. When reaching sp for buttonhole, ch 1, sk 1 st and cont in established pattern. Hdc in last st. Turn.

Row 4: Ch 2. Work fpdc around fpdc and bpdc around bpdc. For each ch-1 sp (buttonhole), work 1 hdc in ch-1 sp, and cont in established pattern. Hdc in last st. Turn.

Row 5: Rep Row 2. Finish off.

BACK SECTION WITH RIBBING (OTHER SIDE)
Note: For the ribbing, always use the smaller hook. For the center pattern section, use the larger hook.

Row 1 (RS): Using smaller hook, and with RS facing, join with a sl st to upper right corner. Ch 2. Work [fpdc around next st, bpdc around next st] for the 1st 107 sts.

Change to larger hook to work the following center panel pattern:

*[Sk next 2 sts, fpdc around next 2 sts, working in front of sts just made, fpdc around 2 skipped sts, fpdc around next 2 sts, (BC begun)], hdc in next st. Sk next 2 sts, fpdc in next 2 sts, working in front of 2 sts just made, fpdc around skipped sts, sk 2 sts, fpdc around next 2 sts, working in back of 2 sts just made, fpdc around skipped sts (Fishbone begun), hdc in next st. [Sk next 2 sts, fpdc around next 2 sts, working in front of sts just made, fpdc around 2 skipped sts, fpdc around next 2 sts, (BC begun)]**, hdc in next st. [Sk 2 sts, fpdc in next 2 sts, working in front of sts just made, fpdc in skipped sts (CW begun)] 4 times, hdc in next st. Sk next 2 sts, fpdc in next 2 sts, working in front of 2 sts just made, fpdc around skipped sts, sk 2 sts, fpdc around next 2 sts, working in back of 2 sts just made, fpdc around skipped sts (Fishbone begun), hdc in next st. [Sk 2 sts, fpdc in next 2 sts, working in front of sts just made, fpdc in skipped sts (CW begun)] 4 times, hdc in next st. Rep instructions from * to ** one time.

Change back to smaller hook. Work [fpdc around next st, bpdc around next st] across to end. Turn.

Row 2 (WS): Ch 2. Work in established ribbing pattern across to center panel.

Change to larger hook to work the center panel pattern.

*Sk next 2 sts, bpdc around next 2 sts, working behind sts just made, bpdc around 2 skipped sts, bpdc in next 2 sts (BC made), hdc in next st, bpdc around next 8 sts, hdc in next st, sk next 2 sts, bpdc around next 2 sts, working behind sts just made, bpdc around 2 skipped sts, bpdc in next 2 sts (BC made)**, hdc in next st, bpdc around next 2 sts, [sk 2 sts, bpdc in next 2 sts, working in front of sts just

made, bpdc in 2 sts just skipped] 3 times, bpdc in next 2 sts, hdc in next st, bpdc in next 8 sts, hdc in next st, bpdc around next 2 sts, [sk 2 sts, bpdc in next 2 sts, working in front of sts just made, bpdc in 2 sts just skipped] 3 times, bpdc in next 2 sts, hdc in next st. Rep instructions from * to ** one time.

Change back to smaller hook. Work in established ribbing pattern across to end. Turn.

Rows 3–5: Rep Rows 1 & 2, then rep Row 1 once more. Finish off.

Row 6: With smaller hook and WS facing, join 13 ribbing sts to the right of the center pattern with a sl st. Ch 2 (counts as hdc), cont working ribbing over 12 sts. Cont center back pattern as in Row 2 above. For ribbing on left side of center pattern, work only 12 sts of ribbing, hdc in next st. Turn (114 sts).

Row 7: Ch 2. Sk 1st post st, work in ribbing pattern for the next 11 sts. Cont center back pattern as in Row 1. For ribbing left of center pattern, work 12 sts in established pattern, hdc in next st. Turn (113 sts).

The following rows cont the dec pattern. One st is dec at the beg of each row.

Rows 8–14: Ch 2. Sk 1st post st, work in ribbing pattern across to center panel. Cont center panel as established. Work in ribbing across to last st, hdc in last st. Turn (106 sts).

Rows 15–23: Ch 2. Work in ribbing pattern for 8 sts. Cont center back pattern as established. Work in ribbing pattern for 8 sts. Hdc in last st. Turn.

Row 24: Ch 2, work in ribbing pattern for 8 sts. Change to larger hook to work the center pattern.

*Sk 2 sts, bpdc around next 2 sts, working in back of sts just made bpdc around 2 skipped sts, bpdc around next 2 sts (BC made)**, hdc in next st, bpdc around next 8 sts, hdc in next st. Rep instructions from * to ** once, hdc in next st, bpdc around next 16 sts, hdc in next st, bpdc around next 8 sts, hdc in next st, bpdc around next 16 sts, hdc in next st, rep instructions from * to ** once, hdc in next st, bpdc around next 8 sts, hdc in next st. Rep instructions from * to ** once.

Change to smaller hook. Work in ribbing pattern for 8 sts. Hdc in last st. Turn.

Row 25: Ch 2. Work in ribbing pattern for 8 sts. Change to larger hook for center panel.

*[Sk next 2 sts, fpdc around next 2 sts, working in front of sts just made, fpdc around 2 skipped sts, fpdc around next 2 sts, (BC made)], hdc in next st. Sk next 2 sts, fpdc in next 2 sts, working in front of 2 sts just made, fpdc around skipped sts, sk 2 sts, fpdc around next 2 sts, working in back of 2 sts just made, fpdc around skipped sts (Fishbone made), hdc in next st.

[Sk next 2 sts, fpdc around next 2 sts, working in front of sts just made, fpdc around 2 skipped sts, fpdc around next 2 sts, (BC made)]**, hdc in next st. [sk 2 sts, fpdc in next 2 sts, working in back of sts just made, fpdc in skipped sts, sk 2 sts, fpdc in next 2 sts, working in front of sts just made, fpdc in 2 sts just skipped (Honeycomb begun)] twice, hdc in next st. Sk next 2 sts, fpdc in next 2 sts, working in front of 2 sts just made, fpdc around skipped sts, sk 2 sts, fpdc around next 2 sts, working in back of 2 sts just made, fpdc around skipped sts (Fishbone made), hdc in next st. [Sk 2 sts, fpdc in next 2 sts, working in back of sts just made, fpdc in skipped sts, sk 2 sts, fpdc in next 2 sts, working in front of sts just made, fpdc in 2 sts just skipped (Honeycomb begun)] twice, hdc in next st. Rep instructions from * to ** one time.

Change to smaller hook. Work in ribbing pattern for 8 sts. Hdc in last st. Turn.

Row 26: Rep Row 24.

Row 27: Ch 2. Work in ribbing pattern for 8 sts. Change to larger hook for center panel.

*[Sk next 2 sts, fpdc around next 2 sts, working in front of sts just made, fpdc around 2 skipped sts, fpdc around next 2 sts, (BC made)], hdc in next st. Sk next 2 sts, fpdc in next 2 sts, working in front of 2 sts just made, fpdc around skipped sts, sk 2 sts, fpdc around next 2 sts, working in back of 2 sts just made, fpdc around skipped sts (Fishbone made), hdc in next st. [Sk next 2 sts, fpdc around next 2 sts, working in front of sts just made, fpdc around 2 skipped sts, fpdc around next 2 sts, (BC made)]**, hdc in next st. [Sk 2 sts, fpdc in next 2 sts, working in front of sts just made, fpdc in skipped sts, sk 2 sts, fpdc in next 2 sts, working in back of sts just made, fpdc in 2 sts just skipped (Honeycomb made)] twice, hdc in next st. Sk next 2 sts, fpdc in next 2 sts, working in front of 2 sts just made, fpdc around skipped sts, sk 2 sts, fpdc around next 2 sts, working in back of 2 sts just made, fpdc around skipped sts (Fishbone made), hdc in next st. [Sk 2 sts, fpdc in next 2 sts, working in front of sts just made, fpdc in skipped sts, sk 2 sts, fpdc in next 2 sts, working in back of sts just made, fpdc in 2 sts just skipped (Honeycomb made)] twice, hdc in next st. Rep instructions from * to ** one time.

Change to smaller hook. Work in ribbing pattern for 8 sts. Hdc in last st. Turn.

Row 28: Rep Row 24.

Rows 29–47: Rep Rows 25–28 four times, then rep Rows 25– 27 once more.

Row 48: Ch 2. Work in ribbing pattern for 8 sts. Change to larger hook. Work bpdc around each st across to ribbing. Change to smaller hook and work ribbing pattern for 8 sts and hdc in last st. Turn.

Row 49: Using smaller hook for the entire row, Ch 2. Work ribbing pattern across row to last 8 sts. Work 1 hdc in sp between last fpdc and 1st st of ribbing pattern. (This will add one st to the row.) Work ribbing pattern for next 8 sts and hdc in last st. Turn.

Rows 50–53: Ch 2. Work ribbing pattern across row. Hdc in last st. Turn.

Finish off at the end of Row 53.

PINEAPPLE EDGING (FOR SHAWL ENDS)

Row 1: With larger hook and RS facing, join with a sl st to corner and work 71 sc evenly across. Turn (71 sc).

Row 2: Ch 3 (counts as 1st dc here and throughout). In 1st sc, work [dc, ch 2, 2 dc], *sk next 6 sts, work [dc, ch 2, dc] in next st, sk next 6 sts, work [2 dc, ch 2, 2 dc] in next st, rep from * across row. Turn (11 ch-2 sps).

Row 3: Change to smaller hook, turn, sl st in 1st 2 dc and in ch-2 sp. [Ch 3, dc, ch 2, 2 dc] in same ch-2 sp. *Ch 1, 6 dc in next ch-2 sp, ch 1, [2 dc, ch 2, 2 dc] in next ch-2 sp. Rep from * across. Turn (5 6-dc shells).

Row 4: Sl st in 1st 2 dc and in ch-2 sp. [Ch 3, dc, ch 2, 2 dc] in same ch-2 sp. *Ch 1 [dc in next dc, ch 1] 6 times, [2 dc, ch 2, 2 dc] in next ch-2 sp. Rep from * across. Turn (48 ch-1 sps).

Row 5: Sl st in 1st 2 dc and in ch-2 sp. [Ch 3, dc, ch 2, 2 dc] in same ch-2 sp. *Ch 1, sk next ch-1 sp, [sc in next ch-1 sp, ch 3] 4 times, sc in next ch-1 sp, ch 1, sk next ch-1 sp, [2 dc, ch 2, 2 dc, ch 2, 2 dc] in next ch-2 sp. Rep from * across. Turn (20 ch-3 sps). Finishing each Pineapple: Each Pineapple is finished individually.

Row 6: Sl st in 1st 2 dc and in ch-2 sp. [Ch 3, dc, ch 2, 2 dc] in same ch-2 sp. Ch 1, sk ch-1 sp, [sc in next ch-1 sp, ch 3] 3 times, sc in next ch-1 sp, ch 1, work [2 dc, ch 2, 2 dc] in next ch-2 sp. Turn (3 ch-3 sps).

Row 7: Sl st in 1st 2 dc and in ch-2 sp. [Ch 3, dc, ch 2, 2 dc] in same ch-2 sp. Ch 1, sk ch-1 sp, [sc in next ch-1 sp, ch 3] 2 times, sc in next ch-1 sp, ch 1, work [2 dc, ch 2, 2 dc] in last ch-2 sp. Turn (2 ch-3 sps).

Row 8: Sl st in 1st 2 dc and in ch-2 sp. [Ch 3, dc, ch 2, 2 dc] in same ch-2 sp. Ch 1, sk ch-1 sp, sc in next ch-1 sp, ch 3, sc in next ch-1 sp, ch 1, work [2 dc, ch 2, 2 dc] in last ch-2 sp. Turn (1 ch-3 sp).

Row 9: Sl st in 1st 2 dc and in ch-2 sp. [Ch 3, dc, ch 2, 2 dc] in same ch-2 sp. Ch 1, sk ch-1 sp, sc in next ch-1 sp, ch 1, sk next ch-1 sp, work [2 dc, ch 2, 2 dc] in last ch-2 sp. Turn.

Row 10: Sl st in 1st 2 dc and in ch-2 sp. Ch 3, [yo, pull up lp in same ch-2 sp, yo, pull through 2 lps, sk next 2 ch-1 sps, yo, pull up lp in next ch-2 sp, yo, pull through 2 lps, yo, pull through all 3 lps, dc in same ch-2 sp. Finish off.

Complete the rem 4 Pineapples by joining yarn with a sl st in the next ch-2 sp on Row 5 and rep Rows 6–10 above.

Reduced View of Pineapple Edging

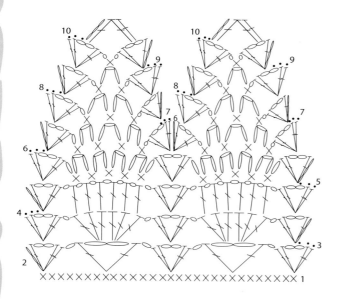

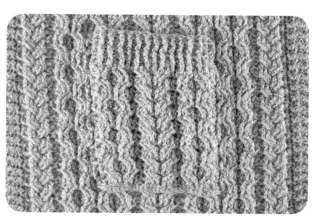

When attaching the pockets, be careful to center them on the fishbone motif. The instructions for the pockets are designed to match the direction of this pattern on each side of the stole.

POCKETS (OPTIONAL)

LEFT SIDE POCKET
With gauge hook, ch 32.

Row 1: Dc in 4th ch from hook and in each ch across. Turn (30 sts).

Row 2: Ch 2 (counts as hdc here and throughout). Hdc in 2nd dc, sk 2 sts, fpdc around next 2 sts, working behind 2 sts just completed, fpdc around 2 skipped sts. Sk 2 sts, fpdc around next 2 sts working in front of 2 sts just completed, fpdc around 2 skipped sts (Honeycomb begun). Hdc in next st, sk 2 sts, fpdc around next 2 sts, working in front of 2 sts just completed, fpdc around 2 skipped sts. Sk 2 sts, fpdc around next 2 sts, working behind 2 sts just completed, fpdc around 2 skipped sts (Fishbone begun). Hdc in next st, sk 2 sts, fpdc around next 2 sts, working behind 2 sts just completed, fpdc around 2 skipped sts. Sk 2 sts, fpdc around next 2 sts working in front of 2 sts just completed, fpdc around 2 skipped sts (Honeycomb begun). Hdc in last 2 sts. Turn.

Row 3: Ch 2. Hdc in next st, [bpdc around next 8 sts, hdc in next st] 3 times. Hdc in last st. Turn.

Row 4: Ch 2. Hdc in 2nd dc, *sk 2 sts, fpdc around next 2 sts, working in front 2 sts just completed, fpdc around 2 skipped sts. Sk 2 sts, fpdc around next 2 sts, working behind 2 sts just completed, fpdc around 2

skipped sts. Hdc in next st. Rep from * twice more. Hdc in last st. Turn.

Row 5: Rep Row 3.

Rows 6–17: Rep Rows 2–5 three more times.

RIBBING
Rows 1–5: Ch 2. Hdc in next st. Work [fpdc in next st, bpdc in next st] across, ending with a hdc in last 2 sts. Turn.

Finish off.

RIGHT SIDE POCKET
Work Rows 1–17 of Left Side Pocket. At end of Row 17, ch 1, turn and work sl st across row. Finish off.

Turn Right Pocket upside down with RS facing. Join yarn with a sl st to right corner. Work Ribbing Rows 1–5 of Left Pocket. Finish off.

FINISHING
Weave in ends.

Sew pockets in place, being careful to match the pattern of pocket with the pattern on the wrap.

Sew buttons in place.

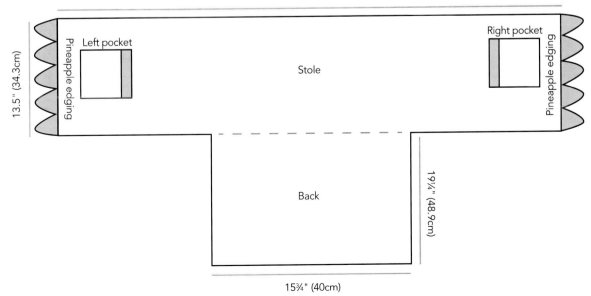

Doolin Delight Sweater Wrap Assembly Diagram

Baby Feet Baby Blanket

Celebrate a new life with this whimsical, textured baby blanket featuring baby's feet! Perfect for that new baby, whether a boy or girl. Enjoy crocheting these Aran stitches, trimmed with elegant, crochet eyelet lace.

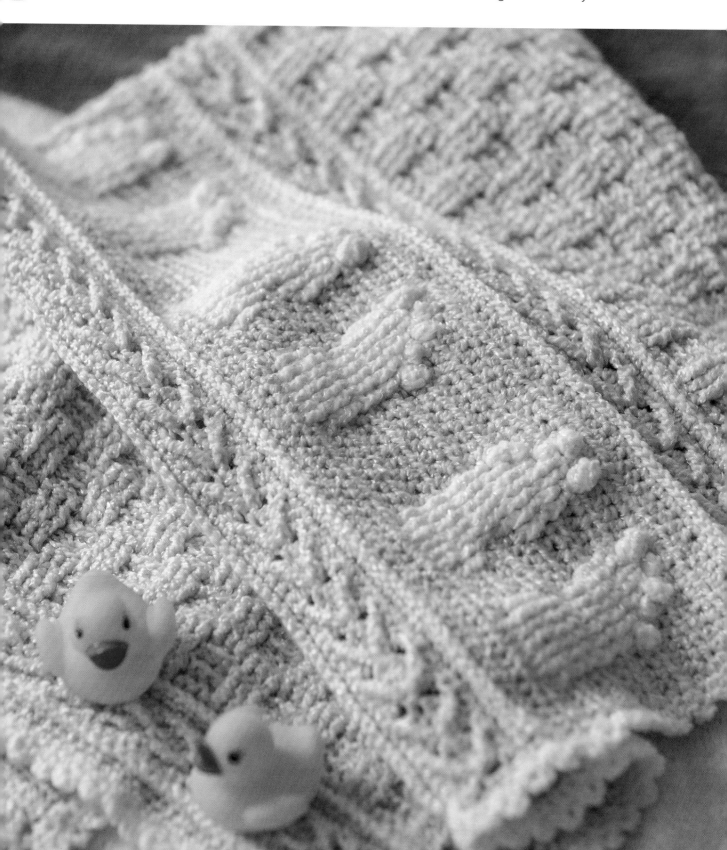

Skill Level

INTERMEDIATE

Materials

- H/8 (5mm) crochet hook
- G/6 (4mm) crochet hook or one hook size smaller than gauge hook
- E/4 (3.5mm) crochet hook or two hook sizes smaller than gauge hook
- For blanket (MC): 4 skeins DK (#3) weight yarn (project shown uses Bernat Baby Coordinates [388 yds/355m per 5 oz/140g skein] in color Iced Mint)
- For feet and trim (CC): 1 skein DK (#3) weight yarn (project shown uses Bernat Baby Coordinates [388 yds/355m per 5 oz/140g skein] in color White)

Finished Dimensions

26" × 31¼" (66cm × 79.3cm), excluding edging

Gauge

15 sts = 3½" (8.9cm) and 6 rows = 2" (5.1cm) in Basket Weave pattern

Special Stitches

Arrow, Basket Weave, Low Ridge Front (LRF)

Popcorn (pc): Pc stitches are worked differently on RS and WS rows.

On a WS row: Work 4 sc in same st. Remove hook and insert hook in the 1st sc of CL *from behind,* or from the WS of the st. (This will help the pc to puff out on the RS of the blanket.) Pull the lp through and ch 1.

On a RS row: Work 4 sc in same st. Remove hook and insert hook in the 1st sc of CL *from the front,* or from the RS of the st. (This will help the pc to puff out on the RS of the blanket.) Pull the lp through and ch 1.

Double Crochet Popcorn (dcpc): Work 4 fpdc around the same hdc post. Remove hook and insert hook in 1st dc just completed *from the front,* or from the RS of the st. Pull up lp and ch 1.

BOTTOM PANEL

With H hook and MC, ch 135.

Row 1 (RS): Sc in 2nd ch from hook and in each ch across. Turn (134 sc).

Row 2 (WS): Ch 1. Sc in each sc across. Turn.

Rows 3 & 4 form the LFR pattern.

Row 3: Ch 1. Working in flps only, sl st in 2nd sc and in each sc across. Sl st in turning ch. Turn.

Row 4: Ch 1. Working in rem lps of last sc row, sc in each sc across. Turn.

Rows 5 & 6 form the Arrow Row pattern.

Row 5: Ch 2 (does *not* count as 1st st here and throughout). Dc in 1st sc, *sk next 3 sc, tr in next sc. Working behind tr just made, dc in each of the 3 skipped sc. Rep from * across row. End by working dc in last 2 st. Turn.

Row 6: Ch 2. Dc in 1st 2 dc, *sk next 3 dc, tr in next tr. Working in front of tr just made, dc in each of 3 skipped dc. Rep from * across row. End by working dc in last dc. Turn.

Rows 7 & 8: Ch 1. Sc in each dc and tr across row. Turn.

Rows 9 & 10: Rep Rows 3 & 4.

Row 11: Ch 2. Hdc in 1st st, *work 1 fpdc around each of next 3 sts. Work 1 bpdc around each of next 3 sts. Rep from * across to last st. Hdc in last st. Turn.

Rows 12 & 13: Ch 2. Hdc in 1st st, *work 1 fpdc around each of next 3 fpdc. Work 1 bpdc around each of next 3 bpdc. Rep from * across to last st. Hdc in last st. Turn.

Rows 14–16: Ch 2. Hdc in 1st st, *work 1 bpdc around each of next 3 sts. Work 1 fpdc around each of next 3 sts. Rep from * across to last st. Hdc in last st. Turn.

Rows 17–31: Rep Rows 11–16 twice, then rep rows 11–13 one more time. You should have a total of 21 Basket Weave rows.

Row 32: Ch 1. Sc in each st across. Turn.

Rows 33 & 34: Rep Rows 3 & 4.

Rows 35 & 36: Rep Rows 5 & 6.

Rows 37 & 38: Rep Rows 3 & 4.

CENTER PANEL—BABY FEET

Switch to G hook.

Rows 1 & 2: Ch 2, hdc in each st across. Turn.

Note: For Rows 3–13, you will need to draw up the white (or color desired) for the feet when working the fpdc, bpdc, and the pc for the toes. This is best done by drawing up the yarn in the last step of the prev st. You can either carry the MC behind your work, or cut the yarn (leaving at least 3" [7.6cm]) to weave into your work later. Rejoin the MC in the same manner. "CC" will indicate the color for the feet, and "MC" for the main color.

Row 3 (RS): Ch 2. Hdc in 7 sts, *with CC, work fpdc over next 5 sts; with MC, hdc in next 6 sts; with CC, fpdc over next 5 sts, with MC, hdc in next 10 sts. Rep from * across row, ending last rep by working hdc in last 7 sts. Turn.

Row 4: Ch 2. Hdc in 6 sts; *with CC, bpdc over next 7 sts; with MC, hdc in next 4 sts; with CC, bpdc over next 7 sts; with MC, hdc in next 8 sts. Rep from * across row, ending last rep by working 1 hdc in last 6 sts. Turn.

Row 5: Ch 2. Hdc in 6 sts; *with CC, fpdc over next 7 sts; with MC, hdc in next 4 sts; with CC, fpdc over next 7 sts; with MC hdc in next 8 sts. Rep from * across row, ending last rep by working 1 hdc in last 6 sts. Turn.

Row 6: Ch 2. Hdc in 6 sts; *with CC, bpdc over next 6 sts; with MC, hdc in next 6 sts; with CC, bpdc over next 6 sts; with MC, hdc in next 8 sts. Rep from * across row, ending last rep by working hdc in last 6 sts. Turn.

Row 7: Ch 2. Hdc in 6 sts; with CC, fpdc over next 5 sts; with MC, hdc in next 8 sts; with CC, fpdc over next 5 sts; with MC, hdc in next 8 sts. Rep from * across row, ending last rep by working hdc in last 6 sts. Turn.

Row 8: Ch 2. Hdc in 6 sts; *with CC, bpdc over next 6 sts; with MC, hdc in next 6 sts; with CC, bpdc over next 6 sts; with MC, hdc in next 8 sts. Rep from * across row, ending last rep by working hdc in last 6 sts. Turn.

Row 9: Ch 2. Hdc in 6 sts; *with CC, fpdc over next 7 sts; with MC hdc in next 4 sts; with CC fpdc over next 7 sts; with MC hdc in next 8 sts. Rep from * across row, ending last rep by working 1 hdc in last 6 sts. Turn.

Row 10 (WS): Ch 2. Hdc in 6 sts; *with CC, pc in next st; bpdc over next 6 sts; with MC, hdc in next 4 sts; with CC, bpdc over next 6 sts; pc in next st; with MC, hdc in next 8 sts. Rep from * across row, ending last rep by working 1 hdc in last 6 sts. Turn.

Row 11 (RS): Ch 2. Hdc in 7 sts; *with CC, pc in next st; fpdc over next 5 sts; with MC, hdc in next 4 sts; with CC, fpdc over next 5 sts; pc in next st; with MC, hdc in next 10 sts. Rep from * across row, ending last rep by working hdc in last 7 sts. Turn.

Row 12: Ch 2. Hdc in 8 sts; *with CC, pc in next st; bpdc over next 2 sts; with MC, hdc in next 8 sts; with CC, bpdc over next 2 sts; pc in next st; with MC, hdc in next 12 sts. Rep from * across row, ending last rep by working 1 hdc in last 8 sts. Turn.

Row 13: Ch 2. Hdc in 9 sts; *with CC, pc in next st; with MC, hdc in next st; with CC, dcpc in next st; with MC, hdc in next 6 sts; with CC, dcpc in next hdc; with MC, hdc in next st; with CC, pc in next st; with MC hdc in next 14 sts. Rep from * across row, ending last rep by working 1 hdc in last 9 sts. Turn.

Finish off CC.

Rows 14 & 15: Ch 2. Work 1 hdc in each st across. Turn.

Row 16: Ch 1. Work 1 sc in each hdc across. Turn.

TOP PANEL

Switch to H hook

Rep Rows 3–38 of Left Panel. At end of Row 38, finish off.

EDGING

Rnd 1: With CC and with RS facing, join with a sl st to last row in upper right corner. Ch 1, *sc in each sc across row. At end of row ch 1, sc again in same sp (corner made). Sc evenly across edge of blanket. At corner, ch 1 and sc in same sp as last sc. Rep from * once around the perimeter of blanket. Connect with a sl st to 1st sc of rnd. *Do not turn.*

Switch to E hook.

Rnd 2: Ch 1. Sc in 1st st, *ch 3, then dc in same st. Sk next st, sc in next st. Rep from * around the edge of the blanket. Connect with a sl st to 1st sc of row. Finish off.

FINISHING

Weave in ends and block if needed.

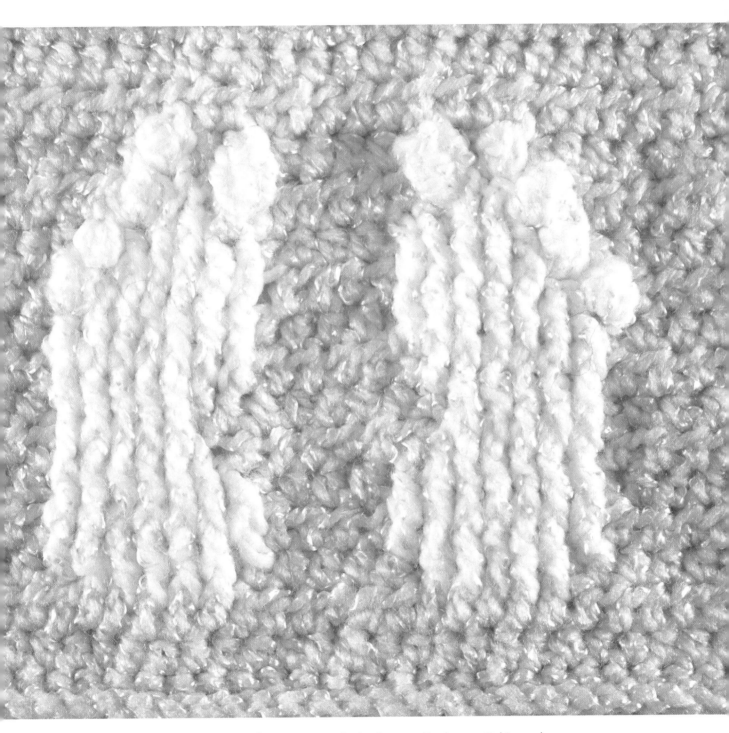

The Baby Feet motif has a raised texture, created using front and back post stitching and popcorns.

Kells Cabled Sweater

Crocheted from the bottom up, you'll love watching these lovely cables take shape. This sweater is named for the Book of Kells located at Trinity College in Dublin. This ancient book, illustrated by Celtic monks around 800 A.D. or earlier, is famous for the intricate swirling pictures interwoven with Celtic knots and Christian imagery. It is among Ireland's finest national treasures.

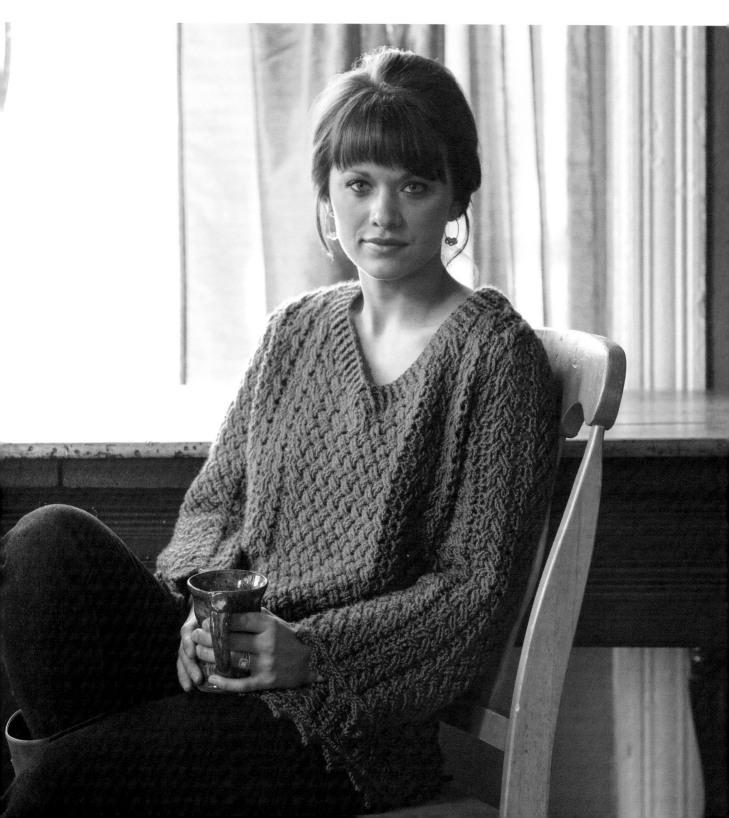

Skill Level

EXPERIENCED

Materials

G/6 (4mm) crochet hook
9 (10, 10, 11, 12) skeins of DK (#3) weight yarn
(project shown uses Caron Simply Soft Light
[330 yds/302m per 3 oz/85g skein] in color
#203 Capri)

Finished Dimensions

Instructions for these sizes are listed in order in parentheses S (M, L, XL, 2X). Be careful to read the correct numbers for the size you are making.

Finished Sizes:
Bust: 39 (42½, 46, 49½, 53)" (99 [108, 116.8, 125.7, 134.6]cm)
Length: 21¼ (21½, 24, 24½, 25¼)" (54 [54.6, 61, 62.2, 64.1]cm)

Gague

9 sts = 2" (5.1cm) and 5 rows = 2" (5.1cm) in dc

Special Stitches

Front post Braided Cable (fpBC) (worked on RS rows): Sk next 2 sts, fptr over next 2 sts, working in front of sts just made, fptr in 2 skipped sts, fptr in next 2 sts.

Back post Braided Cable (bpBC) (worked on WS rows): Sk next 2 sts, bptr over next 2 sts, working behind sts just made, bptr in 2 skipped sts, bptr in next 2 sts.

Front post Celtic Weave (fpCW) (worked on RS rows): *Sk 2 sts, fptr over next 2 sts, working in front of sts just made, fptr in 2 skipped sts. Rep from * across indicated number of sts.

Back post Celtic Weave (bpCW) (worked on WS rows): Bpdc in next 2 sts. *Sk 2 sts, bptr over next 2 sts, working behind sts just made, bptr in 2 skipped sts. Rep from * across indicated number of sts until 2 sts remain. Bpdc in last 2 sts of section.

FRONT OF SWEATER

Ch 88 (96, 104, 112, 120).

Row 1 (WS): Dc in 4th ch from hook and in each ch across. Turn (86 [94, 102, 110, 118] sts).

Row 2 (RS): Ch 3 (counts as 1st dc). FpBC over next 6 sts, dc in next st, fpCW over next 12 sts, dc in next st, [fpBC over next 6 sts, dc in next st] twice, fpCW over next 16 (24, 32, 40, 48) sts, dc in next st, [fpBC over next 6 sts, dc in next st] twice, fpCW over next 12 sts, dc in next st, fpBC over next 6 sts, dc in last dc. Turn.

Row 3: Ch 3. BpBC over next 6 sts, dc in next st, bpCW over next 12 sts, dc in next st, [bpBC over next 6 sts, dc in next st] twice, bpCW over next 16 (24, 32, 40, 48) sts, dc in next st, [bpBC over next 6 sts, dc in next st] twice, bpCW over next 12 sts, dc in next st, bpBC over next 6 sts, dc in last dc. Turn.

Rep Rows 2 & 3 until piece measures approx 14 (14, 16, 16, 16)" (35.6 [35.6, 40.6, 40.6, 40.6]cm) ending on a rep of Row 3.

BEGIN LEFT NECK AND SHOULDER SHAPING:

Row 1 (RS): With RS facing, sl st in 1st 6 sts, ch 3 (counts as 1st st on arm edge), dc in next st, fpCW over next 12 sts, [dc in next st, fpBC (over 6 sts)] twice, dc in next st, fpCW over next, – [8, 12, 16, 20] sts. Turn, do not work rem sts, 38 (42, 46, 50, 54) sts.

The decs in the next section may mean that you have to begin or end in the middle of a section of crossed sts. If that is the case, work bptr or fptr as appropriate on these edge sts.

Row 2: Ch 3 (ch 3 on neck edge does not count as a st). Sk the 1st 2 sts of the row, work in established pattern across the row to last 3 sts. End by working a dc, then a fptr, leaving last st unworked. Turn (35 [39, 43, 47, 51] sts).

Row 3: Ch 1. Sl st in 1st 2 sts. Ch 3, cont in pattern st to the last 2 sts. Do not work last 2 sts. Turn (31 [35, 39, 43, 47] sts).

Row 4: Ch 3. Sk 1st 2 sts, work in established pattern across the row to last 2 sts. Do not work last 2 sts. Turn (27 [31, 35, 39, 43] sts).

Row 5: Ch 1. Sl st in 1st 2 sts. Ch 3, cont in pattern to last 2 sts. Do not work last 2 sts. Turn (23 [27, 31, 35, 39] sts).

Row 6: Rep Row 4. (19 [23, 27, 31, 35] sts).

Row 7: Ch 1. Sl st in 1st 1 (1, 2, 2, 3) sts. Ch 3, cont in pattern to the last 2 sts. Do not work last 2 sts. Turn (16 [20, 23, 27, 30] sts).

Sizes XL and 2X only:

Rows – (–, –, 8, 8) & – (–, –, 9, 9): Rep Rows 4 & 5 (– [–, –, 19, 22] sts).

Sizes S, M, and L only:

Row 8 (8, 8, –, –) (Neck edge dec only): Ch 3. Sk 1st 2 sts, work in established pattern across row. Turn (14 [18, 21, –, –] sts).

Row 9 (9, 9, –, –): Ch 3. Work in pattern to last 2 sts of row. Do not work last 2 sts. Turn (12 [16, 19, –, –] sts).

All sizes cont here:

Row 10: Ch 3. Sk 1st 3 sts, work in established pattern across row. Turn (9 [13, 16, 16, 19] sts).

Row 11: Rep Row 9 (9, 9, 9, 5), (7 [11, 14, 14, 15] sts).

Sizes L, XL, and 2X only:

Row – (–, 12, 12, 12): Ch 3. Sk 1st 2 sts, work in established pattern across the row. Turn (– [–, 12, 12, 13] sts).

Row – (–, 13, 13, 13): Ch 3. Work in established pattern across row, leaving last st unworked. Turn (– [–, 11, 11, 12] sts).

All sizes:

Rows 12 (12, 14, 14, 14)–17 (18, 19, 20, 22): Ch 3. Work in pattern across row. Turn. Finish off.

RIGHT NECK AND SHOULDER SHAPING
With RS facing, join yarn to 1st unworked st of lower front (center neck edge).

Row 1: Ch 3 (on neck edge, ch does not count as a st), work in established pattern across row, leaving last 5 sts and turning ch unworked. Turn (38 [42, 46, 50, 54] sts).

Row 2: Ch 1. Sl st in 1st st. Ch 3, work in established pattern across to last 2 st. Do not work last 2 sts. Turn (35 [39, 43, 47, 51] sts).

Row 3: Ch 3. Sk the 1st 2 sts of the row, work in established pattern across to last 2 sts. Do not work last 2 sts. Turn (31 [35, 39, 43, 47] sts).

Row 4: Ch 1. Sl st in 1st 2 sts. Ch 3, work in established pattern across to last 2 sts. Do not work last 2 sts. Turn (27 [31, 35, 39, 43] sts).

Row 5: Ch 3. Sk the 1st 2 sts of the row, work in established pattern across to last 2 sts. Do not work last 2 sts. Turn (23 [27, 31, 35, 39] sts).

Row 6: Rep Row 4 (19 [23, 27, 31, 35] sts).

Row 7: Ch 3. Sk the 1st 2 sts of the row, work in established pattern across. Do not work in last 1 (1, 2, 2, 3) sts. Turn (16 [20, 23, 27, 30] sts).

Sizes XL and 2X only:

Rows – (–, –, 8, 8) & – (–, –, 9, 9): Rep Rows 4 & 5 (– [–, –, 19, 22] sts).

Sizes S, M, and L only:

Row 8 (8, 8, –, –) (Neck edge dec only): Ch 3. Work in pattern st to the last 2 sts. Leave last 2 sts unworked. Turn (14 [18, 21, –, –] sts).

Row 9 (9, 9, –, –): Ch 3. Sk the 1st 2 sts of the row, work in established pattern across row. Turn (12 [16, 19, –, –] sts).

All sizes cont here:

Row 10: Ch 3. Work in established pattern across row. Do not work last 3 sts. Turn (9 [13, 16, 16, 19] sts).

Row 11: Rep Row 9 (9, 9, 9, 5), (7 [11, 14, 14, 15] sts).

Sizes L, XL, and 2X only:

Row – (–, 12, 12, 12): Ch 3. Work in established pattern across row. Do not work last st. Turn (– [–, 12, 12, 13] sts).

Row – (–, 13, 13, 13): Ch 3. Sk 1st st. Work in established pattern across row. Turn (– [–, 11, 11, 12] sts).

All sizes:

Rows 12 (12, 14, 14, 14)–17 (18, 19, 20, 22): Ch 3. Work in pattern across row. Turn.

Finish off.

BACK OF SWEATER
Work Rows 1–3 of Sweater Front. Rep Rows 2 & 3 until piece measures approx 14 (14, 16, 16, 16)" (35.6 [35.6, 40.6, 40.6, 40.6]cm) ending on a rep of Row 3.

ARMHOLE SHAPING
Row 1 (RS): With RS facing, sl st in 1st 6 sts, ch 3 (counts as 1st st on arm edge), dc in next 2 sts, fpCW over next 12 sts, cont to work in established pattern st across to last 6 sts. Do not work in last 6 sts. Turn (76 [84, 92, 100, 108] sts).

Row 2: Ch 1. Sl st in 1st st. Ch 3. Work in established pattern across the row to last st. Leave last st unworked. Turn (74 [82, 90, 98, 106] sts).

Row 3–6: Ch 1. Sl st in 1st 2 sts. Ch 3, cont in pattern to the last 2 sts. Do not work last 2 sts. Turn (58 [66, 74, 82, 90] sts).

Row 7: Ch 1. Sl st in 1st 1 (1, 2, 2, 3) sts. Ch 3, cont in pattern to the last 1 (1, 2, 2, 3) sts. Do not work last 1 (1, 2, 2, 3) sts. Turn (56 [64, 70, 78, 84] sts).

Sizes XL and 2X only:

Rows – (–, –, 8, 8) & – (–, –, 9, 9): Rep Rows 4 & 5 (– [–, –, 70, 76] sts).

All sizes continue here:

Row 8 (8, 8, 10, 10): Ch 3. Work in established pattern across row. Turn (56 [64, 70, 70, 76] sts).

Size 2X only: Rep Row 9 (– [–, –, –, 72] sts).

All sizes:

Rows 9 (9, 9, 11, 12)–17 (18, 19, 20, 22): Ch 3. Work in pattern across row. Turn. Finish off.

SLEEVES (MAKE 2)
Ch 50 (50, 58, 58, 58).

Row 1 (WS): Dc in 4th ch from hook and in each ch across. Turn. (48 [48, 56, 56, 56] dc).

Row 2 (RS): Ch 3 (counts as 1st dc). Dc in next dc, fpCW over the next 8 (8, 12, 12, 12) sts, dc in next st, fpBC over 6 sts, dc in next st, fpCW over the next 12 sts, dc in next st, fpBC over 6 sts, dc in next st, fpCW over the next 8 (8, 12, 12, 12) sts, dc in last 2 sts. Turn.

Row 3: Ch 3. Dc in next dc, bpCW over the next 8 (8, 12, 12, 12) sts, dc in next st, bpBC over 6 sts, dc in next st, bpCW over the next 12 sts, dc in next st, bpBC over 6 sts, dc in next st, bpCW over the next 8 (8, 12, 12, 12) sts, dc in last 2 sts. Turn.

Rows 4–19 (11, 19, 17, 9): Ch 3, work in established pattern across. Turn.

Row 20 (12, 20, 18, 10) (inc row): Ch 3, dc in 1st st. Dc in 2nd dc, work in established pattern across to last st, 2 dc in last dc. Turn (50 [50, 58, 58, 58] sts).

Row 21 (13, 21, 19, 11): Ch 3. Work in established pattern across. Turn.

Rep Row 21 (13, 21, 19, 11) an additional 2 (2, 2, 0, 0) times.

Row 24 (16, 24, 20, 12): Ch 3, dc in 1st st. Dc in 2nd dc, work in established pattern across to last st, 2 dc in last dc. Turn (50 [50, 58, 58, 58] sts).

Rep Rows 21 (13, 21, 19, 11)–24 (16, 24, 20, 12) an additional 2 (4, 2, 6, 10) times.

Rows 33–34 (34, 34, 34, 36): Ch 3. Work in established pattern across. Turn.

Row 35 (35, 35, 35, 37): Ch 1. Sl st in 6 dc, ch 3, work in established pattern across to last 6 sts. Leave last 6 sts unworked. Turn (44 [48, 52, 60, 68] sts).

Rows 36 (36, 36, 36, 38)–44 (44, 44, 44, 46): Ch 1. Sl st in 1st 2 sts, ch 3, work in established pattern across row to last 2 sts. Leave last 2 sts unworked. Turn (12 [16, 20, 28, 36] sts).

Finish off.

FINISHING
Sew shoulder seams. Sew sleeves to body. Sew sleeve and side seams.

NECK FINISHING
Rnd 1: With garment RS out, join with a sl st where upper right neck section joins the back section. Ch 3, dc evenly around neck, working an even number of sts. Join with a sl st.

Rnd 2: Ch 3. [Fpdc around next st, bpdc around next st] to center front. Sk 2 sts in center (to help form V-neck), cont [fpdc around next st, bpdc around neck st] around. Join with a sl st.

Rnds 3–5: Rep Rnd 2, being sure to work each fpdc over fpdc and bpdc over bpdc. Finish off.

TRIM FOR BOTTOM OF SWEATER AND EDGE OF SLEEVES
Row 1: With RS facing, join with a sl st near seam. Sc in each st along foundation ch around, working dec as necessary to pick up a multiple of 6 sts. Join with a sl st.

Row 2: Ch 1. *Sk 2 sc, work [4 dc, ch 3, sl st in 1st ch, 4 dc] in next st. Sk 2 sts, sc in next st. Rep from * around. Join with a sl st.

Weave in ends and block lightly if needed.

Kells Cabled Sweater Diagrams

1½ (2½, 2½, 2½, 2¾)"
3.8 (6.4, 6.4, 6.4, 7)cm

Front

19½ (21¼, 23, 24¾, 26½)"
49.5 (54, 58.4, 62.9, 67.3)cm

12½ (14¼, 15½, 15½, 16)"
31.8 (36.2, 39.4, 39.4, 40.6)cm

21¼ (21½, 24, 24½, 25¼)"
54 (54.6, 61, 62.2, 64.1)cm

Back

7¼ (7½, 8, 8½, 9¼)"
18.4 (19.1, 20.3, 21.6, 23.5)cm

14 (14, 16, 16, 16)"
35.6 (35.6, 40.6, 40.6, 40.6)cm

2¾ (3½, 4½, 6¼, 8)"
7 (8.9, 11.4, 15.9, 20.3)cm

4 (4, 4, 4, 4)"
10.2 (10.2, 10.2, 10.2, 10.2)cm

17½ (17½, 17½, 17½, 18½)"
44.5 (44.5, 44.5, 44.5, 47)cm

Sleeve

13½ (13½, 13½, 13½, 14½)"
34.5 (34.5, 34.5, 34.5, 37)cm

12½ (13¼, 14¼, 16, 17¾)"
31.8 (33.7, 36.2, 40.6, 45.1)cm

10¾ (10¾, 12½, 12½, 12½)"
27.3 (27.3, 31.8, 31.8, 31.8)cm

Celtic Cross Afghan & Pillow

This throw-sized afghan and pillow use various stitches to frame a cross design of Cable and Knurl stitches, giving it a three-dimensional effect that adds texture and visual interest.

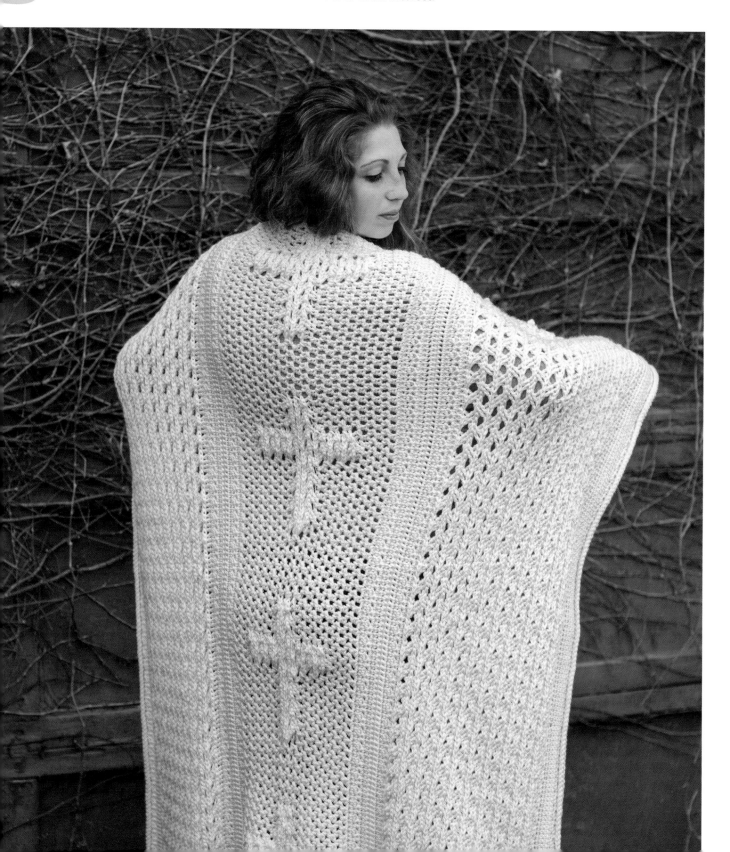

Skill Level

INTERMEDIATE

Materials

Afghan:

J/10 (6mm) crochet hook

K/10½ (6.5mm) crochet hook or one hook size larger than gauge hook

13 skeins of Worsted (#4) weight yarn (project shown uses Red Heart Soft [256 yds/234m per 5 oz/141g skein] in color #4601 Off White)

Pillow:

J/10 (6mm) crochet hook

K/10.5 (6.5mm) crochet hook or one hook size larger than gauge hook

3 skeins of Worsted (#4) weight yarn (project shown uses Red Heart Soft [256 yds/234m per 5 oz/141g skein] in color #4601 Off White)

12" × 16" (30.5cm × 40.6cm) pillow form

Finished Dimensions

Afghan: 58" × 49" (147.3cm × 124.5cm)

Pillow: 11¼" × 16" (28.6cm × 40.6cm), stretches to accommodate a 12" × 16" (30.5cm × 40.6cm) pillow form

Gauge

9 Woven sts = 5" (12.7cm) and 5 rows = 2" (5.1cm) in Woven st

Special Stitches

Low Front Ridge, Cable, Knurl, Celtic Weave

Woven st: Yo, insert hook into indicated st, pull up a lp, pull hook through 1 lp on hook, yo, pull through both lps on hook (1st half complete). Yo, insert hook into same st, pull up a lp, pull through both lps on hook (2nd half and Woven st completed).

Treble cluster (tr cl): *Yo twice, insert hook into indicated st, pull up a lp, [yo, pull through 2 lps] twice, rep from * 2 more times, yo, pull through all 4 lps on hook.

Picot: Ch 3, sl st in 3rd ch from the hook.

Cable and Knurl stitches framed by the Low Front Ridge give this Celtic Cross Afghan and Pillow a beautiful, three-dimensional texture that will look lovely in any room.

AFGHAN

LEFT PANEL

Using smaller hook, ch 177.

Row 1 (WS): Sc in 2nd ch from hook and in each ch across row. Turn (176 sts).

Rows 2 & 3 form the LFR pattern.

Row 2 (RS): Ch 1. Working in flps only, sl st in 2nd sc and in each sc across. Sl st in turning ch. Turn.

Row 3: Ch 1. Working in rem lps of last sc row, sc in each sc across. Turn.

Rows 4 & 5 form the Cable pattern. On Row 4, you will turn the work each time a Cable is made.

Row 4: Ch 1. Sc in 1st st, *ch 3, sk 2 sc, sc in next sc. Turn and work 1 sc in each ch of ch-3 just made. Join to next sc with a sl st (Cable made). Turn and, working behind the Cable, 1 sc in each Row 3 sc that was skipped, sk the sc that was made after the ch 3. Rep from * across to last st. End by working sc in last st. Turn (58 Cables).

Note: In the next row, you will work a sc in the 1st and last st, and 3 sc evenly spaced behind each Cable (on WS). The 3 sc behind each Cable are worked into the sc that were worked into the 2 skipped sc. Work 1 sc in 1 of these skipped sc and 2 sc into the other. Do not work into the sc of the Cables. Push the Cables toward the RS as you work.

Row 5: Ch 1. Sc in 1st 2 sc, *2 sc in next sc, sc in next sc; rep from * across to last sc, sc in last sc. Turn.

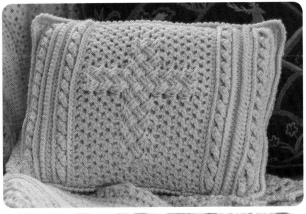

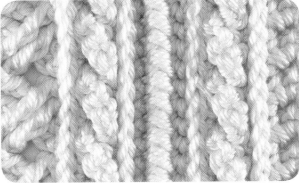

Rows 6 & 7: Rep Rows 2 & 3 to form LFR pattern.

Row 8: Ch 1. Sc in each sc across. Do *not* turn.

Row 9 forms the Knurl pattern and is worked from left to right with the RS facing.

Row 9: Ch 1. Working in the flps only of the prev sc row, *insert hook in sc to the right of hook. Hook yarn and pull through under and to the left of the lp on hook. Yo and draw yarn through both lps on hook. (1 knurl completed.) Rep from * across row. End by working a sl st in last sc of row. Do *not* turn.

Row 10 (RS): Ch 1. Working in the rem blp of Row 8, and from right to left, sc in 1st sc and in each sc across. Turn.

Row 11: Ch 1. Sc in each sc across. Turn.

Rows 12–17: Rep Rows 2–7.

Rows 18 & 19 form the CW pattern.

Row 18: Ch 2 (does *not* count as 1st st here and throughout). Dc in 1st 2 sts, *sk next 2 sts, fptr around post of next 2 sts, working in front of sts just made fptr around each of skipped sts. Rep from * across row to last 2 sts. End by working 1 dc in the last 2 sts. Turn.

Row 19: Ch 2. Dc in the 1st 2 dc. Work a bptr around each of the next 2 tr, *sk next 2 tr, work a bptr around the next 2 tr, working in back of the 2 bptr just made, work a bptr around the 2 skipped sts (CW completed). Rep from * across row to last 4 sts. End by working 2 bptr around last 2 tr, and dc in last 2 dc. Turn.

Rows 20–38: Rep Rows 18 & 19 nine times more. Rep Row 18 once more.

Row 39: Ch 2. Dc in 1st 2 dc, bpdc across row to last 2 sts. Dc in last 2 sts. Turn.

Rows 40–55: Rep Rows 2–17.

CENTER PANEL

Row 56: Ch 2. Sk the 1st st, work a Woven st in the next st, [sk next st, Woven st in next st] across. Turn (88 Woven sts).

Rows 57–59: Ch 2. Woven st in the sp between the 1st and 2nd Woven st. Woven st in the sp between each Woven st across, ending with a Woven st in turning ch. Turn.

Note: For the Cross section, you will need to change to the larger hook when crocheting the dc that form the cross. All of the Woven sts will be crocheted with the smaller size hook. Be careful to switch between the 2 hooks as directed. This will prevent the dc section from being too tight, which will allow the throw to lie flat and not buckle.

Row 60 (Beg Cross): Ch 2. Woven st over 1st 8 sps. *[Sk next Woven st, dc in both 1st and 2nd half of next Woven st, working in front of dc just made, dc in both 1st and 2nd half of skipped Woven st] twice. Sk next sp, Woven st in next 17 sps. Rep from * across row. End last rep with 12 Woven sts and 1 Woven st in turning ch. Turn (32 dc, 72 Woven sts).

Row 61: Ch 2. Woven st over 1st 13 sps. *Bpdc around each of next 2 dc, sk next 2 dc, bpdc around next 2 dc, working in back of sts just made, 2 bpdc in skipped dc, bpdc around next 2 dc, sk next sp, Woven st in next 17 sps. Rep from * across row. End last rep with 7 Woven sts and one Woven st in turning ch. Turn.

Row 62: Ch 2. Woven st over 1st 8 sps. *[Sk next 2 dc, dc in next 2 dc, working in front of dc just made, dc in both skipped dc] twice. Sk next sp, Woven st in next 17 sps. Rep from * across row. End last rep with 12 Woven sts and 1 Woven st in turning ch. Turn.

Rows 63–65: Rep Rows 61 & 62. Rep Row 61 once more.

Row 66: Ch 2. Woven st over 1st 4 sps, *[sk next Woven st, dc in both 1st and 2nd half of next Woven st, working in front of dc just made, dc in both 1st and 2nd half of skipped Woven st] twice. [Sk next 2 dc, fpdc in next 2 dc, working in front of dc just made, fpdc in both skipped dc] twice. [Sk next Woven st, dc

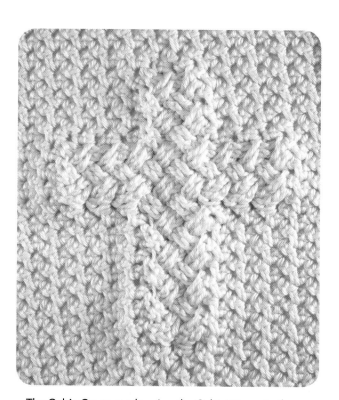

The Celtic Cross, made using the Celtic Weave in the central motif of this throw, crocheted vertically within rows of the Woven stitch.

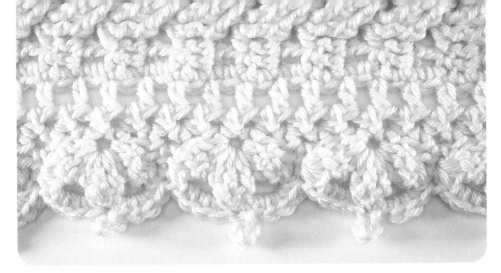

The edging for the ends of this afghan use treble clusters, chains and picots to produce a crown-like trim to complement the Celtic Cross.

in both 1st and 2nd half of next Woven st, working in front of dc just made, dc in both 1st and 2nd half of skipped Woven st] 4 times. Sk next sp, Woven st in next 5 sps. Rep from * across row. End last rep by working last Woven st in turning ch. Turn (128 dc, 24 Woven sts).

Row 67: Ch 2. Woven st over 1st 5 sps, *bpdc around next 2 dc, [sk next 2 dc, bpdc around next 2 dc, working in back of sts just made, bpdc around 2 skipped dc] 7 times, bpdc around next 2 dc, sk next sp, Woven st over next 5 sps. Rep from * across row. End last rep by working 3 Woven sts and last Woven st in turning ch. Turn.

Row 68: Ch 2. Woven st over 1st 4 sps, *[sk next 2 dc, fpdc in next 2 dc, working in front of dc just made, fpdc in both skipped dc] 8 times. Sk next sp, Woven st in next 5 sps. Rep from * across row. End last rep by working last Woven st in turning ch. Turn.

Row 69: Rep Row 67.

Row 70: Ch 2. Woven st over 1st 4 sps, *[sk next dc, Woven st in next dc] 4 times, [sk next 2 dc, fpdc in next 2 dc, working in front of dc just made, fpdc in both skipped dc] twice, [sk next dc, Woven st in next dc] 8 times, sk next sp, Woven st over next 5 sps, rep from * across row. Turn (32 dc, 72 Woven sts).

Row 71: Ch 2. Woven st over 1st 13 sps. *Bpdc around each of next 2 dc, sk next 2 dc, bpdc around next 2 dc, working in back of sts just made, 2 bpdc in skipped dc, bpdc around next 2 dc, sk next sp, Woven st in next 17 sps. Rep from * across row. End last rep with 7 Woven sts and 1 Woven st in turning ch. Turn.

Rows 72–75: Rep Rows 62 & 63 twice.

Row 76: Ch 2. Woven st over 1st 8 sps, *[sk next dc, Woven st in next dc] 4 times, sk next sp, Woven st over next 17 sps, rep from * across row. End last rep by working Woven st in last 12 sps and 1 Woven st in

turning ch. Turn (88 Woven sts).

Rows 77–80: Ch 2. Work Woven st across row. Turn.

Row 81: Ch 1. Work 2 sc in each sp across row and in turning ch. Turn (176 sc).

RIGHT PANEL
Rows 82–135: Rep Rows 2–55 of Left Panel. Do not finish off, but work edging.

EDGING
Rnd 1: *Ch 2, turn 90°, and with RS facing, work 152 sc evenly across row edges. Ch 2, turn 90°, sl st across row. Rep from * once more around perimeter of throw. Join with a sl st to ch-2 corner. Finish off.

BOTTOM EDGING
Row 1: With RS facing, join with a sl st to bottom edge. Ch 4 (counts as dc + ch 1), *sk 1 st, dc in next st, ch 1, rep from * across row. Work last dc in corner ch-2 sp. Turn (88 ch-1 sps).

Row 2: Ch 2. Woven st in each ch-1 sp across. Turn.

Row 3: Ch 2. Woven st in each sp between Woven sts across and in turning ch. Turn.

Row 4: Ch 1. *Sk next sp, in next sp work [tr CL, ch 3, tr CL, ch 3, tr CL], sk next sp, sc in next sp. Rep from * across. End by skipping 2 Woven sts and working last sc in ch-2 corner sp. Turn (44 ch-3 sps).

Row 5: Ch 2. *Sk next tr CL, 4 sc in ch-3 sp, [sc, picot] in tr CL, 4 sc in next ch-3 sp, sk next tr CL, sc in next sc. Rep from * across, ending with a sl st in last st. Finish off.

Repeat Bottom Edging on top edge.

FINISHING
Weave in ends and block lightly if needed.

PILLOW

FRONT OF PILLOW

Ch 42.

Row 1 (WS): Sc in 2nd ch from hook and in each ch across. Turn (41 sts).

Rows 2 & 3 form the LFR pattern.

Row 2 (RS): Ch 1. Working in flps only, sl st in 2nd sc and in each sc across. Sl st in turning ch. Turn.

Row 3: Ch 1. Working in rem lps of last sc row, sc in each sc across. Turn.

Rows 4 & 5 form the Cable pattern. On Row 4, you will turn the work each time a Cable is made.

Row 4: Ch 1. Sc in 1st st, *ch 3, sk 2 sc, sc in next sc. Turn and work 1 sc in each ch of ch-3 just made. Join to next sc with a sl st (Cable made). Turn and, working behind the Cable, 1 sc in each Row 3 sc that was skipped, sk the sc that was made after the ch 3. Rep from * across to last st. End by working sc in last st. Turn (13 Cables).

Note: In the next row, you will work a sc in the 1st and last st, and 3 sc evenly spaced behind each Cable (on WS). The 3 sc behind each Cable are worked into the sc that were worked into the 2 skipped sc. Work 1 sc in one of these skipped sc and 2 sc into the other. Do not work into the sc of the Cables. Push the Cables towards the RS as you work.

Row 5: Ch 1. Sc in 1st sc, *2 sc in next sc, sc in next sc; rep from * across to last sc, sc in last sc. Turn.

Rows 6 & 7: Rep Rows 2 & 3 to form LFR pattern.

Row 8: Ch 1. Sc in each sc across. Do not turn.

Row 9 forms the Knurl pattern and is worked from left to right with the RS facing.

Row 9: Ch 1. Working in the flps only of the prev sc row, *insert hook in sc to the right of hook. Hook yarn and pull through and to the left of the lp on hook. Yo and draw yarn through both lps on hook (1 knurl completed.) Rep from * across row. End by working a sl st in last sc of row. Do not turn.

Row 10 (RS): Ch 1. Working in the rem blps of Row 8, and from right to left, sc in 1st sc and in each sc across. Turn.

Row 11: Ch 1. Sc in each sc across. Turn.

Rows 12–17: Rep Rows 2–7.

Row 18: Ch 2 (counts as hdc). Work a Woven st in the next st, [sk next st, Woven st in next st] across to last st. Hdc in last st. Turn (20 Woven sts).

Row 19: Ch 2. Woven st in the sp between the 1st and 2nd Woven st. Woven st in the sp between each Woven st across, ending with a Woven st in sp before hdc, hdc in last hdc. Turn.

Note: For Rows 20–39, change to larger hook when working the dc that form the cross. Change back to the smaller hook to work the Woven sts.

Row 20 (Beg Cross): Ch 2. Woven st over 1st 7 sps, [sk next Woven st, dc in both 1st and 2nd half of next Woven st, working in front of dc just made, dc in both 1st and 2nd half of skipped Woven st] twice, sk next sp, Woven st in the next 9 sps between sts, hdc in turning ch. Turn.

Row 21: Ch 2. Woven st over 1st 9 sps. Bpdc around each of next 2 dc, sk next 2 dc, bpdc around next 2 dc, working in back of sts just made, 2 bpdc in skipped dc, bpdc around next 2 dc, sk next sp, Woven st in next 7 sps. Hdc in turning ch. Turn.

Row 22: Ch 2. Woven st over 1st 7 sps, [sk next 2 dc, fpdc in next 2 dc, working in front of dc just made, fpdc in skipped dc] twice, sk next sp, Woven st in the next 9 sps between sts, hdc in turning ch. Turn.

Rows 23–27: Rep Rows 21 & 22 twice. Then rep Row 21 once more.

Row 28: Ch 2. Woven st over 1st 3 sps, [sk next Woven st, dc in both 1st and 2nd half of next Woven st, working in front of dc just made, dc in both 1st and 2nd half of skipped Woven st] twice, [sk next 2 dc, fpdc around next 2 dc, working in front of dc just made fpdc around 2 skipped dc] twice, [sk next Woven st, dc in both 1st and 2nd half of next Woven st, working in front of dc just made, dc in both 1st and 2nd half of skipped Woven st] 4 times; sk next sp, Woven st in next sp, hdc in turning ch. Turn (32 dc, 4 Woven sts).

Row 29: Ch 2. Woven st in 1st sp, bpdc around each of next 2 dc, (sk next 2 dc, bpdc around next 2 dc, working in back of sts just made, 2 bpdc in skipped dc) 7 times, bpdc around next 2 dc, sk next sp, Woven st in last 3 sps, hdc in turning ch. Turn.

Row 30: Ch 2. Woven st over 1st 3 sps, [sk next 2 dc, fpdc around next 2 dc, working in front of dc just made fpdc around 2 skipped dc] 8 times, sk next sp, Woven st in next sp, hdc in turning ch. Turn.

Row 31: Rep Row 29.

Row 32: Ch 2. Woven st over 1st 3 sps. [Sk next dc, Woven st in next dc] 4 times, [sk next 2 dc, fpdc around next 2 dc, working in front of dc just made fpdc around 2 skipped dc] 2 times, [sk next dc, Woven st in next dc] 8 times; Woven st in last sp, hdc in turning ch. Turn.

Row 33: Rep Row 21.

Row 34: Rep Row 22.

Rows 35–37: Rep Rows 33 & 34. Then rep Row 33 once more.

Row 38: Ch 2. Woven st in 1st 7 sps, [sk next dc, Woven st in next dc] 4 times, Woven st in last 9 sps, hdc in turning ch. Turn.

Row 39: Ch 1. Sc in hdc, 2 sc in sp between each Woven st across, 2 sc in turning ch. Turn (41 sc).

Rows 40–55: Rep Rows 2–17.

EDGING
Rnd 1: *Sc in each sc across (41 sc), ch 2, turn 90°, work 45 sc evenly along edge, ch 2, turn 90°, rep from * once more. Join with a sl st to 1st sc. Finish off.

BACK PANELS (MAKE 2)
Ch 41.

Row 1: Sc in 2nd ch and in each ch across. Turn (40 sc).

Row 2: Ch 2. [Sk next sc, Woven st in next sc] across row (20 Woven sts).

Rows 3–25: Ch 2. Woven st in the sp between the 1st and 2nd Woven st. Woven st in the sps between each Woven st across, ending with a Woven st in turning ch. Turn.

Row 26: Ch 1, turn. Work 2 sc in each sp between Woven sts and in ch-2 sp. Do not turn.

EDGING
Ch 1, turn 90°, work 26 sc evenly along edge (1 sc per row end), ch 1, turn 90°, sc in each st across, ch 1, turn 90°, work 26 sc evenly along edge. Join with a sl st to 1st sc. Finish off.

Row to join front to back pieces:

Note: Pieces will be joined with the RS facing out. Overlap back pieces and line up evenly, (st by st using pins or st markers) lining up sts of the front pieces to those of the back sections. The back pieces will overlap in the center. (Three layers to line up in this section for the opening to remove pillow, allowing for easier cleaning of cover after completing.)

Rnd 1: Join with a sl st and sc around, being careful to work 2 sc in each corner. Join with a sl st to 1st sc of row.

Rnd 2: Ch 1. Working from left to right and working through *both* loops, work knurl around pillow. Join with a sl st to 1st st. Finish off.

FINISHING
Weave in ends. Insert pillow form.

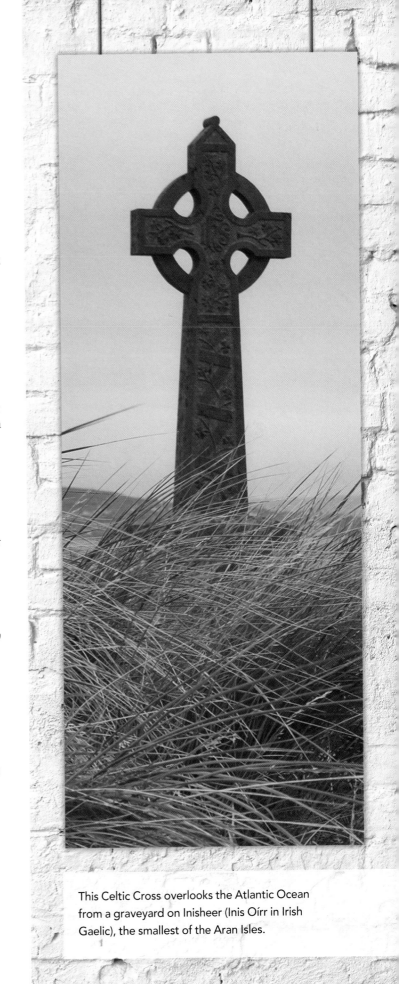

This Celtic Cross overlooks the Atlantic Ocean from a graveyard on Inisheer (Inis Oírr in Irish Gaelic), the smallest of the Aran Isles.

RESOURCES

I want to thank the yarn companies that generously provided yarn to me for this book. Getting boxes of fiber delivered to my doorstep was like having Christmas all year long! I especially want to thank Bobbie Matela and Terri Geck of Red Heart Yarn, Martha Wissing with Berroco Yarn, Jo Ann Walus with Cestari Yarns, Sarah Smuland with Blue Sky Alpaca Yarns and Susie with Knitting Fever Yarns (Phoenix). An extra special thanks to Diane Irvine for the most amazing fused-glass buttons I have ever seen or had the pleasure of adding to my designs.

Berroco, Inc.
1 Tupperware Dr., Suite 4,
N. Smithfield, RI 02896-6815
401-769-1212
www.berroco.com

Blue Sky Alpacas, Inc.
P.O. Box 88
Cedar, MN 55011
763-753-5815
888-460-8862
www.blueskyalpacas.com

Caron
320 Livingstone Avenue South
Box 40
Listowel, ON
Canada N4W3H3
1-800-811-2325
www.caron.com

Cestari Sheep and Wool Company
3581 Churchville Avenue
Churchville, VA 24421
540-337-7270
www.cestarisheep.com

Knitting Fever and EURO Yarns
K.F.I.
P.O. Box 336
315 Bayview Avenue
Amityville, NY 11701
www.knittingfever.com

Lion Brand Yarn
135 Kero Road
Carlstadt, NJ 07072
800-258-YARN (9276)
www.lionbrand.com

Red Heart Yarn
Coats & Clark Consumer Services
P.O. Box 12229
Greenville, SC 29612-0229
800-648-1479
www.redheart.com

So Original Yarn Shop
3494 Olney-Laytonsville Road
Olney, MD 20832
301-774-7970
www.sooriginal.com

Design by Diane Irvine
Plymouth, MI
www.diirvine.com

Caleb Barker Media
www.calebbarker.com

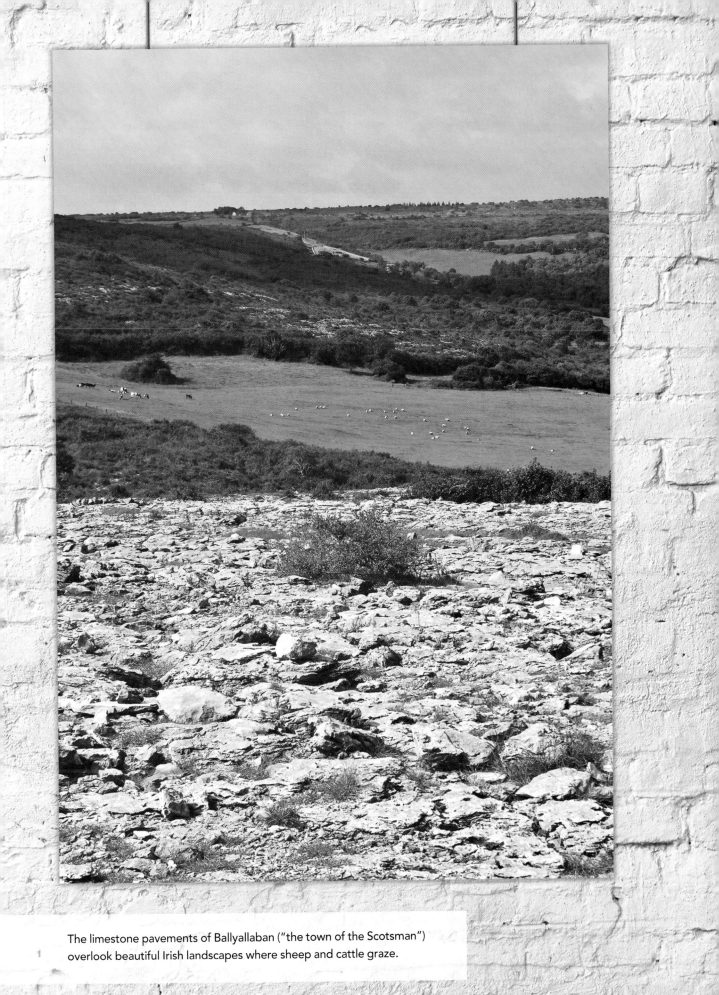

The limestone pavements of Ballyallaban ("the town of the Scotsman") overlook beautiful Irish landscapes where sheep and cattle graze.

Meet Bonnie Barker

I first picked up a crochet hook when I was seven years old. I watched my neighbor crochet a granny square that kept getting bigger and bigger until it covered her full-sized bed as an afghan, and I was so impressed that I just had to learn! She patiently taught me the double crochet stitch, and by the time I was nine I, too, had a giant granny square afghan on my bed.

When I was about ten, my best friend's mom began teaching me how to read patterns. I loved the beautiful ponchos and shawls my best friend Becky wore to school and longed to learn how to crochet like her mom. Her mom was incredibly patient with me when I would show up unannounced on her doorstep and ask her to clarify confusing language in the pattern.

That was many years ago. I have now been crocheting for more than forty years, and I have been teaching crochet to the next generation through the church (Girls' GEMS Club) and home school communities for more than a decade.

My family and I have been volunteers at the Montgomery County Agricultural Fair, working in the home arts building where the crocheted entries are showcased. The first year I won best of show for the crochet department, I received a call from a woman who lived in New Jersey. She wanted to know where I had bought the pattern for my afghan from the fair so that she could buy one, too. It was then that I decided to try to get some of my original patterns published. Before then, I had no idea where to begin the journey into the publishing world. Since that time, I have given a lot of people a chance to tell me, "No," to getting my patterns published, and to my delight some have actually said, "Yes!"

I am a graduate of Hialeah High School (Hialeah, Florida) and the University of South Carolina, where I earned a Bachelor's degree in music education. I occasionally teach music lessons in my home and love leading worship for preschoolers at our church. I have learned to enjoy teaching algebra, geometry, history, government, chemistry and, of course, crochet classes. Life is full, life is good, God is amazing!

Bonnie Barker (second from right) and her family.

Acknowledgements

Starting at the very beginning, I want to thank the two ladies who introduced me to the wonderful world of crochet when I was a child: Claire Cox, my next door neighbor, who taught me how to form my first crochet stitches and started me on my first afghan; and my best friend's mom, Carolyn Stone, who taught me how to read crochet patterns, and who always cheerfully answered my questions.

To Teresa Morse for being the best, most supportive and unselfish county fair crochet chairwoman on the planet!

To Linda Malcomb, Emily Hoover and my daughters Becky and Hannah for being willing to be thrust into the crochet modeling world, no matter how silly you may have felt wearing sweaters, capes, and scarves in the heat of summer.

To Svetlana Ford and her daughter, Anya, who have patiently answered my one million and one questions about the amazing yarns in their shop.

To Ope Aboagye, BJ Thomas, Laura Pfannschmidt and Teresa Mitchell for being prayer warriors on my behalf, as well as for encouraging me, but most importantly, for being my friends.

To my editor, Noel Rivera, whom I just met, but already recognize as a kindred spirit. Thanks for making this so easy for me.

To Christine Polomsky for being a patient photographer and just plain fun to talk to.

To Bobbie Matela for helping me learn to think outside the box on my crochet designs.

To Carol Alexander for raising the bar to new heights in the crochet world and for graciously including a few of my designs in your publications.

To Carolyn Mahaney for keeping the high calling of serving in the home and for teaching women like me to love and cherish it at a time when the world would encourage us to abandon it. I can't wait until I hear Him say, "Well done!" on your behalf.

To my Mother-In-Law, Irma Barker and my sister, Brenda Schweitzer, you two are the most generous ladies I have ever known. When I grow up, I want to be more like you!

To my mom, Harriette Schweitzer, who has been my cheerleader throughout my life, even when I've fallen flat.

To my dad, Robert John Schweitzer, artist, American patriot and defender of freedom. I know you can see this from your place in glory! You are the most creative person I've ever known, never afraid to try or to fail at new things. Thanks for letting me be by your side as you created so many things in our home. I'm looking forward to seeing you again on *that* day.

To my children, Becky, Caleb, Hannah, Hudson and Joseph, and my beloved best friend, Craig, for putting up with yarn piles that magically multiply, and for getting me out of countless I.T. disasters. You, more than anyone, see the good, the bad and the ugly in living color and are, henceforth, sworn to secrecy! You know that I love you more than my inadequate words can say.

A monumental thank you to Lindsey Stephens for turning my crochet hieroglyphics into a more understandable language for crocheters. I think I owe you a case of Advil by now.

Finally, to my Lord and Savior, Jesus Christ, the Supreme Creator and Designer who laid it all down. The best we can ever do is imitate what you have already done. May this book echo a faint whisper to Your glory. "Such a tiny offering, compared to Calvary, nevertheless, I lay it at Your feet. . . ."

US Crochet term		UK Crochet term
slip stitch (sl st)	• or —	slip stitch (ss)
single crochet (sc)	+	double crochet (dc)
half-double crochet (hdc)	T	half treble (htr)
double crochet (dc)	╪	treble (tr)
treble crochet (tr)	╪	double treble (dtr)

fw media

www.fwmedia.com

18 17 16 15 5 4 3

DISTRIBUTED IN CANADA BY FRASER DIRECT
100 Armstrong Avenue
Georgetown, ON, Canada L7G 5S4
Tel: (905) 877-4411

DISTRIBUTED IN THE U.K. AND EUROPE BY F+W MEDIA INTERNATIONAL
Brunel House, Newton Abbot, Devon, TQ12 4PU, England
Tel: (+44) 1626 323200, Fax: (+44) 1626 323319
E-mail: postmaster@davidandcharles.co.uk

DISTRIBUTED IN AUSTRALIA BY CAPRICORN LINK
P.O. Box 704, S. Windsor NSW, 2756 Australia
Tel: (02) 4560-1600 Fax: (02) 4577-5288
E-mail: books@capricornlink.com.au

Edited by Noel Rivera
Cover designed by Julie Barnett
Interior designed by Brianna Scharstein
Production coordinated by Greg Nock
Photography by Christine Polomsky & Corrie Schaffeld

METRIC CONVERSION CHART

CONVERT......TO..........MULTIPLY BY

Inches	Centimeters	2.54
Centimeters	Inches	0.4
Feet	Centimeters	30.5
Centimeters	Feet	0.03
Yards	Meters	0.9
Meters	Yards	1.1

Notes:

Gauge (or tension in the UK) is measured over 4" (10.2cm) in single crochet (except for Lace [0], which is worked in double crochet).

In this book, US hook sizes are given first, with UK equivalents in parentheses.

Steel crochet hooks are sized differently from regular hooks—the higher the number, the smaller the hook, which is the reverse of regular hook sizing.

CROCHET HOOK CONVERSIONS

US size	Diameter (mm)
B/1	2.25
C/2	2.75
D/3	3.25
E/4	3.5
F/5	3.75
G/6	4
H/8	5
I/9	5.5
J/10	6
K/10½	6.5
L/11	8
M/13, N/13	9
N/15, P/15	10
P/Q	15
Q	16
S	19

Index

Abbreviations, 5
Afghan, 116–121
Aran Diamonds Cardigan & Vest, 92–97
Arrow, 6–7

Baby Feet Baby Blanket, 108–111
Baby feet toe popcorn, 7
Back post double crochet (bpdc), 8
Back post treble crochet (bptr), 9
Backpack, 48–50
Bag, 48–50, 68–71
Basket Weave, 10–11
Beginning chain (beg ch), 14
Big toe popcorn, 12
Blanket, 54–55, 62–63, 80–82, 108–111, 116–121
Blarney Blanket, 54–55
Braided Cable (BC), 13
Burren Braids Hat & Scarf, 46–47
Busking Beauty Sweater Wrap, 98–100
Buttonholes, 14

Cable, 15–16
Cables Meet Lace Cape, 64–67
Cape, 64–67
Celtic Carryall, 68–71
Celtic Cross, 17
Celtic Cross Afghan & Pillow, 116–121
Celtic Weave (CW), 18–19
Crochet hook conversions, 126
Crochet in the round, 20

Diamond, 21–22
Doolin Delight Sweater Wrap, 102–107
Double crochet (dc), 23

Front post double crochet (fpdc), 24
Front post treble crochet (fptr), 25

Gaithersburg Stole, 72–75
Gavotte Gigs, 88–91

Hat, 46–47
Headband, 52–53

Hialeah Honey Baby Blanket, 62–63
Honeycomb, 26–27

Inisheer Sweater Wrap, 76–79

Jig Infinity Scarf & Headband, 52–53

Kells Cabled Sweater, 112–115
Knockardakin Wrap, 84–86
Knotted fringe, 28
Knurl (reverse sc), 29

Liffy in a Jiffy, 44–45
Low back ridge (LBR), 30
Low front ridge (LFR), 31

Pennywhistler's Purse & Pack, 48–50
Pillow, 116–121
Popcorn (pc), 32
Purse, 48–50

Ribbing using front post & back post, 33

Sailboats Baby Blanket, 80–82
Scarf, 46–47, 52–53. *See also* Stole; Wrap
Shadow box, 34–35
Shell with picot, 35
Single crochet ribbing, 36
Single crochet (sc), 36
Skill levels, 4
Slip knot, 37
Slip stitch (slip st), 37
Stitch guide, 6–41
 arrow, 6–7
 baby feet toe popcorn, 7
 back post double crochet (bpdc), 8
 back post treble crochet (bptr), 9
 basket weave, 10–11
 beginning chain (beg ch), 14
 big toe popcorn, 12
 Braided Cable (BC), 13
 buttonholes, 14
 cable, 15–16
 Celtic Cross, 17

Celtic Weave (CW), 18–19
crochet in the round, 20
diamond, 21–22
double crochet (dc), 23
front post double crochet (fpdc), 24
front post treble crochet (fptr), 25
honeycomb, 26–27
knotted fringe, 28
knurl (reverse sc), 29
low back ridge (LBR), 30
low front ridge (LFR), 31
popcorn (pc), 32
ribbing using front post & back post, 33
shadow box, 34–35
shell with picot, 35
single crochet ribbing, 36
single crochet (sc), 36
slip knot, 37
slip stitch (slip st), 37
treble crochet (tr), 38
wheat, 39
woven, 40–41
Stole, 44–45, 72–75. *See also* Scarf; Wrap
Sweater, 56–61, 76–79, 92–97, 98–100, 102–107, 112–115

Terms, US vs. UK, 126
Tipperary Sweater & Vest, 56–61
Treble crochet (tr), 38
Turning chain, 4

Vest, 56–61, 92–97

Wheat, 39
Woven, 40–41
Wrap, 76–79, 84–86, 98–100, 102–107. *See also* Scarf; Stole

Yarn substitutions, 4
Yarn weights, 4